THE PHOTOGRAPHER'S ASSISTANT

<u>John Kieffer</u>

Acknowledgments

I would like to thank the following people for their contribution to this book. First and foremost to my wife Beth, whose help and understanding have been most helpful throughout the long process. The following photographers were also especially helpful: Brian Mark for the use of his Denver studio, photographic expertise, and physical presence in the cover shot; Jim Cook, Todd Droy, and Jim Havey for reading the manuscript and their invaluable observations; and to Vicki Mann of Mann Communications for producing the line-art.

I also wish to thank Michal Heron for her efforts in finding both exceptional and articulate photographers for the interviews and the photographers themselves: Nancy Brown, Todd Droy, Carl Fischer, Michal Heron, David MacTavish, Shel Secunda, and Steve Umland. Finally, thanks to publisher Tad Crawford for his editing of the manuscript and for his insight as to how to make this book most effective, and to David Milne for his work in designing the book.

© 1992 by John Kieffer

All rights reserved. Copyright under Berne Copyright Convention, Universal Copyright Convention, and PanAmerican Copyright Convention. No part of this book may be reproduced, stored in a retrieval system, or transmitted in any form, or by any means, electronic, mechanical, photocopying, recording or otherwise, without prior permission of the publisher.

Published by **Allworth Press**, an imprint of Allworth Communications, Inc., 10 East 23rd Street, New York, NY 10010

Distributor to the trade in the United States: Consortium Book Sales & Distribution, Inc. 287 East Sixth Street, Suite 365 Saint Paul, MN 55101

Distributor to the trade in Canada: Raincoast Book Distribution Limited 112 East 3rd Avenue Vancouver, B.C. V5t 1C8

Distributor to photographic supply outlets: Amphoto Books 1515 Broadway New York, NY 10036

Book design by Douglas Design Associates, New York, NY

ISBN: 0-9607118-8-0

Library of Congress Catalog Number: 91-77927

Cover photograph: Brian Mark and his assistant at work in Brian's Denver studio © 1992 by John Kieffer

Table of Contents

Table of Contents continued

Chapter Seven: The Medium Format Camera Key Characteristics • Medium Format Film • The Film Magazine • Cleing the Film Magazine • Prerequisites to Loading • Loading the Film Mazine • First Things First • Positioning the Film • Advancing the Film • The Exposure Process • Unloading the Film Magazine • Film Processing • ternative Film Processing • The Roll Film Holder • Lenses, Filters, and Compendium • Using a Tripod	ean- iga- Γhe Al- the
An Interview with Michal Heron	.77
Key Characteristics • Plane of Focus and Perspective • The Camera Moments • The View Camera • Camera Stands and Tripods • The Large Form Lens • Preparing the Lens • Compendium Lens Shade • Filters • Focus Aids • Sheet Film • Preparing the Sheet Film Holder • Preliminary Ta • Labelling the Holder • Identification Cards • The Dark Slide • Cleaning Film Holder • Removing Dust • Take Your Time • Loading the Film Hole • Before the Lights Go Out • Lights Out! • Inserting the Film • Lights (• The Exposure Process • Why You Identify Film • Unloading the Film Hole • Lights Out, Again! • Ensuring Proper Processing • The Different Film Ty • Other Materials • The Changing Bag • Summary of Responsibilities Relate Camera and Film	mat sing isks the der On! der
Chapter Nine: Polaroid Instant Film Why Use Polaroid Instant Film? • Checking Exposure • Checking Fo • The Best View in the Studio • General Characteristics • Processing Polar Material • The Assistant's Responsibilities • Annotating the Polaroid Pr • The Small and Medium Format Instant Film Back • Loading the Inst Film Back • Developing the Polaroid Print • Polaroid for the View Cam • Why Use Polaroid Instant Film? • The 4x5 Inch Polaroid System • The Mo 550 Film Holder • The 8x10 Inch Polaroid System • Summary of Responsibilities	roid rint tant tera odel
An Interview with Steve Umland1	108
Chapter Ten: Artificial Lighting	pply am- um- rent sure Re-

Table of Contents continued

Chapter Eleven: Working with Light
An Interview with Todd Droy139
Chapter Twelve: Photographic Hardware
Chapter Thirteen: Surface Preparation
Chapter Fourteen: Background Materials
An Interview with Carl Fischer162
Chapter Fifteen: Studio Departments
Chapter Sixteen: Photographic Specialties

Table of Contents continued

Chapter Seventeen: How to Learn While Assisting	185 'hat's Avail-
An Interview with Shel Secunda	187
Glossary	193
Appendix A: Professional Associations	197
Appendix B: Creative Directories	198
Appendix C: Photographic Literature and Catalogs	200
Appendix D: Periodicals	204
Index	205

Credit for the photographs that accompany the interviews:

- 1. Nancy Brown, ©Joe Polillio
- 2. Michal Heron, ©1990 Shel Secunda
- 3. David MacTavish, ©Laurel Spingola
- 4. Todd Droy, ©Todd Droy
- 5. Steve Umland, ©Steve Umland
- 6. Shel Secunda, ©Marcos Villasenor

The Assistant and the Photographic Community

any of us experienced a special fascination with photography from our earliest encounter, and we continue to nurture the dream of being a professional photographer. Unfortunately, one of the first and greatest stumbling blocks is just getting your foot in the door. The best approach to getting started as a professional photographer is to become a professional photographic assistant.

The Photographic Assistant

Just what is a professional photographic assistant? In general, it's an individual with both photographic and related skills, who assists the professional photographer. Being a photographic assistant can be both a transitional period and a learning experience. It can allow the advanced amateur or recent photography school graduate to turn professional more smoothly. A good assistant has marketable photographic skills, but also performs as an apprentice.

Before you can appreciate the importance and responsibilities of the assistant, it's necessary to dispel some common myths regarding professional photographers, especially those photographers most likely to hire assistants. Photographers who regularly utilize assistants receive photographic assignments that have budgets for an assistant. They get the better jobs because of their ability to consistently produce a technically excellent photographic product, regardless of the subject or shooting conditions.

Many aspects of high level photography must be approached very precisely. What is almost perfect is unacceptable. Being a little out of focus, seeing only the edge of a piece of double-stick tape, or overlooking a speck of errant dust on the set is intolerable. Imagine several professionals viewing an 8x10 inch color transparency with a magnifying lupe. There's no place to hide mistakes.

Photography is a process where the production of the final piece of film is the result of many small steps. Failure to perform any of these steps satisfactorily can render the film useless. To consistently sustain this high level of output requires both technical and creative skills. It also necessitates a certain fastidious nature, attentiveness to detail, and overall organization by photographer and assistant.

Photography is often mistakenly perceived as a fairly laid-back, almost casual occupation. This is largely untrue for professional photography as a whole, and entirely unfounded when assistants are utilized. An acceptable product must be delivered on schedule, often by the end of the day.

Besides, along with the photographer and assistant, others might be involved with the day's work. These may be an art director, the client, stylist, or a model. Either their schedules or the budget, may not allow for an extension of the shooting schedule. A photographic assistant is an integral part of this creative effort and can be a tremendous asset. Conversely, mistakes can cost thousands of dollars and damage the photographer's credibility.

The bottom line is, the most successful photographers are those who won't let something go out of the door until they're satisfied that the work is the best it can be. These are the photographers assistants want to work for the most. Keep in mind, as the day grows longer and the take-out pizza gets colder, there are likely to be only two people left in the studio — the photographer and the assistant. As an assistant, you should expect long days and demanding work. The rewards are financial, educational, and an active involvement with a high quality photographic experience.

The Assistant's Responsibilities

A clearer view of the photographer's working environment makes it easier to appreciate why the successful photographer needs a competent assistant. With this in mind, what are an assistant's responsibilities? In general terms, the assistant is hired to free the photographer from many lesser, routine tasks. This allows the photographer to concentrate on what is in the frame, and ultimately on film.

To be most effective, the assistant must integrate a variety of skills into many different kinds of photographic situations. Besides receiving instructions from the photographer, a good assistant anticipates the progression of the shoot, and takes the initiative regarding assisting duties. Finally, the assistant must be in tune with the photographer...a sort of mind reader.

More specifically, assistants work with photographic equipment. However, this equipment is rarely the kind mentioned in the popular photography magazines. The 35mm, single lens reflex camera (SLR), so familiar to

amateur photographers, is probably the format encountered least by the assistant. This small format camera is likely to be replaced by medium format cameras (6x6cm and 6x7cm), and large format view cameras (4x5" and 8x10").

Associated with every camera are film handling responsibilities: loading and unloading film from camera bodies, film magazines, or sheet film holders; organizing the exposed film to ensure proper processing; and ultimately taking it to the lab and possibly delivering it to the client.

The need to produce on schedule requires the photographer to control as many variables as possible. Hence, the use of constructed shooting environments. Artificial lighting is a big part of this controlled environment. The small flash units that attach to 35mm, SLR cameras are replaced by powerful, electronic flash systems. These lighting systems consist of large power supplies and individual flash heads.

In addition, stands and numerous light modifying devices are used to control this raw light. Some of the assistant's responsibilities are to set up the lighting system, subtly change its position and character, and to tear it down. Reliance on artificial lighting greatly increases the need for an assistant.

Artificial lighting also necessitates the use of Polaroid™ instant film, and Polaroid film means more work for the assistant. Generally, a photographer won't go to film until all that can be done is done. Polaroid helps confirm important aspects ranging from composition and lighting to focus and exposure. Everything must be just right to avoid unwanted surprises.

Like an artist, the photographer often starts with only a general idea and a blank camera frame. This is especially true when working in the studio. This means a background must be selected, or even specifically designed and constructed. Both the subject of the photograph and all related props must be as desired. Those surfaces visible through the camera need to be prepared, so they reproduce as desired on film.

Every item must then be precisely positioned, by whatever means necessary. The solution may dictate the simple use of a clamp, but frequently demands real ingenuity. It's imperative that everything stays together, at least until the last exposure is made.

A key to being a good assistant is the ability to prioritize your many responsibilities. You must work at being efficient in accomplishing required tasks. At the same time, you must keep one ear dedicated to the photographer. There's more to professional photography than what's visible in the final image. To be a successful assistant, you need many skills. Not all are thought of as photographic, but they're still essential in creating successful photography.

Benefits from Assisting

The benefits you receive by being a professional photographic assistant are almost too numerous to list. In simple terms, it's an incomparable learning experience...and you get paid for it. You work with the better photographers in your community, and in the process you're exposed to a vast array of photographic challenges and creative solutions.

By assisting different photographers on countless photographic assignments, the day-to-day tasks of photography gradually become routine. As a result, you'll be far less likely to have difficulties when making the transition from assistant to professional photographer.

Perhaps of greatest value is the knowledge you gain regarding every aspect of lighting. As your photographic eye evolves, you learn to appreciate the subtleties of light. If you're perceptive, techniques used to control light can become invaluable tools for use later on. No one works with the photographer as closely as the assistant. Assisting also gives you a familiarity with a range of photographic equipment that's impossible to obtain any other way. This hands-on experience makes the inevitable purchase of costly

photographic equipment less of a gamble.

The assistant is part of a creative team, commonly working with models, stylists, set builders, and other assistants. Working with these people imparts valuable knowledge. Later in your career, many of these same individuals may even be of service to you. When assisting, your daily routine is likely to include running errands. These will consist of stops at film processing labs, repair shops, and other photo-related resources. Support services are essential to virtually all areas of professional photography, and many times aren't readily located in the phone directory. Assisting builds knowledge of their access, and familiarity with their use.

Finally, assisting provides a unique avenue for becoming part of the local photographic community. As a successful assistant, the transition to professional photographer will be more direct. With time, your employers will become your peers.

The Professional Photographic Community

The field of professional photography is extremely diverse, and skills useful to virtually every photographic endeavor can be acquired by assisting. However, it's critical to know which areas of photography require assistants and why. This information helps to define where the assistant fits into the photographic community, and is used to design a marketing strategy.

The following list consists of those areas with the greatest potential to utilize photographic assistants. It's fair to say that several categories could apply to many photographers over the course of a busy year. They are: advertising, annual reports, architectural, audio-visual, catalogs, commercial, editorial, fashion, food, illustration, industrial, location, photojournalism, portraiture, product, still life, studio, table top and technical.

Commercial Photography

Commercial photographers use assistants more than any other group of photographers. These photographers commonly obtain work from advertising agencies, graphic design firms, and larger companies. The resulting photographic product is then used in some form of commercial endeavor, such as in a magazine advertisement or a piece of literature.

The field of commercial photography is not precisely defined, and encompasses a variety of disciplines. With such diversity, it holds the potential to expose the assistant to every kind of shooting experience.

Product Photography

Product photography is a branch of commercial photography, essential to many businesses and photographers alike. When the objects are small, it's often referred to as *table top* or *still life* photography. Whatever you call it, you take pictures of things, usually things that are sold. Ideally, this work is performed in the studio, where photographic control can be maximized. Proper lighting is critical, not only to show the product most favorably, but also to elicit a response or convey an idea. Utilizing view cameras, professional lighting systems, and every type of related equipment is the routine.

Architectural Photography

Architectural photographers also depend on assistants. Whether shooting interiors or exteriors, they are often called on to illuminate large areas. This translates into lots of equipment. Photographers often need to be in two places at once, and when large spaces are involved, what's better than a good assistant? As you'd expect, it's always a location job and everything must be transported to and from the site.

With much of product and architectural photography, exposing the film is anti-climatic and almost a formality. Lighting and composition problems are solved and verified, with Polaroid instant film. Unless an important variable cannot be precisely controlled, like the pouring of a beverage or rapidly changing natural light, a limited number of exposures are made.

People Photography

For some subjects, going to film signals a higher level of activity. This is true with photography involving people, especially in fashion. Here the fast handling 35mm and medium format cameras are most useful, with electronic flash helping to freeze the action. Due to a model's movements, the photographer cannot control the final outcome and a certain level of tension can exist on the set.

This uncertainty also increases film usage, to assure the photographer gets the shot. As the assistant, it becomes more important than ever to be attentive to the needs of the photographer, and to what's happening around the set. If there's a delay in the action, it better not be because of you.

Commercial work differs from wedding and portrait photography, where the general public is buying the product for personal use. Editorial photography and photojournalism isn't considered commercial work because the photography is not directly involved with selling something.

Editorial Photography and Photojournalism

Editorial photography and photojournalism is the non-commercial photography found in magazines and newspapers. The photographers pro-

ducing this work tend to use assistants less frequently than commercial photographers. Unfortunately, many editorial budgets just don't have any extra money for an assistant.

Besides budget, there is a fundamental difference in the subject matter. In most instances, the editorial subject possesses an inherent quality which makes it interesting to the viewer. A commercial product or idea doesn't have this advantage. It's a box, a thing, and the public often has little interest in it. The commercial photographer has to work hard to evoke any kind of response...that's part of the challenge. On the other hand, the very nature of editorial photography and photojournalism requires a less contrived approach, which means less need for an assistant.

Wedding and Portrait Photography

When the lay person envisions professional photography, both weddings and portrait studios quickly come to mind. From an assistant's viewpoint, both share some common traits. First, they draw their livelihood from the general public. This usually translates into a restricted budget. In addition, shooting situations and lighting solutions are less complex. The result is less need for an assistant. It's important to realize though, that there's still tremendous opportunity to photograph people, although it's usually related to a commercial job.

Freelancing and Full Time Assisting

Another aspect of assisting must be addressed. This is whether to be a freelance or full time assistant. As a full time assistant you are like an employee of any small business, except that the job is with a photographer who owns an independent studio. While as a freelance assistant, you provide services to many photographers on an as needed basis.

Before deciding if one position is best, it's important to examine the city where you intend to work. There may not be a choice to make. Larger, economically healthy, metropolitan areas have larger, photographic communities. These markets hold the greatest potential in finding a full time position. Metropolitan areas with less than one-half million people may only have a handful of full time positions. Wherever the market, there are always more free lancers than full time assistants.

If given the opportunity to pursue either, understanding how the two positions differ will help you make an informed decision. The word that best describes freelance assisting is diversity. One day you're on location, involved with a fashion shoot. You're working with a medium format camera, strobe, models, and a stylist. On another, you'll spend the day in the studio, fine tuning a single product shot. Here the photographer utilizes a view camera, different lighting equipment, and more importantly, a different viewpoint.

No matter how skilled, a photographer doesn't practice every type of photography or utilize every valid approach. Freelancing allows you to explore the widest range of photographic experiences. You can become more familiar with those areas you think you want to pursue professionally. But just as likely, you might become side-tracked by areas you never even knew existed. Try it, you might like it. If it doesn't hold your interest, don't worry, your next assisting job will probably be quite different.

Working with different photographers means different equipment. Freelance assistants get hands-on experience with a vast array of equipment. This helps you decide which style of photography or particular camera format feels right for you.

Don't conclude that freelance assisting is all pluses. As a freelance assistant, you are essentially running your own business. Free lancers don't find one job, and then stop looking. They build a clientele and work at keeping it. This means you don't receive a steady pay check. You bill your clients and wait for payment.

When pursuing a full time position, it's important to evaluate both the photographer and the kind of work he or she performs. The assistant works very closely with the photographer and a certain degree of compatibility is essential. Does the kind of work the photographer shoots day in and day out fit into your learning goals?

An Interview with Nancy Brown

ancy Brown is a professional photographer based in New York city. She is primarily involved with photographing people.

John Kieffer: What photographic skills do you feel are most important for a photographic assistant?

Nancy Brown: Technically, assistants have to know strobes and cameras, especially how to load cameras, every format. For me, it's 35mm and medium format, I don't use 4x5 or 8x10. In addition, assistants must have a knowledge of different kinds of strobes, for me it's just one, I use Dyna-LiteTM.

It's also important for my assistants to know printing and darkroom work because I do a lot of head shots and composites. We don't develop the negatives here anymore, but we do make prints. Just about all assistants can print, it's something they learn right away. Those are really the basics. Assistants, if they're smart and have good sense can learn what it takes to be a good assistant, if they like the business.

But for the most part, I hire assistants or take assistants on because of their personality. I've found most of my assistants either at workshops I've taught or at seminars that I've held. Consequently, I've had a chance to work with them and get to know them. I don't think more than one or two free lancers have come through here that have been put on as a full time person. By and large, I get assistants from having been with them in a workshop arrangement. I watch them. I know if their personalities are good, that's the main thing.

J.K.: Could you be more specific? What personal attributes do you feel are most important?

N.B.: Assistants have to talk, have opinions, be alive; I want to hear what they have to say. Some photographers want assistants to blend into the woodwork, I like assistants to be very equal with me. I want them to be able to take over. They're part of my team. Assistants are not like employees in that sense. When we are going to do something, they should start to do it before I tell them. That happens after being with me for awhile and they know how I work.

I have a different arrangement than a lot of people, I don't have all those rules. If I like someone's personality and I know they like this business, they can learn very quickly. Some kids come from these big schools, but could never work for me because their personalities are not what I need.

J.K.: Do you find that most of the assistants you take on have formal photographic training?

N.B.: Most have at least gone to a two year school, although not all. For example, currently I have two photographers with me in the studio, both were previously my assistants. One learned by doing, while the other went to a four year college for photography.

J.K.: If someone catches your eye and you haven't worked with them before, do you interview them or review a portfolio?

N.B.: I don't look at portfolios, my studio manager looks at portfolios and sees the assistants. If we need an assistant I'll look at her list. My studio rents out to other photographers and 99% of the time, I'll see an assistant here that looks good. I'll try him before I'll try someone who walked in the door. I met the free lance assistant I'm using now that way. I loved the way he worked with this other photographer and I loved the way he left my studio clean after the end of the day. He was great...alive, talking, a friendly part of the group. I like people who talk and I have problems with people who don't. But a lot of photographers are just the opposite. They want their assistants to be mute and just to do the job, but that would drive me crazy.

Remember, the photography I do is people-oriented, the lighting is fairly straightforward. The people are the main thing—what the model and my talent are doing. I'm not doing technical things, where quiet and concentration might be really important. Everyone must know their skills, the lighting and loading cameras. But after that, you lighten up. The technical skills should be second nature.

J.K.: When you're photographing people and using a stylist, do you want the assistant to interact with the model?

N.B.: We always work with a stylist. The make-up and hair is the stylist's responsibility. I don't mind people talking to the model, but when we start shooting, I'm the only one who is communicating with the model. But the atmosphere is not rigid, and not so structured that no one can move. That's not the way I work. Working with children is different. They have to know that I'm the one who is giving the orders. So we let the mothers and other people be a little quieter. I want their attention on me and kids get distracted more easily.

Believe mc, everyone works differently. As I said, I rent my studio and some photographers are just the opposite even though they are shooting people—fashion. But it's their way of concentrating one-to-one with the model.

J.K.: Do you have a full time assistant, or do you use free lancers?

N.B.: I have a number one assistant and then I'll hire free lancers to back him up. When I shoot stock photography, I hire free lancers to go out with me.

J.K.: Do you have any preference for male or female assistants? Does that ever enter into it?

N.B.: No, however I've only had a couple of female assistants. Guys seem to be better than girls, I don't know what it is, but guys seem to be more confident with equipment and work more quickly. On the other hand, girls can style. I've

yet to have a guy who can do make-up and hair. So girls can do more in some sense. If I was doing a job that required a room set, intricate lighting, and windows built, I'd rather have a guy because they can do it. Ideally, my studio would have a girl as studio manager/make-up and hair stylist/assistant on small things and a male assistant.

J.K.: Do you think strength plays a role in assisting?

N.B.: Oh definitely, I've had female assistants who could pick up anything a guy could, while others can't lift anything and I tell them to go to the gym. When you're trying to load a van you need some physical strength. You need people who can carry the load.

J.K.: When you go on location overnight do you take assistants with you?

N.B.: Yes, I take my full time assistant and free lancers if they are needed.

J.K.: Regarding day rates, what do you pay your assistants?

N.B.: \$125.00 to \$150.00 a day. Your first assistant would be the one getting \$150.00 and your second assistant would be getting \$125.00. The first assistant would be giving the second assistant the orders.

J.K.: Do you stick with that rate when you travel?

N.B.: Sure you pay the same, but let's say you're going on a trip for five to eight days. You might work a deal, maybe five days at \$100.00 per day. Actually it shouldn't be that way because it's going to be harder work on location than it would be in the studio in the city. But there's something about backing up days, same for myself. If the client tells you it's going to be five days, you might make a better arrangement money-wise with the client because you are going to have more days involved. That's normal. If you're just going to be gone one or two days, no way. There's no reason. Assistants work harder on the road than they do in the studio, if anything they should be paid more.

J.K.: Can you recall any disasters that were caused by assistants?

N.B.: Not really, one time the assistant plugged my flash meter's cord into the wall socket instead of into the strobe's power supply, and blew the thing right up. Luckily the Minolta meters are circuited so she only blew out half the circuits and we had it fixed. And I've had assistants knock things over or hit the tripod after it's all set-up. But we all do that, I've done that myself.

We've also had situations when the strobes were left back in the studio. Those mistakes can be costly. Fortunately we were able to have them delivered across town. There were all kind of excuses as to why the strobes weren't in the van. That's caused by not thinking, their hearts not being in their job and you can't be that way in photography. You've really got to like what you're doing and assistants have got to put your interest ahead of theirs. All the good ones do that. Your job, your pictures, your interests are first and foremost when they're with you, and that's hard for people. You have to be natural at that, that's why some assistants are so good.

I wish there would be a group of "professional" assistants—people who never wanted to be photographers, are really good at what they do, and get \$300 to \$400 per day. You could draw from this pool of assistants who would know everything. Assisting is a good job, but it's thought of as a stepping stone to becoming a photographer. Assistants work harder on the set than anybody, but they get paid the least. That's just the way the business is.

J.K.: Do you think that most assistants who go to a photography school and then work as a full time or free lance assistant for a couple of years make a successful transition to professional photography?

N.B.: I think it takes a long time. Maybe years ago it was easier. Now it's so costly to get into this business. With the overhead of running a studio it's hard even for the people who are already in it. There are also too many people coming out of the schools, but the jobs aren't increasing. So the ones who are really good and really want to be photographers will stay in it. But those who are even borderline aren't going to make it. It's a very tough business. Most schools don't alert the students as to how this business really is. Why should they, they wouldn't have students.

J.K.: Considering costs, do you see a trend to hire free lance assistants on an as-needed basis versus hiring a full time assistant?

N.B.: Probably, if you don't want to carry the staff overhead. What the three of us are doing in this studio is utilizing the same equipment and space, so there aren't three separate investments.

J.K.: Have you come across any unethical behavior on the part of an assistant, such as contacting your clients?

N.B.: Never, but I've heard the stories. Like I said, personality is a big part of the business and you get to know how a person is.

J.K.: Have you experienced any instances where the assistant performed above the call of duty?

N.B.: I think most of mine have over the years, especially the ones who have stayed with me a long time. We've had to move and build studios and all kinds of things. Believe me, if they didn't have my interests as a priority it would never been done as smoothly. When I look back, I've been very, very lucky with the people I've had to work with.

J.K.: How long do your assistants tend to work with you?

N.B.: A couple of my assistants have lasted three years, and they were excellent.

J.K.: Have your full time assistants gone into the same type of photography that you shoot?

N.B.: Everyone who has been with me and gone off somewhere has shot people in one way or another. That's what I do. To be with me very long and not be interested in people would be silly. They use a different approach or style. You don't want people to be clones, that's not good for them.

Capitalizing on Your Assisting Skills

efore running out the door to seek employment as a photographic assistant, it's best to have a strategy. One aspect of any approach should be to determine those skills most marketable. Then, ascertain which skills you already possess and work to develop the others. With this base information, you can begin to capitalize on your unique attributes.

Assisting Skills

To make this task easier, now is the time to begin your Skill List. The list found in this chapter is merely a starting point, a way to highlight some of the basic photographic skills used by assistants. More importantly, it demonstrates that skills not thought of as photographic are invaluable. As you investigate the field of photography, try to become aware of how your unique background relates to assisting. Blank spaces are provided to record your insights.

A well-kept skill list serves several functions. It's a means of developing a list of talents specific to you, a pool of raw information that can be drawn from to construct promotional material. Later, it will make follow-up phone calls more productive, by quickly reminding you of skills of particular value. Start your skill list now, as it grows so does your confidence.

Expanding Your Repertoire

Most of this book is directed towards what the assistant needs to know to perform effectively. However, there's a wealth of photographic information readily available to help you perfect your skills. The key is to tap into these varied resources now, many are free or relatively inexpensive.

Printed Material

First, you should visit your local public or college library. Most likely, you'll be able to find a book or two on view camera technique or basic lighting. But most importantly, it's a valuable introduction to the abundance of professional magazines and journals. If you're not familiar with the following publications, you're missing out; Photo District News, Photo/Design, Photo Electronic Imaging, Studio Photography, and Industrial Photography.

These periodicals are directed to a professional audience and address a broad range of technical and business matters. Some trade journals routinely attach free subscription cards and easy to use literature response cards.

Professional photographic equipment literature can also be of value by providing information on the kind of equipment rarely mentioned in the amateur photography magazines. Literature can take the form of a large, general purpose catalog, containing all the basic and not so basic items. Or, it might offer more esoteric items, such as background materials or artificial ice. All of it can be informative, and lend insight into the nature of professional equipment.

Other important sources of information are the *creative directories* for professional photographers. Basically, directories are large books in which commercial photographers buy advertising space. The photographers and the kinds of photographs selected are very representative of much of the work associated with assisting. These vital resources serve several functions and will be discussed more thoroughly later.

Professional Organizations

Learn which professional organizations are most active in your area. The American Society of Magazine Photographers, (ASMP) is the largest national organization. Local chapters have regular gatherings which are open to non-members for a nominal charge. In some cities, the Advertising Photographer's of America (APA) might be most valuable. In many circumstances, it will be necessary to contact an organization's national office, in order to find a local representative.

Professional Resources

Finally, become familiar with the film processing labs, retail stores, and rental shops utilized by the local professionals. These often have bulletin boards for posting a variety of professionally oriented material. All will provide valuable information and contact with the photographers most likely to use assistants.

No photographer knows everything about every piece of equipment. How do you go about filling in some of the inevitable gaps? Acquiring printed material is fairly easy. Obtaining hands-on experience with unfamiliar equipment can be a bit more difficult.

Try visiting a professional retail store or rental shop, under the guise of a buying customer. Bring in a roll of 120 size, medium format film and practice on a Hasselblad. Examine a couple of different power supplies and related lighting hardware. Doing this, while referring to the information presented in this book can be very useful. When there's time after a day's shoot ask for the photographer's indulgence. This can be a good time to examine unfamiliar equipment or ask the photographer a question.

Utilizing Your Non-photographic Skills

It's been emphasized that many non-photographic skills come into play when trying to translate someone's idea to film. One area of particular importance includes carpentry, painting, and a familiarity with tools in general. An active participation in the maintenance of the average home provides a good foundation. When combined with a little ingenuity, it becomes even more useful.

This is especially true for commercial studio photography, where a shooting environment or set is routinely constructed for one shot. Building even a simple wall utilizes a range of talents. With time, you'll apply paint using a variety of techniques, on an even greater variety of surfaces. You can't appreciate the meaning of a perfectly painted surface until it has to withstand the scrutiny of a photographer behind a view camera.

If you've ever been labelled a perfectionist, then take advantage of this attribute. Whatever's in frame must be exactly as desired and every component of the shot must come together at a singularly critical moment, the exposure. To consistently make it all work, you don't have the luxury of glossing over minor details.

Location and Travel Skills

Due to the rigors of location work an assistant can become a necessity. The location might be just down the street or an extended stay out-of-town. Here again, what non-photographic skills do you have that make you an asset and not a liability? You'll find that being articulate and resourceful is more important to a corporate annual report photographer than being an accomplished black and white printer. It's these attributes that allow the assistant to function most effectively in this type of environment.

If you wish to travel and have travel-related skills, capitalize on them. Extended location assignments always have an element of uncertainty and it's reassuring to be able to call a self-sufficient assistant, who can also get to the airport on short notice. Assets might include excellent physical conditioning, coupled with a health insurance policy. Add to these a passport, immunization shots, and a fluency in a foreign language, and you could be the perfect candidate. A second language can be of value even in the United States. An assistant in Miami, who's fluent in Spanish and has a good knowledge of the city, could be indispensible.

When thinking of location, think environmentally. The environment might be corporate America or America's heartland. Are there places you feel particularly attuned to? If you live in a smaller market or an environment to which photographers travel, explore related possibilities. My outdoor oriented experience, coupled with a passion to shoot large format landscapes, led to assisting on location and location scouting assignments.

Being Objective

An honest self-critique is imperative whenever you evaluate your assisting skills because mistakes cost time and money. A thorough familiarity with the Hasselblad doesn't translate to an equal finesse with a Mamiya medium format camera. Nowhere is this concern more valid than working with film. Here, you can do something 99% correct and still end up with 100% disastrous results—useless film. What this means to the assistant is that you don't state that you're familiar with something when you're not. If questions arise after you've carefully examined the equipment, be honest and ask. Lack of a particular assisting skill won't make or break anyone. Assisting is a learning experience, but one in which limited mistakes can be made.

Assistant's Skill List

Small Format Cameras
Familiar with these manufacturers
Attachment of lenses and filters
Film handling
Polaroid film back
Other
Medium Format Cameras
Familiar with these manufacturers
Attachment of lenses and filters
Film handling
Polaroid film back
Other
Large Format View Cameras
Familiar with these manufactures
Familiar with these manufacturers
Attachment of lenses and filters
Film handling
Polaroid film holder
Other

Lighting
Electronic flash systems
Specific manufacturers
Small on-camera flash
Tungsten
Soft boxes
Umbrellas
Stands and booms
Other
Darkroom
Black and white film processing
Specific formats
Black and white printing
Color printing
E-6 processing
Other
Photo-Related
Utility knife and straight edge
Surface preparation
Mounting prints
Make-up
Sewing
Hair styling
Other
Familiarity with Background Materials
Seamless paper
Formica
Plexiglass
Black velvet
Support systems
Other

Set Building	
Painting	
Carpentry	
Power and hand tools	
Model building	
Locating props	
Other	
Location and Travel	
Excellent physical conditioning	
Health insurance/Workmen's compensation	
Foreign language	
Intimate knowledge of area	
Skills specific to an area	
Location scouting	
I ravel experience	
Credit cards	
Passport/Immunization	
Other	
General Employee	
Resourceful	
Articulate	
Reliable	
Attentive to details	
Tactful	
Driver's license	Trust of the State
Commitment to quality	

Promotional Material

It's time to begin integrating your attributes with what you know about assisting. This process will help you design effective promotional material that fits into an overall marketing strategy. The following is a combination of traditional approaches, general observations, and new ideas. Their need

and effectiveness will depend on your background and specific market.

Professional photography is an interesting mix. At times, it's conducted in a very businesslike manner. A photographer must make money to survive, and considerably more to prosper. At other times, the photographer must be very creative and unrestrained. This paradox can influence how you present yourself to the photographic community. Just what is assisting? It is fun, work, learning, creative expression, and even sweeping the floors!

The Resume

The resume is fundamental to almost any job search. It may be quite conventional, such as a chronological listing of education, work experience, and related skills. On the other hand, if you have less formalized photographic training a less structured approach might be better. Try listing skills and attributes in appropriate categories, such as studio, location, camera formats, lighting, or whatever best illustrates what you have to offer.

Regardless of your resume's structure, it should be designed to be easy to read. Don't make it an effort for the photographer to get to know you. Also, don't assume the photographer knows anything about you. Convey what you feel is important, clearly and concisely. Keep your resume to one, well-designed page. Additional thoughts can be expressed in a cover letter.

Sending your resume may be the first contact you have with the photographer. If the resume is ineffective, this first contact may be the last. Avoid misspellings and grammatical errors. Remember that overall appearance can tell much about you and how you relate to assisting. A hastily prepared resume doesn't bode well when the work you seek often demands meticulous care.

A resume can provide some direction to your career. It should represent you in such a way that it leads to the work experience needed to reach your specific goals. For example, you do not need to mention the goal of becoming an accomplished food photographer. However, you must convey information that makes you invaluable to food photographers. At the other end of the spectrum, resumes can be directed to a wider audience, allowing for a broader range of photographic experiences.

Your resume can also illustrate desirable traits which can be difficult to state credibly. It's easy to say that you're reliable. Unfortunately, alone it doesn't have any substance. It doesn't prove that you're reliable, nor does it convey that you appreciate how important being reliable is in assisting. Find ways to present intangible, but important traits by giving substantive examples.

My own assistant resume contained the phrase, "Years of rock climbing assures precise foot placement and a sure grip, while on the set." This served several functions. First, it informed the photographer that I was aware of how critical it was to be careful, while working on a crowded set. Second, my past experience lent credibility to the statement. And finally, it was a way to solicit more demanding outdoor assignments.

A successful photographic session is characterized by many qualities. These can be: cooperation and teamwork, creativity, resourcefulness, at-

tention to detail, commitment to excellence. It's difficult to gain validity by simply stating that you're resourceful and ingenious. Try to draw on past accomplishments and experiences to illustrate these qualities in a photographic context. A successful photographic assistant should possess the basic attributes that make anyone a good employee.

The Cover Letter

A short cover letter should accompany any resume. In fact, it's often more important than the resume. A conventional resume tends to be a listing of your experiences. It's also written for a general audience and printed in large quantities. A cover letter allows for a more personalized introduction of you and your services.

Quality versus Quantity

There are two basic approaches to cover letters: those produced in large numbers, much like a resume, and those composed for a specific photographer. A personalized cover letter is obviously more difficult and time consuming to write. Although not essential, it should be seriously considered.

It's really a matter of quality versus quantity. You cannot write nearly as many personalized letters as the "Dear Photographer" variety, but an individually written letter is of much greater value. By value, I mean more photographers read it and respond favorably. This approach makes your subsequent contact with the photographer more effective. People in general are overwhelmed by impersonal mail, and "Dear Photographer" doesn't give the best first impression. You can at least sign a preprinted cover letter, but a personalized cover letter holds far more promise.

When a personalized cover letter is written to an individual photographer, it provides the opportunity to comment on some aspect of the photographer's work, perhaps an exhibit, book, or advertising campaign. This shows an interest in that specific photographer. However, there's no need to overdo the accolades. Information gained by researching creative directories can be especially useful when writing a cover letter. With this additional insight, you're in a good position to mention particular skills which may be most beneficial to a specific photographer.

Whether personalized or not, cover letters share some similarities. They serve as an introduction of you and your services as an assistant. Cover letters allow you to expand upon statements made in the resume, and to elaborate on less defined attributes. You can mention how you enjoy the meticulous and precise nature of product photography. Or, you can state that you're at your best when things are most hectic during a fashion shoot.

At this stage of contact avoid bringing up any potential conflicts, such as schooling or a second job. You must be accessible and available for work. If appropriate, state that you have a portfolio and whether you intend to contact the photographer by phone. Let the photographer know you would like to meet with him or her at their convenience. Don't plan any spontaneous visits.

Incorporating both preprinted and personalized cover letters may be a productive combination. Consider mailing a relatively large number of preprinted cover letters and resumes to less established photographers. Send personally written letters to more established photographers, those who tend to receive a greater number of inquiries regarding assisting. To convey a sense of professionalism, resumes and cover letters should be printed or typed and not photocopied. A good quality, 20 weight white paper is commonly used.

Business Cards

Business cards serve many functions, especially for the freelance assistant. They are used to advertise your services or ensure that someone has your correct mailing address. You'll probably use more business cards than any other piece of promotional material, so take care in its design.

What to Convey

A business card should contain enough information to be useful, but shouldn't become cluttered. Basic information is your name, address, phone number, and even pager number. Next, tell something about your services. Possible terms include, "Freelance Photographic Assistant", "Professional Photographic Assistant", or "Studio Assistant." This title will occupy a prominent position on the card, and might be in a bold typeface or of a larger print size. Remember, you are promoting yourself as an assistant and not as a professional photographer.

Subheadings are used to provide additional information. A generalist might print "Studio and Location." An experienced assistant can print "All Formats-All Strobes," to signify a familiarity with most equipment. The phrase "Love to Travel," suggests location work. If you intend to specialize, be sure the market is suitable or design two different cards.

Technical Details

Basically, you must decide what is to be printed and where it's to be positioned. Next, determine the style of print or type face. Clean simple styles are easier to read than more ornate ones. Then, establish the relative size of what's to be printed. Here, the measuring unit is a point: four point type is small, fourteen point type is large. Visit a printing shop to get ideas, or better yet, go to where assistants post their cards. Next, stop by an art supply store. You can purchase sets of different type faces, whose letters can be transferred onto a mock-up card. A less precise approach is to write down exactly what you want printed and where it's to be positioned on the card. Then visit a smaller printing shop, during a less busy time of day. A knowledgeable person won't need long to supply an adequate type face and determine appropriate print sizes.

Alternate Approaches

The aforementioned approaches might be considered safe because they're unlikely to offend or be misunderstood. Safe doesn't always mean best.

Earlier, I mentioned that you may need to strike a balance between the business and creative appearance of your promotional material. There's also a delicate balance between presenting yourself as a professional photographic assistant, and not as a professional photographer.

As an assistant you'll come into contact with many different people, including the photographer's clients. You are hired to assist unobtrusively, not to compete. Is it possible to look too professional, or to invest more than necessary or even desirable on promotional material?

Few circumstances dictate slick promotional material or large expenditures of money. However, this doesn't mean you shouldn't break with tradition. If you feel you're in a highly competitive market, that conventional goes unnoticed, or you're just unconventional, then certainly try other approaches. Often something is done differently to get attention, or to stand out from the crowd. But to be really effective, it needs to be remembered. You will most likely be remembered, if whatever you put your name on is kept.

Before going much further, it's important to decide when the promo piece is to be used. If it's intended to serve as your initial contact with the photographer it should be relatively inexpensive to produce, since it's likely to be used in large numbers. When it's to be given to the photographer after your interview, far fewer will be needed.

The following ideas are presented to stimulate your creative process.

- ☐ It's not uncommon to produce a photograph, print it, and mail it. Photographers do it all the time as a means of self-promotion. Use a black and white piece to keep costs down. If the photo conveys what you want it to, there won't be need for elaborate copy. You might consider being in the photograph, perhaps carrying or surrounded by the equipment you can operate. This idea lends itself to a humorous approach.
- ☐ In addition to business cards, design cards that fit into the Rolodex card filing system. This is a common method for alphabetically filing names and services. It's an inexpensive, yet very useful approach.
- ☐ The facsimile or FAX machine has become commonplace in studios. It can be used to send printed material directly to the photographer. It can also be a way to intrude on the photographer, so a little additional ingenuity might be in order. If you intend to exploit this medium, consider sending a discount coupon for your services.
- ☐ You'll find that scheduling one worthwhile interview will require you to contact several photographers. To simplify the process, enclose a stamped, self-addressed envelope and questionnaire. Ask if they utilize assistants, how often, and would they like you to call them?

- ☐ After an interview or other personal contact you can decide if more than a final handshake is in order. The most useful item I've seen is a pair of *L-shaped croppers*, with your name and phone number on them. Since these may be handled by the photographer's clients be sure you are identified as an assistant. Croppers are used everyday to crop transparencies and Polaroid prints to the desired proportions. They're made from high quality cardboard, which has a matte black surface on both sides. A pair of croppers for 4x5 inch format measure about 6x7 inches, along the inside edges. Plastic croppers are a more expensive option, but never thrown out.
- ☐ Of course, pens are given away by all sorts of businesses. A most useful approach is to use a pen that can write on a Polaroid's surface, not a common characteristic. They'd never be misplaced, but may be prohibitively expensive.

Extravagant promotional ideas won't replace you as your best representative. The postal service won't be as effective as legwork. Evaluate your market and your goals carefully when designing promotional material. Particularly if considerable cost is involved. Don't forget, you may still need a portfolio.

The Portfolio

A portfolio is a critical selection of your photography. Both the material and how it's presented provide information about you. The relative value of the portfolio can depend on individual circumstances. Graduating from an established photography school imparts a certain level of credibility. Here, portfolio pieces might be less personal and more likely graduation requirements. As such, they may say less about you. If you are self-taught, a portfolio can lend credence to what you've said or stated in your resume. Therefore, it might take on greater significance.

What's Important

Professional photographers often show a certain style of photography in order to obtain similar work. However, it's often how the assistant's portfolio is put together that determines the response. While the assistant's portfolio is unlikely to contain high level commercial work, it must be technically correct and presented in a well thought out manner.

All portfolio material must be free of scratches or dust spots. The assistant is required to handle a variety of precious materials with the utmost care, and presenting scratched transparencies and tattered prints sends all the wrong signals. Scrutinize your work. Make certain that what's supposed to be in focus is in focus, and that it's properly exposed. Any piece requiring excuses has no place in your portfolio.

The most obvious benefit from a portfolio is employment. Ultimately this is true, but there are other advantages. Critically reviewing your photography while putting together a portfolio can be very enlightening. It tends to

raise your standards. Knowing that it will be shown to many established photographers is even more incentive to do your best.

Maximizing Your Potential

An assistant usually begins the selection process by sorting through everything that's been shot during the last couple of years. It's easy for your portfolio to become a reflection of what you like to shoot, but a well-executed portfolio conveys much more. It represents specific skills and provides insight into your personality. When evaluating your selections, remember that more than photographic skills are required to be a competent, well-rounded assistant.

By carefully integrating selected pieces you maximize what you have to offer. Presenting 4x5 inch, color transparencies can be used to represent multiple skills. First, it shows that you are familiar with a view camera and its many related tasks. The specific subject matter can illustrate other talents. For instance, studio product shots reflect an understanding of this kind of work.

A photographer may not care about your lighting technique, but will care about the different kinds of electronic flash systems you've handled. For some photographers, the fact that you built and then positioned everything on the set in an apparently impossible way, might be most important. Look for components of a shot to address other skills.

This holds true for a well-executed black and white print. A finished print demonstrates you can properly expose, process, print, and mount black and white material, a long sequence that requires care and different techniques at each stage. Besides showing that you care about your work, it demonstrates you're adept with a utility knife and straight edge. You might spend more time using these two items than working in the darkroom.

Editing Your Work

By defining your skills, the material you have available, and what's expected of an assistant, you are in a position to begin editing your work. A good starting point is to organize material into categories. First, compile all color transparencies into their respective formats, such as 35mm and 4x5 inch. It's easier for the photographer to examine all color transparencies at one time, since a light box is needed.

Next, sort each format into subjects or themes. It's difficult to display any depth in your work when jumping from subject to subject. If you want to integrate different camera formats consider having duplicates or *dupes* made. You might have several very high quality 35mm slides that are best included with your 4x5 inch material. These slides can be duplicated onto 4x5 inch film. Since a good dupe is not easy to make, use a quality lab.

Preparing Your Material

Color transparencies are generally mounted on black *presentation boards*. Professionally manufactured boards usually hold sixteen to twenty, 35mm slides. Here, mixing vertical and horizontal 35mm slides isn't a problem because the photographer doesn't have to rotate the presentation board when a horizontal image follows a vertical one.

However, this isn't the case with the premade presentation boards designed to hold four, 4x5 inch transparencies. Therefore, it's best to mount each transparency on a separate presentation board. This has several advantages. First, it maximizes the impact of each transparency, because it can be cropped to its best dimensions. Also, individually mounted transparencies let you restructure your portfolio quickly and easily.

Photographic Prints

Photographic prints should be neatly trimmed and dry mounted. Standardize on a good quality, acid-free mat board. Try a white or black color, with a not-too-textured surface. Also, stick to one size of mat board, regardless of print size. These two procedures can lend continuity to prints produced over a period of time. To facilitate viewing, put together effective sequences of horizontal and vertical prints.

If you want to produce black and white material, but don't have a dark-room, check out rental darkrooms. Some introductory photography courses provide access to darkrooms at more reasonable rates. Another resource are the self-service, framing shops. These supply everything needed to mount prints and color transparencies.

Everyone likes large prints, but large prints require an even larger portfolio case. A standard, 11x14 inch print is usually mounted on a 16x20 inch board. Unfortunately, it can be difficult finding cases that accomodate 16x20 inch material. Don't discount using larger pieces, but it's a good idea to examine some portfolio cases to know your options. I'm not suggesting you design your portfolio around your case, but to make sure you're material can fit into it.

Presenting Your Material

A common concern is how many pieces to put into your portfolio. Several sources on portfolios for the professional photographer suggest a total of about fifteen to thirty pieces. However, an assistant's portfolio has greater variability. First of all, you may not have enough material that even qualifies. Ten excellent pieces will be more effective than those same items padded with five mediocre ones.

If you wish to convey greater photographic range, more pieces may be necessary. For example, showing both black and white prints along with color transparencies tends to increase the total number. So will a desire to show more than one kind of photography. Although an exact figure is hard to pin down, efforts to convey all that you know through a large portfolio can end up being counter productive.

It can be helpful to pretend to show your portfolio, like practicing a speech in front of a mirror. This can point to areas with too much material or awkward transitions. Later, while showing it to potential clients, be attuned to their subtle responses, the good, the bad, and the indifferent. Noticing that most photographers consistently thumb through the last four or five pieces, signals that it's too long. Thin out redundant pieces or try a little reorganization. It's worth the interview just to have your work critiqued by a professional photographer, take advantage of it.

Generally, it's best to let the portfolio speak for itself. Your work shouldn't need much explaining or excuses. However, during the process be alert for occasional opportunities to mention other skills. This is when knowledge about the photographer is especially helpful. At the very least, examine what's hanging on the studio wall.

Finding the Right Photographers

n many ways, the professional photographic community is a reflection of the local environment as a whole and your marketing strategy must take this into account. Therefore, when utilizing the following resources to develop a list of potential clients or employers, it's important to view your market in a broad sense.

Defining Your Market

One of the most important factors influencing the marketing of your assisting services is population. In larger cities, you have the opportunity to become involved with almost every type of photography, or pursue a more specialized direction. Whereas intermediate-sized cities offer plenty of diversity, but perhaps fewer chances to specialize. In small cities you have to be increasingly creative just to keep busy.

Market size can influence your marketing approach in another way. For example, a complete listing of every qualified photographer in a large metropolitan area will be overwhelming. You'll either need to be more selective, or have a way to take advantage of many names. As the market size becomes smaller, every photographer and potential avenue becomes increasingly important.

In addition to its population, is your market known for anything specific? Whether you live in a community based on hi-tech manufacturing firms or tourism, you can expect it to influence what the local photographers shoot. Unique environments, man-made or natural, are also likely to attract out-of-town shooters.

Creative Directories

Perhaps the most useful resources for the marketing of photography are the creative directories, also referred to as photography annuals and sourcebooks. Creative directories are used by commercial photographers to advertise their services to graphic design firms, advertising agencies, and larger companies which regularly utilize commercial photographers.

Full of Information

Creative directories provide several kinds of information for the aspiring assistant. Directories show excellent quality work, much of it similar to the photography you'll be associated with as an assistant. Individual ads often contain a client list, which provides further insight into the assistant's working environment.

If a photographer's ad consists of carefully crafted still lifes, coupled with a second floor address, then you can expect to assist in small product photography. Just as likely, an advertisement might show work produced on location, accompanied by a list of national accounts.

This information gives you a good idea of the photographer's needs in an assistant. If you have an interview with a location specialist who relies on a 35mm SLR camera, don't waste everyone's time by discussing your expertise with the view camera. You'll mention many skills, none of which are of benefit to that particular photographer.

A better perspective regarding the field of commercial photography can be obtained by viewing almost any creative directory. However, as you begin to produce and distribute your own marketing material, more specific directories are needed. At this later stage, the directory must address your marketplace, and should ideally be the most recent edition. Creative directories are fairly expensive, so use discretion if you intend to make a purchase.

Older directories can often be obtained from used book stores, especially those specializing in graphic arts and photography. Also, ask anyone you know who's involved with any aspect of commercial photography or advertising. You might inquire at those libraries associated with photographic institutions.

Kinds of Creative Directories

It's important to realize that directories are produced for a particular market. National directories represent photographers from across the country, and are distributed nationally or even worldwide. As you would expect, such coverage can be prohibitively expensive.

However besides cost, this kind of advertising doesn't meet every photographer's need. Consequently, only a relatively small proportion of the photographers in your local community will purchase advertising space. Even so, a national directory can be an excellent starting point because of its index. The index provides a listing of many photographers throughout the United States.

To meet the needs of more photographers, there are both regional and local creative directories. A directory might cover the New England re-

gion, California, or Chicago. A local directory gives an indication as to the quality and nature of photography in the area. It also includes the most complete index of local photographers.

The Index

An important part of every directory is its index. However to be best utilized, you must understand that the index only provides a name, address, and phone number, nothing personal. Also, a photographer can usually be listed simply by doing some paper work. Therefore, while an index consists of many excellent names, it takes time and effort to isolate them.

Depending on the market, a directory's index might yield too many names. For those of you faced with this dilemma, try to cross-reference the indexes from several directories, and construct a list of those photographers found in more than one directory. The assumption being that these are more established photographers, taking advantage of every directory.

An alternative is to compile a complete list and narrow it down by zip code. This allows you to direct your efforts within a smaller, yet concentrated area. A final note: many local creative directories provide a free listing for assistants.

Additional Resources

Other resources are available to locate those photographers who need assistants. Professional photographic associations can provide you with a local membership list, and information regarding activities in your area.

The largest is the American Society of Magazine Photographers (ASMP). The ASMP distributes regional newsletters which have listings for local assistants. Periodically, it contains the local membership list. In several larger markets, The Advertising Photographers of America (APA) publishes an assistants directory.

Of course, there are the yellow pages in the telephone book. These should be discounted, except in the smallest markets, where every avenue must be pursued. Look under the listing, "Photographers-Commercial." Generally, even the best photographers in the better markets only have an unobtrusive, one-line listing.

Alternate Approaches

Besides actively contacting selected photographers, it's possible to use more passive approaches. One is to post information in strategic locations and wait for the phone to ring. Every photographer requires support services, such as equipment stores, processing labs, repair facilities, and rental studios. These businesses rely on a regular flow of professional photographers, and they often have bulletin boards. Use a push pin and post a stack of four to five cards, so photographers can readily take one of your cards.

Corporate America

Larger companies can be located anywhere and may offer opportunities. Look for national companies that manufacture a product or advertise heavily. Those of you living in a smaller community will hardly have to look for them if they're there.

Once located, simply call and ask whether there's a photographic studio or company photographer at the facility, or in-house. If so, contact the appropriate individual as to any assisting needs. On the other hand, if the receptionist has no immediate response and you get the feeling this person thinks you have a wrong number, don't give up.

If it's unclear whether there's an in-house photographer, find a more knowledgeable source. This might be the personnel or marketing department. Try to determine if the company hires a local photographer, and who it is. In small communities, it's very possible that an out-of-town photographer is brought in to do the necessary product or annual report photography, perhaps a freelance location photographer or a staff photographer from another facility.

Once you find the appropriate individual, explain the assistant's value to the success of the shoot and ask if you can send your resume. A local assistant is of great use to a location photographer in an unfamiliar setting. This rather elaborate example was presented to illustrate that potential clients exist in many places.

Solicit Out-of-Town Shooters

If you've concluded that your area might attract location photographers, consider a different slant to your advertising. For starters, classified ads can be placed in a variety of publications for a reasonable cost. Becoming a member of ASMP will provide national exposure through their membership list. Another excellent source is Photo District News, a monthly publication addressing the varied needs of the commercial photographer. A classified in this widely read periodical is quite affordable.

Word of mouth or referrals also hold potential. Many photographers only require assistants occasionally. Consequently, they'll meet with you, but may only need you periodically. This doesn't mean they aren't familiar with what's going on in the photographic community. If you feel the interview went well, ask if they know anyone who needs a good assistant, including the occasional out-of-town photographer.

In larger metropolitan areas, determine if there is an assistant's group. These are becoming more common all the time and can provide informal instruction and a free exchange of ideas.

Contacting Prospective Clients

While developing a list of prospective clients or employers you will come across not only names and addresses, but useful information. Later when you start contacting these photographers, you'll obtain even more. However, for it to remain useful it must be kept organized. Obvious ways might be an address book or a file of index cards, but a more productive tool is the Call Report.

The Call Report

The Call Report is a form which helps you keep track of all the information that is going to accumulate. Begin the call report before contacting a prospective client. When filling in the photographer's name and address, a description of his or her work and where you saw it, can be equally important. Photographers often spend considerable time and money promoting themselves. Consequently, they're usually curious as to how you became familiar with them. The remainder of the call report can be completed during the natural sequence of events.

It's not uncommon to feel apprehensive when contacting someone for the first time. One way to be more relaxed is to prepare a few questions beforehand, especially the kind which require more than a simple yes or no answer. Also, use the call report to write down any specific points you want to be sure to convey.

In many cities, photographic studios are located in certain areas, often referred to as photo districts. When arranging interviews, it can be helpful to organize your call reports geographically. This can maximize your efforts.

Call reports can also be organized alphabetically. When a last minute job or interview comes up, you can grab one piece of paper and be out the door. It might have essential directions to a hard to find studio, or possibly the photographer's home phone number. If anything is going to delay your arrival you need to be in touch with the photographer. Reliability is critical.

When you're relatively inexperienced or unfamiliar with a particular photographer a call report can aid in your mental preparation. A quick review on the way to the studio can be helpful. By knowing the type of equipment you'll be using, you can mentally load a certain film magazine or recall the specifics of a power supply. After the day is over, any pertinent information can be readily added to the call report.

Maintaining a Clientele

An established freelance assistant often comes to rely on the same group of busy photographers for a sizable portion of his or her bookings. Unfortunately, if the work load of several of these key photographers slows down, the freelance assistant is quickly affected. Call reports allow you to reconnect with photographers with whom you may have lost touch. You were probably fortunate to have been booked the last couple of times they called. Well organized files make this latter marketing effort relatively painless.

Call Report					
Photographer:					
Studio:					
Street:					
City/State:					
Phone: (w)					
Other individuals:					
Use of Assistants: I					
Contact Date and Com	ments:				
How did I find photogr	apher's name?:				
Type of Photography: Comments:					
Type of Equipment					
Camera Formats: Ma	nufacturer/Usa	age	Lighting: Manu	ufacturer/Usa	ge
Small:	; _	%	Strobe:	;	%
Medium:	;	%	Tungsten:	;	%
Large: Comments:	; _				
Additional Information					
Location and Direction	s:				
Location and Direction	s:				

Your First Phone Call

In most cases, a promotional mailing merely helps you make a more effective follow-up phone call. This phone call may only be as productive as being asked to call back at a later date. It could also lead to an interview or a job that very day, so be prepared to make the most of any response.

Preparation

Before calling, take a moment to review what you know about the photographer. It can be helpful to write down what you intend to say, at least an opening line or two. Since the assistant often answers the studio phone, an articulate phone demeanor is an asset. If the photographer is too busy to talk, state that you're an assistant and inquire as to a more appropriate time to call. This question alone will often establish any assisting needs.

In the early stages, it can be helpful to evaluate your telephone conversations. An objective review can lead to a better response on your next call. You'll find that many of the same questions are likely to be asked, so plan ahead.

Timing the Phone Call to Your Mailing

It's important to consider how to correlate phone calls and your mailing. No matter how distinctive a promo piece, as more time elapses it becomes increasingly difficult to associate the person on the phone with a piece of promotional material. A typical scenario might be to mail fifty resumes, and begin calling the recipients in a week or two. You'll inevitably get interviews and a few jobs. Undoubtedly, these will undermine your time on the phone. After a month, few photographers will recall your name or what you sent. It might be better to distribute your material in batches, thereby allowing you time to follow-up.

Scheduling Interviews

If the photographer utilizes assistants and feels you have potential, the next logical step is an interview. It makes sense to try to schedule several appointments in the same area, on the same day. Unfortunately, this is easier said than done.

Photography can be a spontaneous business, an unexpected job might come in at the last minute. At other times, the day's shoot can be put on hold until a product arrives. Because of this kind of uncertainty, photographers tend to refrain from making appointments several days in advance. Consequently, it's impractical to expect to arrange three to four appointments for the same day the following week.

There is a way to get around this problem. When you leave for an appointment, bring some appropriate call reports with you. These could be for photographers in the same area, or for those you especially want to contact. After the scheduled interview, position yourself close to these photographers and phone them. Inform the receptive photographer that you're just a couple of minutes away, and ask if he or she has a spare minute to meet with you. If schedules permit, a photographer who's hesitant to make an appointment will see you on short notice, especially if you're just down the street.

Being strategically positioned allows you to take advantage of a photographer's less busy moments. However, don't assume you can drop by unannounced. Even when a photographer isn't shooting, there's much to be done. Unrequested visits are counter productive and an indication that you don't understand the nature of professional photography.

The Inevitable Answering Machine

Phone answering machines are commonplace. Know exactly what you intend to say before calling, disjointed messages don't leave the best impression. If you repeatedly connect with an answering machine note it on the call report, regardless of whether you leave a message. Eventually, you'll have an answer concerning their need for assistants. Photographers who are never available or accessible usually aren't busy. Who can get hold of them? You expect good location photographers to be away from the phone. However, they'll usually return your call because location work is very demanding and good assistants are a real asset.

How to Become a Regular

After you contact a number of photographers, you'll find that photographers who utilize freelance assistants tend to have their regulars. However, don't make the mistake of disregarding these photographers and their call reports. Very likely, some of them will need an additional assistant to call in several months. A well prepared call report makes a follow-up call very straight forward and you'll have more experience to offer. Don't plan on building a good clientele overnight.

The Interview

You've probably already succeeded in one interview, your telephone conversation. As before, your personal interview will be more successful if you anticipate questions and develop positive responses. It's not uncommon to be asked whether you attended a photographic school. If you didn't, don't reinforce the negative by saying: "No, I didn't attend a photo school." State that you're mostly self-taught, and explain how you gained experience.

Don't feel that developing photographic skills through personal study and perseverance is a liability. This is exactly how most top photographers did it and why they continue to get better.

At first, your interview may appear a little less formal. You won't need a suit and tie, and you probably won't be opposite someone sitting behind an imposing desk, but don't be mislead, you're looking for work. Regarding your attire, a neat overall appearance is sufficient, though jeans and tennis shoes are a bit too casual. Keep in mind that first impressions are important, and it's best to err on the side of caution.

Questions are for Both of You

A little knowledge about the person you hope to work for can always pay dividends during an interview. Whether obtained from a creative directory or a perceptive scanning of the studio, this insight should yield some worthwhile questions.

Questions are an excellent way to direct an interview and to reinforce what you have to offer. When fortunate enough to receive a studio tour, be alert. If a well equipped workshop is on the premises and you're adept with tools, say so. Paying attention now will also make your first day on the job a little easier.

Photographers are often interested in knowing if you're familiar with specific kinds of photographic equipment. It's imperative to be honest about your skills. Trying not to dwell on what you can't do is one thing, stating you can do something you can't is entirely different.

You may be asked about your goals beyond assisting. Most individuals are involved with assisting as a way to learn and to transition to professional photography. If you have similar aspirations as the photographer, you might be viewed as motivated and having a desire to learn. On the other hand, you can be seen as a future competitor. It's possible that both interpretations are valid and exactly how you're perceived often depends on the specific photographer.

Either view can be further reinforced by what you say, so be guarded and aware of what you want to convey. You may think you're playing it safe by stating you hope to experience all kinds of photography, then decide on a specific direction. This could be viewed as either non-threatening or uncommitted, and illustrates that analyzing your interview can be interesting to say the least.

The Photographer's	Assistant	
*		

Business Matters

he freelance assistant can't escape the fact that assisting is a business. Plan to track all income and expenses from the start, both to remain solvent and for tax purposes. In addition, you'll need to make proper business decisions in order to maintain a viable clientele.

Establishing Your Rates

For those of you considering a full time position with a photographer or studio, the financial arrangement is fairly simple. Assistants are usually paid a set salary, not an hourly rate. The photographer should withhold all state and federal taxes, including workmen's compensation.

As a full time employee, you might be eligible for personal health insurance at a reduced rate. Be advised, a personal health insurance policy may not cover an on the job injury. Workmen's compensation is probably necessary. It's difficult to give absolutes because workmen's compensation is administered by each state, and health insurance through independent, private companies. You must know where you stand because assisting can be strenuous.

The photographer may opt to give a full time assistant a set salary, but not withhold taxes. Here, you are being viewed as an independent contractor. Though this is probably not correct, you are required to handle all income as a freelance assistant.

In general, freelance assistants are viewed by photographers as self-employed, independent contractors. However, because assistants are told by the photographer when to arrive on the job and are then instructed as to what to do, this classification is probably not correct. The problem arises

when an assistant is injured on the job. If the freelance assistant is not really an independent contractor then the hiring photographer should be paying for workmen's compensation. On the other hand, if the freelance assistant is an independent contractor the assistant should acquire a private health insurance policy to cover work related injuries.

The Market Rate

When it comes to freelance assisting, financial matters are more involved than for a full time assistant. Being self-employed, you establish a set of rates. The Market Rate is the amount an experienced assistant can expect to charge for a particular service in your city. Therefore, the Market Day Rate is what an experienced assistant charges for one day assisting.

It follows that a necessary starting point is to determine what experienced assistants are charging. With this information you can decide how much to alter your basic rate, depending on experience or as circumstances vary. If you are relatively inexperienced, you might begin by charging 75% of the market rate. For example, if experienced assistants charge \$100.00 for one full-day, you would charge \$75.00.

This also serves as a sound base from which to develop half-day or overnight travel rates. To find out what a professional photographic assistant makes in your city, ask some assistants and photographers who use assistants. If you inquire as to experienced assistants, day rates are not likely to vary too widely. The same resources utilized to promote your services will provide access to suitable names.

Full-Day Rates

Before establishing your day rate, you should understand what is meant by a full-day. A full-day is usually as long as it takes to complete the day's work. A ten to twelve hour day is not uncommon, and even longer days are by no means rare. Also, don't expect to be let off work at a designated time, because most jobs must be completed on schedule and to the photographer's satisfaction. If this requires a late evening, so be it.

There are several ways to structure a rate schedule for a full-day. First, you simply charge a fixed amount and work until the day is over, hoping for a gracious photographer to pay extra for those excessively long days. You can also decide that ten hours constitutes a full-day. Afterwards, charge an hourly rate on top of your full-day rate. Finally, it might be easiest to simply charge by the hour. A note regarding meals, usually lunch. Meals are paid for by the photographer, whether in the studio or on location. This is only fair because assistants are not provided an official lunch break.

Half-Day Rates

A photographer may inquire about a half-day rate. A few points should be noted with regards to half-day jobs. First, it's difficult to accomplish much in less than four to five hours, and half-days have a tendency to run longer than expected. Consequently, a half-day rate needs to be open-ended, and usually you can't book another job on the premise that a half-day job will finish up on time.

Establish a minimum rate for half-days, perhaps four hours. Remember, you must invest time and transportation to get to and from the studio. After four hours start billing on an hourly rate, so at the appropriate time you reach your full-day rate. For example, if your full-day rate is \$100.00, charge \$50.00 for a minimum half-day. After four hours, charge \$10.00 per hour.

A dilemma facing most freelance assistants is the difficulty in booking four to five days a week, week after week. Even if you have five days in requests, a couple are bound to be for the same day. On top of this, the photographer you turn down ends up calling another assistant. After this scenario is repeated a few times, that photographer begins to call the second choice assistant, first. Your frequency of calls just decreased. The full time assistant is not faced with this predicament. Consequently, the freelance assistant requires a day rate greater than the daily salary of the full time assistant.

Overnight Travel

A freelance assisting job typically runs anywhere from a half-day to a week, with one and two day jobs most common. However, it's possible for overnight travel to become part of your routine. When setting rates, it's important not to expect travel to be all fun, where ever you go. It's unlikely you'll have much free time to yourself, and the term full-day takes on new meaning.

When away from home, it's possible you'll have to make some long distance phone calls. You can't let messages accumulate on your answering machine and expect to return to a happy clientele. To alleviate this burden, change the outgoing message to state your services are booked through a certain date. To be safe, you might need to add a day or two buffer. Unfortunately, this may impact short-term bookings. These factors need to be considered when establishing overnight travel rates. Before leaving, verify that all travel related expenses, such as lodging and meals are covered by the photographer.

Alternative Rates

You don't need to be so conventional in what you receive for your services. One of the oldest ways of conducting business is bartering. Bartering should be viewed both as a way to actively solicit work and to acquire equipment. This may seem like a novel approach, but photographers and models often exchange services. To maximize its potential, you must appreciate that far more than photographic equipment is required to start a small business.

Where do you look for these opportunities? An excellent source are the photographers for whom you already work. Many photographers acquire new equipment and unneeded items end up in the corner. The classified ads found in professional newsletters and ads pinned-up where commercial photographers congregate also hold potential.

Responding to a classified ad or posting most likely begins with the phone. Before calling, be prepared with what you feel is a reasonable proposal. For example, if a tripod is listed at \$150.00 and your day rate is \$100.00, suggest two days assisting in exchange. Be flexible, offer what you feel good about while inviting their input. Don't be discouraged with a neutral re-

sponse, this proposal may catch some photographers off guard. It may also get them thinking, so always leave a name and phone number.

A better opportunity is when a photographer either relocates to another city or sells the studio. Either undertaking is made more bearable with the help of a good assistant. The newspaper classifieds often have these listed as studio sales. At other times the wording is more discrete. Watch for entire camera systems, professional lighting equipment, and items specific to photographic studios. Associated with any move is plenty of back breaking work, and some material may never be moved. For most, moving is a good time to trim down one's possessions.

Bookkeeping

Maintaining accurate records is an integral part of business. All expenses and many activities related to running your business must be documented and organized. To accomplish this, it's essential to have an efficient system and use it. Every assistant has basic start-up costs. There's your portfolio and related marketing materials. Later, there will be transportation costs associated with the job search. As an established freelance assistant, you'll routinely bill clients and record income.

I have no intention of discussing taxes in detail. It's an ever changing subject and a good accountant is essential. However, I will offer a few general guidelines. Have a bank account solely for business, and retain all receipts related to assisting and your photography. It's useful to organize receipts into labelled envelopes, as they accumulate. Categories might be: office supplies, postage, film and processing, equipment purchases greater than \$100.00, and miscellaneous photographic supplies.

Invoicing the Client

Once an assisting job is complete, you send a bill or invoice to the photographer. Invoice forms can be purchased at any office supply store. Before you mail too many invoices, set-up a filing system consisting of two envelopes, one for unpaid or *open accounts*, and a second for paid or *closed accounts*.

Preparing a preprinted invoice is fairly simple, although a few points are worth noting. Begin by numbering each invoice in a logical sequence that can be followed throughout the entire calendar year, such as 1992-01. Establish whether an account or job number should be included. If not, briefly describe the shoot and its date. It won't take long before jobs and dates become indistinguishable.

The most important part involves a billing for all services and expenses. Here it's critical to itemize your figures into two categories, *income* and *reimbursement of expenses*. The largest figure is likely to be taxable income generated from your assisting. Other figures will be for expenses incurred while on the job. When making a purchase for the photographer that's to be reimbursed through your invoice, retain the sales receipt for your records to verify it's an expense.

When using your vehicle to run an errand for the photographer, record all mileage and bill the photographer. If you charge equal to or less than the government allowance, it is not taxable income. In 1991 this was 27.5 cents per mile. Come payday you'll only receive one check, itemizing the invoice ensures you know what's taxable income. To simplify matters, use the photographer's petty cash for all purchases.

The billing process is a formality when the figures reflect what was made clear before the shoot. If you are not paid within thirty days, send a second invoice. If you're still not paid within forty-five days, call the photographer and ask when you can expect to be paid. In this respect assisting is based on trust, as few contracts exist.

Minor Business Purchases

A prerequisite for success as a freelance assistant is accessibility and reliability. This means a telephone, an answering machine, possibly even a pager. If you anticipate changing your residence, an answering service and post office box will make you more accessible over time. A final note regarding telephones, keep a log book to record messages. This provides a quick reference for names, dates, and phone numbers.

The following items can be used to maintain records and help keep you organized. A large, desk-top calendar is especially useful. It provides plenty of space to write down appointments and business tasks. Another is a notebook for recording mileage to interviews, freelance assisting jobs, and business errands.

A self-inking rubber stamp with your name and address on it will come in handy from your first promotional mailing to your last invoice. Be sure to acquire a good city map, since studios and photo related resources can be almost anywhere.

Ethical Considerations

A discussion about business issues wouldn't be complete without addressing a few potentially difficult situations. Tentative bookings and cancellations are two unavoidable occurrences, which can quickly add an element of uncertainty or conflict into the schedule of even the most adept freelance assistant.

Tentative Bookings

In preparing for a shoot the photographer needs to correlate many things, only one of which is making certain there's an assistant on the set. Unfortunately, there can be any number of variables over which the photographer hasn't any control. If any of these are subject to change, this uncertainty can be passed onto the photographer, and then the assistant. The result is being asked to hold a day open or a tentative booking.

These troublesome requests are quite understandable. As photographers

work with you more often, they begin to appreciate your services and want to secure you for an important job. It's easy to espouse a philosophy of "first come, first served," but a more practical approach is probably a combination of flexibility and diplomacy.

Cancellations

The second predicament is a cancellation, another hazard of the trade. It's usually a last minute call from the photographer, saying the job has been postponed or cancelled. You probably won't line up another job for that day, but on top of that, you may have turned down another request for your services. Do you bill the cancelling photographer for all or part of your rate? This is not always accepted practice. It's probably best to forget about photographers who consistently call with tentative bookings and cancellations, while giving your better clients some latitude.

Difficult Questions

Photographers often ask who you've worked for as a way of judging your experience. They might also inquire as to who's been keeping you busy. This is to be expected, but it shouldn't go much further. For instance, you might be asked specific questions concerning the type of shoot or client. This is privileged information and if pressed, state that you make it a policy not to discuss other photographers and their jobs. Speaking openly and without concern is likely to be appreciated only momentarily. When you leave the studio, the photographer will be left to wonder how much of his or her information you will take to your next job.

Besides talking about a photographer's clients, what do you have to gain? It takes considerable time and money for a photographer to find accounts. The result of that work is right in front of you. Assistants are exposed to what might be considered inside information. After ten hours on the set, you'll know the art director, the client, possible future jobs, and more. Will you go home and write it all down, show up at the advertising agency with your portfolio, or hand out a business card when the photographer's back is turned? For your sake, I hope the answer is no, to all of the above.

A final consideration relates to equipment. As an assistant you'll work with equipment all day, every day. What if you break something? For everyone's sake, the photographer had better be insured. What if you're shooting in a busy public building, moving from site to site? You were careful, but there's a camera body missing at the end of the day. You probably won't be assisting at the next shoot, and the photographer had better be insured. As you see, an assistant has many equipment-related responsibilities and must be careful.

An Interview with David MacTavish

David MacTavish is a commercial photographer based in Chicago.

John Kieffer: Could you give me a brief description of the kind of photography you do?

J.K.: Does your camera equipment cover as much diversity as your subject matter?

D.M.: I pretty much stick with 35mm. I do shoot two and a quarter, but I'm one of the few people who really dislikes Hasselblads®, and on occasion I shoot 4x5.

J.K.: Then what kind of lighting do you use?

D.M.: I bring Balcar® strobes to the location. It's not uncommon to take half a day or more to light a scene. Sometimes we only have a few minutes to shoot it, but preparation seems to be almost everything. The kind of work I do doesn't really lend itself to the use of on-camera flash units.

J.K.: Since you're out and about so much, what kind of person are you looking for as an assistant?

D.M.: It's probably easier to tell you what I don't look for, and I feel this is contrary to what most assistants think. Invariably when an assistant calls here they want to show a portfolio. Frankly I don't even care, because I don't need a photographer to be an assistant. What I'm interested in is someone who is willing to work with me, who is willing to listen, and someone who is willing to learn about lighting and the rest of it. It doesn't really matter whether they can handle a camera or not, so I tend not to be at all interested in a portfolio.

I guess what I'm looking for is someone who is articulate and intelligent, someone who is thoughtful. I've been on jobs before when I've had to photograph the chairman of the board of a major corporation, and I've had guys show up in torn blue jeans and a sleeveless tee shirt. So I try to find people who are intelligent and who can understand the situation they're going into. I like people whose major concern is the product, the job we're doing.

One of the things I'm impressed by is someone who can make those repeat phone calls. It's tough to pick-up the phone that third and fourth time when you

feel you're not getting anywhere. But an assistant who does, will always rate a little higher with me. I've moved recently and an assistant called me up a few days before. He asked if he could see me and show his portfolio as usual. I told him I was busy and to call me again in a month. I'd be more settled and we could talk. Anyway, one of his follow-up phone calls was just when I needed an assistant. I told him I didn't need to see a portfolio, but asked for a few references. After calling one of the references I hired him. So perseverance, without being obnoxious can get you the job.

J.K.: How do you find assistants or do most of them approach you?

D.M.: What I've found that works particularly well for me is to call another photographer whom I respect and trust, and ask for two or three names. Usually I like to interview them, but it doesn't always work out that way. At times I can just tell from the recommendation and what I hear over the phone that it's the kind of person I want to work with. However, I've had surprises.

J.K.: When you have the opportunity to meet with an assistant, do you try to convey how you would like them to act with clients? For example, do you prefer assistants to stay in the background or interact with the client?

D.M.: I've never really done that, but I do know some photographers who really fret about those things, almost to the point of distraction. I've talked to some photographers about it and I've realized to some of them it's an overwhelming concern as to how the assistant will deal with the client. I'm not worried about it and seldom bring it up, since our prior contact tells me how they will do.

If an assistant is curious about what my thoughts are I'll tell them that they're there to set up the lights and get things ready. But I'm also expecting them to pipe up, if they see something wrong. If they see something wrong with the client, like the tie doesn't look right, I want them to tell me quietly and not make a big issue of it. I don't go into it in a big way, I just want them to keep their eyes on me and not get distracted.

There was one time I wish I had really discussed this issue pointedly. I had an assistant who I really liked a lot and had worked with for a number of years, but he was a very forward individual. I never thought that could be a problem, but it was. I was shooting a job for a major brewery and we were going to be on location for about a week and a half. On the second day I was trying to light this large, computerized stainless steel panel. It measured about ten by fifty feet and we couldn't have any glare on it. I sent the assistant to get our inside corporate contact because I needed his help. He didn't show and didn't show, and finally I got someone to watch my equipment. I found my assistant with the P.R. man discussing the merits of how the annual report should be done and how he could do the photography. That's a little disconcerting and I never called the guy back.

I assumed he would be a little more courteous, but he wasn't. As I said, I've never made it a big deal and it's never been a real problem before or since. Jobs go best if we work like a team, where we're all involved to make this thing happen and make it work right. I think assistants respect and understand that, and I don't mind if they talk to the client.

J.K.: Do you rely on free lancers or do you have a full time assistant?

D.M.: For awhile I used a woman who was a free lancer, but she was the only one I'd call. But recently I've had to rely on people that I've not known. Fortunately I've been lucky and the last two assistants have been really good. However, both are very close to striking out on their own as photographers and it's probably just the economy that's holding them back, so I'll probably lose them in the near future.

J.K.: Do you find that most assistants have gone to a photography school or are they self-taught, perhaps an advanced amateur?

D.M.: I think I'm one of the last of the breed of self-taught people. Most of the folks that I've known that were self-taught came out of the sixties and early seventies. If you started in the late seventies you probably went to photo school. I'm sensing that just about everyone now has gone to a photo school, at least the assistants. It could be a year or two at Columbia or four years at Brooks.

I must say that the vast majority of these people are not well educated about what it takes to be a professional photographer, and that's a big shame. I really don't know what schools are teaching. The schools must know a large percentage of the students have dreams of becoming professional photographers because they come out and become assistants. Unfortunately, I think most of them drop by the wayside because real life is so different from what they were taught.

I just had a guy with me the other day who's taken any number of photography classes and has been a student at Columbia for three or four years. We started out on this job and he turned to me after about an hour and said, "they don't teach you any of this stuff at Columbia." And it wasn't anything extraordinary, just little tricks I was teaching him on the job. I've talked to other photographers about this and they pretty much agree that it's a problem.

J.K.: Do you think the photo schools educate their students about assisting and how being an assistant differs from being a photographer?

D.M.: I've never really thought about what the schools tell them in terms of assisting. Students are probably told that assisting is a good way to get into the business, and that's about as far as it's taken. If these people were informed that assisting is the first major step in a career I would think they would work at it a little harder.

I'll get calls from assistants and I ask what they charge, let's say it's \$100 per day. Then I'll ask them what kind of lighting they know, Balcar® or Speedotron® for instance? Some won't be familiar with it and I can't understand why they think they are worth \$100 a day. I'll tell them to go down to Balcar and learn about that equipment in Balcar's office. You can sense it in their attitude that they'll never go down, it just won't happen. That attitude doesn't bring anything to the job that I'm willing to pay money for. On the other hand if an assistant tells me they they've been to conventions and they've gone to lighting seminars, or they mention that they can operate Nikon®, Canon, Hasselblad®, and Sinar® inside and out, then I know they have been actually thinking about and working at it.

J.K.: So a thorough knowledge of cameras and strobe is important to you?

D.M.: Sure, I really need more than someone who can pick up a stand and with my direction learn how to open it up. Some of these people coming out of school look at a piece of equipment, but can't figure out how to attach it to a light stand, much less how to attach a speed ring and soft box. I don't have time to explain all that.

As I mentioned, I have chosen assistants for other attributes. One woman didn't know that much about photography such as lighting, but she was exceptionally good with people. I could take her into a room full of executives and her presence would light up the room. She knew how to apply a little make-up on subjects and the photographs were much better because of it. I felt she could learn the other things, and she did. As a result, she was very valuable to me.

J.K.: Since assisting can be physically demanding and location work even more so, do you have any reservations about hiring a woman assistant?

D.M.: No, never. I have any number of friends in this business who will get the biggest case they can find and dump everything they own in it, then claim women can't handle it. Years ago I made a major investment in smaller cases. Nobody, including assistants should have to pickup a case weighing more than about thirty or forty pounds. I've never worried about male versus female, but whether an individual can do the job. If they have the qualities I need I'll try them.

J.K.: When traveling on an overnight location shoot do you take an assistant with you, or do you try to find an assistant at the location?

D.M.: I stress to the client that working with my regular assistant is probably going to save them money in the long run. You can't always do that with a first time account, but if they've seen you working together they seem to understand. Fortunately there are many good assistants around the country now and accessing them is now possible through the ASMP and it's local chapters. Finding an assistant isn't as difficult as it used to be.

J.K.: When you take an assistant on a extended location shoot, do you stick with your standard day rate?

D.M.: I wouldn't pay them less. If anything I tend to tell the client that it'll cost a little more, if I think I can get it. While on location the assistant is taken away from their usual routine, they can't get messages, or work for others. One thing I have real problems with is when a photographer marks up an assistant's rate and that mark up never makes it to the assistant. Somehow it doesn't seem fair to take that extra away from them.

J.K.: I guess part of the pay back is the learning.

D.M.: I always try to bring the assistant over after I've shot the Polaroid and talk about the lighting and explain what's happening. There isn't always time, but more often than not I try to see if they understand what's going on.

J.K.: Have you ever encountered any situations where the assistant has been put in danger?

D.M.: I was doing a series of jobs for a manufacturer of power tools, and had to get on a roof two to three stories high to show a roofer at work. What I've learned is that many assistants will not get up on a roof top. If I know that I'm going to have to do something like that I'll bring it up before hand.

Speaking of danger, I'll tell you a circumstance I had with an individual who wasn't an assistant, but was helping me. I was doing a lot of photography for a major helicopter operator and we were shooting in the Rocky Mountains in Montana. We were in a large military helicopter, big enough to hold fifteen people. The account exec from the ad agency had a little movie camera with him and was taking movies of me taking pictures. My job was to photograph another helicopter working below us. In order to get better pictures he loosened his seat belt and eventually took it off.

All of a sudden the helicopter made a tight turn and this guy started to slide across the floor. He dropped his camera and I saw it drop out of the open door. Miraculously it didn't hit the helicopter flying below us. Somehow I saw him out of the corner of my eye and was able to put my foot out into the walkway, stopping him from also sliding out the door. He was grabbing for anything and finally got back in his seat. We landed immediately and had a little safety talk.

When I feel we are going to be in a dangerous situation, like a steel mill or a railroad yard I always go through a little safety discussion with all the people who will be with me, not just the assistant. I want everyone to know that this is just photography and there's nothing out here that we have to give our lives for.

As a small aside, I take exception with photographers who feel they have to stand out of a helicopter to get the shot. I've been a airplane pilot for 28 years and have done a lot of aerial photography and have never felt the need to be hanging out on the strut playing Rambo. If I'm in a plane with an assistant I have them put the seatbelt on and if conditions warrant I'll tape the latch shut with gaffers tape. I want them as safe as I am.

J.K.: When you're in an air plane or helicopter, does the assistant have any unique responsibilities?

D.M.: When I'm going up in an aircraft I tell the pilot that I don't want to put the aircraft in a dangerous position, such as too close to towers or close to people on the ground. I also like assistants to keep their eyes open for obstructions. If I know there is a radio tower in the area I'll point it out and try to have the assistant keep an eye on it because the pilot can't always be watching. This also keeps them husy; people who don't fly often can get air sick and keeping busy helps reduce that.

In addition I show the assistant how to position their body and how to get out of the door in the event of a crash. I also tell the assistant to put the camera strap around his neck when reloading film. I bring a lot of gaffers tape and we strap everything down. For instance, camera cases are taped to the legs of the seat.

J.K. What do you think of assisting as a way to learn about professional photography?

D.M.: I wish I would have had that opportunity when I was learning the business. I came from a small town in Michigan and I only knew about the local portrait and wedding photographers. I thought that was the only kind of photography there was so I started out doing that, but I wasn't very happy with it. I saw photography in magazines, but I really didn't know how to begin doing it or where I could get these kind of jobs. So it was a bit of a mystery to me. I've thought that if I'd come up as an assistant it certainly would have cut my learning time down.

J.K.: Any parting advice for assistants aspiring to be professional photographers? **D.M.:** I love photography, but I've never been one to walk around with a camera on my shoulder all the time because I only live, sleep, and breathe photography. I know too many photographers who are mono dimensional and that's all they think about.

Too many assistants only think about photography, especially those who want to make it a career. They should realize that there is more to life. You can't just sit around and look at photo magazines, you have to look at other things in the world. Too many assistants try to get into this business who aren't terribly prepared. Perhaps they can produce a picture that can please a client, but they aren't well prepared in other life skills, like business. I always suggest assistants or students take classes on how to run a small business or accounting. Usually their eyes glaze over because they just want to take photography courses, because they're fun.

Although photography is a crowded field and isn't a growth industry, I'd recommend it to anyone who has ideas, intelligence, a love of adventure, perseverance, and artistic skills...what a great way to make a living!

Your First Day on the Job

he professional photographic assistant has a long list of potential tasks and responsibilities. To consolidate this information, both text and an outline describing the day in the life of an assistant is provided. Although there will be unfamiliar terms, it's best to begin the next learning phase with a clearer idea of how the information pertains to the assistant. I suggest rereading this chapter after completion of the book. For quick reference, pertinent sections will be noted.

Preliminary Information

The process really starts several days before the shoot, with a phone call from a photographer checking your availability. (See: Business Matters, Ethical Considerations) Besides establishing when and where you'll meet, obtain some background information regarding the day's work. Will you be in the studio or on location? Will it be a series of product shots or a fashion shoot? (See: Photographic Specialties)

By knowing the camera format, you can make certain you're familiar with related film handling responsibilities, including Polaroid instant film. Also, having an idea as to the day's activities, before you walk into a busy studio, can be very helpful in the early stages of freelance assisting.

Beginning Your Day

Plan to arrive a few minutes early for every assisting job. Before leaving for the studio, take the appropriate call report so you'll have directions and phone numbers. The photographer is very dependent on a good assistant and must be notified in case of a delay. In addition, you'll always need a wristwatch and possibly other items. (See: Finding the Right Photographers, Contacting Potential Clients and Your First Day on the Job, List of Essentials)

Upon arriving at the studio try to become familiar with the studio's layout, when given the opportunity. Key items include the camera, lighting equipment, and the set cart. Important areas will be those used to store background materials, lighting related hardware, and the workshop. Don't forget the telephone. If it's only you and the photographer, you'll be answering it. (See: *Studio Departments*)

Occasionally, there can be two assistants on the set. The two might be referred to as the first and the second assistant. The first assistant has greater experience and is responsible for the second assistant. It could also be two freelance assistants, both of equal standing. Whatever the exact relationship, make certain you understand who is responsible for what. This is especially important when it comes to critical tasks, such as film handling. You don't want to find yourself saying, "I thought you were going to do it."

Prioritize

Throughout the day the photographer will have much for you to do. But whatever it is, it's important to prioritize and work at integrating several tasks. Your "to do" list might begin with taking down yesterday's set, followed by straightening up the studio, and setting up a new background material. Once a background is in position, the subject and props need to be prepared, basic lighting put in place, and more.

Let's say the day's schedule consists of four different shots and the photographer expects to expose eight sheets of film per shot. This requires a total of thirty-two sheets of film, loaded in sixteen holders. Cleaning and loading all sixteen film holders is time consuming. It's more expeditious to begin by loading eight holders and finish the remainder as time permits. This provides film for the first two shots and allows you to return to more immediate tasks on the set. Learn to integrate several responsibilities to avoid delaying progress on the set because of your actions. (See: *The View Camera*, *Sheet Film*)

Working on the **S**et

Before much progress can be made the background needs to be put in place. This might be a roll of seamless paper, a piece of painted canvas, or a specially constructed backdrop. As an assistant, you're often working with several backgrounds throughout the day and a knowledge of their care and handling is essential. (See: Surface Preparation and Background Materials)

With the background in position, you can begin to bring some artificial lighting into the shooting area. The exact lighting requirements differ for each shot. Most often however, as the shot evolves more lights, light modi-

fying devices, and related hardware are gradually incorporated. (See: Working with Light, Light Modifying Devices and Photographic Hardware)

Before proceeding much further the photographer needs a camera. View cameras usually remain attached to a camera stand. If so, roll it into place. (See: The View Camera) Small and medium format cameras are likely to be used with a tripod. (See: The 35mm SLR Camera and The Medium Format Camera) Now is an appropriate time to bring the set cart close to the work area. (See: Studio Departments, The Set Cart)

Don't forget the reason for all this effort, the subject. It, and everything else in frame must be precisely positioned and their surfaces properly prepared. (See: Surface Preparation; Studio Departments, The Workshop; and Photographic Specialties)

Pay Attention and Anticipate

The assistant works closely with the photographer and as you become more familiar with a particular photographer you begin to understand what is meant with less explanation. One way to arrive at this point more quickly is to pay close attention both to the photographer and to what's occurring on the set. For example, the photographer grabbing the flash meter is a cue that it's time to take a meter reading, so act accordingly. Knowing whether the flash meter is set in the cord or non-cord mode, influences how you respond.

Being able to anticipate the photographer's intentions allows you to perform most efficiently. If by observing you know the photographer is interested in metering only one of several flash heads, you should make arrangements to fire that specific light by turning-off unnecessary flash heads. (See: *Artificial Lighting* and *Working with Light*)

Working with Equipment

If it's the first exposure of the day, recheck the camera. It must be synced to the master power supply and the camera's shutter set at the appropriate sync speed, usually one-sixtieth of a second. The large format lens found on a view camera requires several additional steps before being operational. You must be familiar with this procedure. (See: *The View Camera*)

Next, make certain the power supply is turned on and its ready light illuminated. Additional power supplies must be connected to the master power supply, via flash slaves or radio receivers. When multiple pops or long exposures are required, both the modeling lamps and studio lights are turned off. (See: Artificial Lighting, The Electronic Flash System)

Working with Film

You might hear the photographer comment to the stylist or art director that it's time to shoot another Polaroid. More than likely, this remark is also directed to you. Long before now, you should have made sure the

Polaroid film holder is loaded and that there's an adequate supply of film at room temperature. Polaroid film is a wonderful problem solving tool, but to be most useful, each instant print needs to be numbered sequentially and pertinent data noted. (See: *Polaroid Instant Film*).

During the shoot, it's critical to monitor film usage. When using sheet film, it can be important to record exposure data for each sheet of film. A film holder containing exposed film can then be correlated to an appropriate Polaroid print.

Due to the time it takes to clean and load film holders, it's very important to track film usage. If the photographer is exceeding earlier estimates, make time to load more holders. You don't want to be holding up a shot's conclusion because there aren't any loaded film holders. (See: *The View Camera*). If utilizing roll film, plan to notify the photographer when nearing the end of the roll and have unexposed film immediately available. (See: *The Medium Format Camera*)

Keeping Organized

During the evolution of the lighting arrangement, a large soft box may be exchanged for a smaller one or perhaps a silver fill card will be replaced by a white one. As the assistant, you must strike a balance between keeping the studio organized, yet not overdoing it.

The decision to put aside or to put away is influenced by several factors, one being studio size. Smaller studios have little extra space for unneeded stands or soft boxes, and can quickly begin to feel crowded. Larger studios let you set objects aside for possible use later in the day. Another point to consider is how many shots remain. If much still needs to be done, minimize your organizational efforts. Later as the day winds down, begin to put things away as time permits.

The assistant's day isn't over just because the last shot is complete. If the photographer has seen some film from the day's shoot, it's possible that the set will need to be torn down and everything associated with it returned to its appropriate place. (See: *Studio Departments*)

The exposed film is extremely valuable and requires proper handling. Some or all of it may need to be taken to the processing lab on your way home. If the film has been kept well organized from the beginning, this should be a straight forward task. Remember you may not be at the studio tomorrow, just the photographer and a lot of potential questions, if you didn't do things right.

Finishing Up

As the end of the day draws near, consider asking the photographer whether there's anything you could do to be more useful. This feedback can help you to be more effective, not only with that particular photographer, but with others as well. When the day is finally over take some time to reflect on the day's activities, while they're still fresh in your mind. Were there mistakes or things you'd do differently? This can be one of the best ways to learn and improve.

The Day's Agenda

On this hypothetical day the agenda calls for the completion of three different product shots. The work will be performed in the studio, utilizing a 4x5 inch view camera and an electronic flash lighting system.

AGENDA

- 7:50 AM.. Arrive at the studio a few minutes early.
- 8:00..... Gain a general understanding of what's on the day's agenda, especially camera format and film requirements. This information will help establish how much time must be alloted for film handling responsibilities throughout the day.
- 8:10..... Clean and load nine, 4x5 inch sheet film holders with color transparency film.
- 8:30..... Confirm the type of Polaroid instant film to be used. Load the Polaroid film holder and place an adequate supply on the set cart. Begin to familiarize yourself with the studio, as time permits.
- 8:40..... Prepare the shooting area, so work can begin on the first of three shots.
- 8:50..... Set up the background material. Shot number one requires a roll of seamless paper to be suspended from a crossbar, and swept onto a sheet of elevated plywood.
- 9:15..... Bring the required lighting equipment onto the set, including power supplies, flash heads, stands, and light modifying devices.
- 9:30..... Position the camera and have the set cart nearby.
- 9:45..... Prepare the subject and props, then start to position them on the set.
- 10:00.... Adjust the lighting and composition, until both are far enough along to warrant the first Polaroid print.
- 10:30.... Prepare to expose Polaroid film by readying the camera and strobes. Expose a sheet of Polaroid film and annotate it.
- 10:40.... Fine tune the lighting arrangement and composition. The number of Polaroid prints may range from as few as a couple to as many as a dozen per shot.
- 11:30.... When everything is as desired, prepare the camera to expose film. Medium format cameras require the film magazine to be attached and additional film made immediately available.

 Large format camera lenses must be made ready and the appropriate number of film holders brought onto the set.
- 11:40.... Reexamine the set. Confirm that everything is still clean and positioned as desired. If you must work on the set at this point, it's imperative not to disrupt anything.
- 11:45.... Position yourself close to the photographer during the process of exposing film. The photographer must always have film available. Be ready to remind the photographer of any filter changes or variations in the exposure sequence.

 Make certain the photographer doesn't outpace the power

make certain the photographer doesn't outpace the powe supply's recycle rate.

- NOON.....After the exposure process is complete, organize the film and correlate it with a Polaroid print. Then place the exposed film in a safe place. Determine whether any film needs to be processed at this time.
- 12:10.... Prepare the set for the next shot.
- 12:30.... Establish which materials are to be reused on the second shot. These might be the background material, lights, and light modifying devices. Necessary items should be left on or near the set, and unneeded items can be put away.
- 12:45.... Prepare the subject and related props.
- 1:00..... Like the previous shot, the lighting equipment and composition will be fine tuned and confirmed through a series of Polaroid prints.
- 1:50..... Prepare to go to film. The art director has decided on a slight variation in composition, so the second shot is designated as shot 2A and 2B.
- 2:00..... With two of the three shots finished, the photographer instructs the assistant to unload one sheet of film from shots 1, 2A, and 2B. This is the middle exposure of a tight bracket. All three sheets will be processed normally.

 Clearly label the film with regards to contents and processing instructions.
- 2:10...... Everyone breaks for lunch.Turn off power supplies.While getting the take-out lunch the assistant takes the film to the lab, noting exactly what time it will be ready later that day.
- 2:45..... After lunch, the assistant cleans up.

 When an opportunity presents itself, call your answering machine to check for messages related to freelance assisting.
- 3:00..... Load more film holders, due to the unexpected variation on the second shot.Check supplies of Polaroid film.If necessary, make time to organize the exposed film.
- 3:15..... The third and final shot requires the seamless roll paper to be exchanged for a sheet of plexiglass, as the background. Carefully clean its surface.
- 3:30..... As before, follow the progress of the shot through the exposure process. Time permitting, begin to put away items that have accumulated around the set's perimeter.
- 4:00..... Be sure to monitor the clock. The photographer wants you to pick up the processed film from the prior two shots.

 Leave for the lab.
- 4:20..... Upon your return, the photographer checks the film for exposure, sharpness, and color.
- 5:30..... Finalize the third shot by exposing film.
- 5:45..... Now, make certain you understand exactly what the photographer wants done with all the exposed film. At the very least, it must be well organized and clearly labelled.

Due to the client's immediate need for the film the remaining film from shots 1, 2A and 2B, and all from shot 3 is downloaded, and will be run normally.

As soon as the final shot is complete, turn off the flash head's modeling lamp and let the fan cool the head.

- 6:00..... Establish whether the set is to be dismantled.

 Begin to take down the set. Due to their relatively fragile nature it's a good idea to remove the camera first then the lights.

 If the flash heads have not had time to cool down keep the flash tube protected with a reflector, until the reflector can be replaced with a flash tube protector.
- 6:20.... Objects on the set are now readily accessible.

 It's important that everything is returned to its proper place. You may not be there tomorrow to help find it.
- 6:40.... If appropriate, ask the photographer how you did.
- 6:50.... Before leaving for home, grab the film and take it to the lab. It must be labelled with instructions and it will be ready early tomorrow morning.
- 7:00..... Reflect on how the day went, what you learned, and things you might do differently next time.

List of Essentials

Call report for the studio's exact address, phone	number, and directions.
☐ Wrist watch with a second hand to time the dinstant film.	evelopment of Polaroid
☐ Indelible pen to annotate Polaroid prints.	
☐ Local map to aid in running errands.	
☐ Spare clothes for dirty jobs, like painting and d	larkroom work.
☐ Hip belt to hold useful items, especially for loc	ation work.
☐ Small flash light for working in dark studios.	
☐ Emergency food for those unanticipated late n	ights.

The 35mm Single Lens Reflex Camera

hatever sparked your interest in photography, it more than likely led to the use of a 35mm single lens reflex camera. This is true of most professional photographers, regardless of the format they utilize now. As an assistant you will continue to use the 35mm SLR, but you will also expand your equipment repertoire to include other formats.

Characteristics of the 35mm SLR

The 35mm SLR has qualities that are unmatched. Of the three most commonly used formats, it's undoubtedly the easiest to manipulate and the least expensive to operate. Due to the 35mm camera's light weight and small size, a tripod is often unnecessary. Entire systems consisting of several camera bodies, multiple lenses, and on-camera flash can often be carried by one, strong shouldered individual. And by providing 36 exposures per roll, overall film handling is minimized.

Unfortunately, it's these very characteristics that tend to limit the necessity for an assistant, but not all is lost. For assignments calling for a large selection of lenses, especially of longer focal lengths, the 35mm system is unequalled. Jobs characterized by a diverse shot list, coupled with plenty of activity are more readily accomplished using a lighter, more varied camera system. And finally, some fast paced events can only be captured with

an endless supply of film and a motor drive. You might find that the conditions necessitating the use of the 35mm camera can dictate the need for an assistant after all.

Although most assistants are familiar with their own 35mm SLR camera, as a group they can be confusing. There are many manufactures, and the different models and features tend to change more quickly than the medium or large format systems. When confronted with a manufacturer's newest camera body, you might find that you're not as comfortable with it as you first thought. For instance, a thorough knowledge of the Nikon F2 may translate to a limited familiarity with the Nikon F4.

The Assistant's Responsibilities

Many of your responsibilities involving the camera are related to film. Due to the speed at which 35mm SLR cameras can be operated, the most important task is often just keeping the photographer supplied with film. To do this, the assistant must be able to do more than properly load and unload film.

Assisting jobs often begin at a fast pace, which generally gets faster. If this is the case and you're confronted with an unfamiliar camera, concentrate on what's important to you, the assistant. At this stage some aspects of the camera's operation are absolutely essential, while others hardly matter. Prioritize.

Prerequisites to Loading

Before you can begin loading the camera you must be certain you understand the day's film requirements. Exactly what type of film will be used? When there is more than one kind, it must be kept well organized so mistakes don't occur. For example, a photographer might have one camera body for black and white negative film, and a second body dedicated to color transparency film. Clearly differentiate the two camera bodies with regard to film type.

Whether assisting in the studio or on location, try to find a clean, level surface before you begin to handle film. While on location you have to make due with what you can get, perhaps the top of a camera case or your lap. Either way, plan on keeping the camera and all film away from anyone not directly responsible for it.

Confirm the Camera is Empty

You're still not ready to load the camera body with film. First, confirm it's empty. Ask the photographer or check the frame counter. If the film counter indicates the letter "S", the camera should be empty. If the counter indicates frame 36, the back hasn't been opened since the film was exposed, so check the rewind crank knob for resistance. When the rewind crank freely moves both clockwise and counter-clockwise, the camera is either empty or the exposed film has been rewound into the film cartridge. In either case,

attempt to rewind the film just to be sure. Now, it's safe to open the camera back. The camera back is most commonly opened by pulling up on the rewind crank. Once open, examine the film chamber for dust. If necessary, carefully clean the film chamber with canned-air or an anti-static brush. Do not touch the shutter curtain and avoid blasting it with air.

Loading the 35mm SLR Camera

I suspect that virtually every reader is familiar with the 35mm film cartridge and how it's loaded into the camera. However, it's useful to reread your camera's instruction manual for a good standard procedure. In addition, here's a general outline to follow and potential hazards to avoid.

Begin by installing the film cartridge into the camera's *film cartridge chamber*. This is located on the left side, when looking into the back of the camera body. Afterwards, make sure the cartridge is held securely by the forked *rewind post*.

With the film cartridge securely in place, insert the film leader into a slot found on the *takeup spool*. Once inserted, advance the takeup spool with your finger, or by using the film advance lever. At this point, make absolutely certain the film is held tightly by the takeup spool. If necessary, use a little extra film to make certain.

If the film leader slips out of the takeup spool, the film will fail to advance. This must be avoided. Before closing the camera back, check that the perforations found along the film's edge are properly aligned with any sprocket teeth.

Advancing the Film

After you have closed the camera back, use the film advance lever or motor drive to advance the film to frame number one. While doing so, check to see that the rewind knob rotates and is under tension—conditions which indicate that film is moving through the camera. These two points are also worth noting occasionally throughout the exposure process.

A minor note. When a photographer is utilizing the motor drive, you should continue to use it when changing film. Alternating between manual advance and the motor drive can cause problems. Before considering the job finished, check that the camera's ASA, f-stop, and shutter speed settings remain as desired.

The Exposure Process

Before the photographer begins to shoot film you should establish whether it will be exposed in a particular sequence. The photographer may want to expose color film first, and finish each individual shot with black and white film. With this basic understanding, you're in a position to to set up the appropriate camera and film at the beginning of each shot.

You're also better able to anticipate when the photographer might change from one film type to another. Now you can be sure to have the correct camera ready and waiting. When changing film types, it's always a good idea to state what it is to the photographer to make certain there is no misunderstanding.

Before going to film, prepare for the inevitable accumulation of exposed film. By being organized from the start, you can avoid confusion. To aid the process have a couple of plastic bags to segregate exposed and unexposed film, or possibly different film types. A pen with indelible ink, like the Sharpie® brand is necessary so you can write directly on the metal film cartridge. When unavailable, a grease pencil will suffice. Notes might include the shot number or processing information.

Monitor Film Usage

Since the assistant is responsible for keeping the photographer in film, it's important to know when the photographer is nearing the end of the roll. It can be difficult to see the frame counter and almost impossible to keep count, but try.

When the photographer does run out of film, the assistant must have unexposed film immediately available. It's either loaded in a different camera body, or you have a fresh roll ready to be loaded into the camera in use. Some photographers like to be told when there are only a few frames remaining, so they can better decide how to finish a particular shot.

Unloading the Camera

After you are handed a camera containing exposed film be sure to rewind it. Then open the back and remove the film cartridge. It's always worth numbering each roll of film sequentially. Depending on the photographer's preferences, you might also include a shot number or correlate the film to a Polaroid print. There's more than one way to process a roll of film. It can be *pushed* or *pulled*, or perhaps the photographer may want a *clip* or *snip* test done.

When handed a camera with unexposed film, note how much remains. Under some situations it's best to change rolls when given the opportunity, especially when only a few frames remain on the roll. Imagine the stylist is finally done, the model is holding a precarious position, and the photographer begins. Unfortunately, after a couple of exposures the camera is out of film. You just got very busy and everyone is waiting. The voracious appetite of a motor drive can often complicate matters.

Both 35mm SLR and medium format cameras utilize roll film. Consequently, many film related tasks are common to both formats. Because potential assistants are less likely to be familiar with medium format cameras, additional detail will be presented on that format.

Lenses and Filters

Not every camera related task involves film. The assistant will need to change lenses and filters. Lenses are usually attached to the camera with some form of bayonet style mechanism, and removed by depressing a lens release button and rotating the lens. When not in use, both the front and rear elements should be protected with lens caps. If you encounter a dirty lens or filter, use a blower brush or lens tissue. First blow off any dust particles which could scratch the lens, then wipe gently with the tissue.

Any lens might need to have a filter attached to it. The most common are glass filters which screw onto the front lens element. However, you will certainly encounter other kinds. Another group of filters are designed to be held in a filter frame. The *filter frame* either clips onto the lens barrel, or screws onto its end. The filters are made from a variety of materials, but measure either 3x3 or 4x4 inches square. Because these filters are most likely to be used with large format view cameras, their handling characteristics are presented in the section of this book on view cameras.

Lens Shades

You'll find that lens shades are standard equipment among professional photographers. Most lens shades screw onto the end of the lens, much like a filter. However, each is designed for a specific focal length lens. Long lenses have long, narrow lens shades. While wide angle lenses require a short, wide lens shade. Inadvertently placing a lens shade designed for a 105mm lens on a 50mm lens will greatly crop the frame.

The Medium Format Camera

n many ways, the medium format camera is simply a larger version of the 35mm SLR. Ideally, it retains many attributes of its smaller relative, while providing larger film size. Both utilize roll film, Polaroid film holders, built-in light meters, and bayonet style, interchangeable lenses.

However, there are fewer manufacturers of medium format cameras and there is greater stability in their design. This is an advantage for the freelance assistant, since most assistants don't own medium format cameras. At first you may need some on the job training, but you'll find that regardless of manufacturer, your assisting responsibilities are very similar.

Key Characteristics

Medium format camera features are directed towards professional photographers. To meet their diverse needs, medium format cameras tend to be more modular in design. One unique feature is the interchangeable film magazine. A *film magazine* or *back* holds the film, and is designed to be attached to and removed from the camera body quickly. Having several film magazines allows the photographer to change film type in mid roll, and reduces down time when out of film. Also, Polaroid™ instant film is readily integrated into the system, so the photographer can quickly alternate between a film magazine and Polaroid film holder.

The medium format camera is likely to be used while mounted on a tripod. This is partly due to it's weight and size, but also because of the critical nature of the work for which it is used. However when necessary, it can

still be hand-held. The medium format camera is well-suited for work both in the studio and on location.

But wherever you're working, its qualities are best highlighted under fast paced or quickly changing shooting conditions. The ability to view through the lens while exposing film is indispensible, when the subject isn't static. The camera's usefulness is further enhanced by being able to quickly advance the film, either manually or with a motor drive. All of these features increase the likelihood of getting the shot, while supplying a larger film size.

These same features are taken for granted if you're only familiar with the 35mm SLR camera. However, the alternative when larger film size is required is the view camera, a rather cumbersome camera when fast changing shooting conditions prevail.

Medium Format Film

As with any camera, there are film handling responsibilities integrated throughout the assistant's day. Here are a few general notes concerning medium format roll film. There are two standard sizes of roll film, designated 120 and 220. Both sizes are the same width and the figure denotes the length of each roll. The 120 format being the shorter of the two.

The absolute number of exposures per roll will depend on the exact image size or format size of the camera. For example, the three more common image sizes found in medium format cameras are: 6x4.5 cm (2 1/4 x 1 5/8 in); 6x6 cm (2 1/4 x 2 1/4 in); 6x7 cm (2 1/4 x 2 3/4 in). The number of exposures per roll of 120 size film are 16, 12, and 10, respectively.

The 220 size film provides twice the number of exposures. It's also important to know that 120 size film must be used in film magazines designed for 120 size film, and 220 size film must be used in magazines designed for 220 size film.

Roll film doesn't have the protection of a metal film cartridge. The film, or more precisely, the film and its protective *backing paper* are wound around a spindle and secured with a paper tab. There are times during the loading or unloading process when roll film can unravel, if dropped or mishandled. Therefore, extra care is required at these times. If you haven't seen a roll of medium format film, buy one and take it apart. This will help clarify why things are done a certain way.

Since it's usually the assistant's responsibility to keep the photographer in film, here are a few manufacturers you're most likely to come across. The Hasselblad provides a 6x6 cm format, and between Mamiya and Bronica, all three formats can be found.

The Film Magazine

In principle, the various models of film magazines are quite similar, but be aware that there are subtle differences. Film magazines differ in how they

attach to the camera body, and how the film compartment opens and closes. Aspects concerning placing the film in the magazine and advancing it to the first exposure, also differ. All seemingly minor points that can cause major problems.

The film magazine consists of two main parts. An *exterior housing* that protects the film from light, and physically attaches to the camera body. The second is the *film holding assembly* or *film carrier*. This holds the film, and is enclosed within the housing. A film magazine is opened and closed using some form of locking mechanism. Once opened, the two parts can be completely separated. Add a roll of film and you have your hands full.

When unfamiliar with a specific model, examine it, and ask for help. Always view film handling as critically important. If you've never handled one of the three aforementioned manufacturers, try to get some hands on experience. The Hasselblad being the camera of choice.

Cleaning the Film Magazine

While the film holding assembly is removed from the housing clean the two pieces with canned-air. Be sure to remove the metal, *dark slide* from the housing unit and examine the border defining the image area. Look for any small, hair-like particles that may ultimately lie on the film surface.

When using canned air, it's easy to nonchalantly blow out the inside and assume it's clean. Make it a point to look. As time permits, it's also a good idea to check for dust when changing film. Before handling film, check that the dark slide is completely reinserted and the film take up spool is on the correct side.

Prerequisites to Loading

As with any shoot, make certain you understand the day's film requirements, before you load any film. Establish whether more than one type of film will be used, if so, mark each film magazine accordingly. You should also know if there's a particular exposure sequence, or whether the film should be designated in any way. This basic understanding allows you to be more efficient and minimizes errors.

Loading the Film Magazine

It's best to standardize on a film handling procedure and refine it with experience. This will help you keep your wits, when tensions heighten. Because film magazines come apart into several pieces, try to find a relatively clean, level work surface before you get too involved.

An interchangeable film magazine can be loaded and unloaded, regardless of whether it's attached to the camera body. In the following description, imagine that the entire film magazine has been removed from the camera body.

Magazine Operation

Loading the Magazine

The magazine may be loaded on, or off the camera. If it is to be loaded off the camera then the magazine slide must be inserted, its flat side towards the rear. This facilitates removal of the film holder for loading. Follow the procedure below.

- 1) Fold out the film holder key.
- Turn the key counter-clockwise and withdraw the film holder.
- 3) An empty take-up spool should be placed under the spilined knob of the spool clamp bar. Insert a roll of film under the other end of the bar, ensuring that it is turned the same way as in the illustration. Be careful to remove all the paper tape that surrounds a new roll of film.
- Turn the film holder key clockwise to open the film clamp. Pull 8 - 10cm (3 - 4 in.) of paper backing off the film roll and slide the edge under the clamp.
- 5) Insert the tongue of the backing paper into the slot in the take-up spool.
- Turn the splined knob clockwlse until the arrow on the paper backing is opposite the triangular index on the spool clamp bar, but no further.
- 7) Turn the film holder key counter-clockwise and insert the film holder into the magazine – jiggling it a little if it does not click into place. Lock the film holder into the magazine by turning the key clockwise.
- Fold out the film crank and rotate it clockwise about ten turns until it stops. Turn the crank counter-clockwise and fold it in.

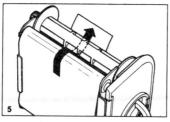

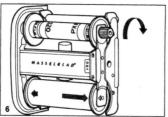

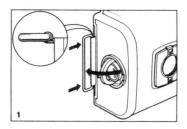

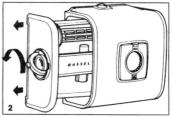

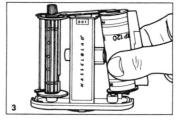

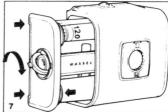

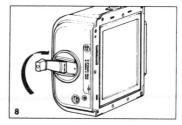

Number 1 will now be displayed in the frame counter window and the magazine is loaded – ready for use.

The magazine's film winder crank is only blocked at frame 1. A partially exposed film may be wound off at any frame thereafter.

The frame counter is automatically reset when the film holder is withdrawn from the magazine.

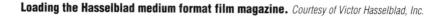

First Things First

First, check that the magazine is empty. You are generally safe when the frame counter indicates anything other than a number. If in doubt, try to wind any film onto the takeup spool, check the film magazine in a darkroom, or ask the photographer.

An empty film carrier has one takeup spool. The exposed film is wound onto this spool. Since you do not rewind medium format roll film once the last exposure is made, the remaining film and its protective backing paper is advanced entirely onto the takeup spool. This means the takeup spool is always supplied by the last roll of film. This results in the empty spool being situated where the new, unexposed roll needs to go. Therefore, the empty spool must first be moved to the film take up position.

Positioning the Film

The film must be held securely by the film carrier. This is accomplished by inserting the two posts, found at the top and bottom of the film carrier, into each end of the film spool. The unexposed roll must also be positioned so that film and not the paper backing will be exposed.

Now completely remove the paper tab that keeps the film from unraveling, making certain that no stray paper is left in the film back. The *paper leader* must feed out from the underside of the roll, not over the top. When done correctly, the black, inside surface of the backing paper is facing out as it's pulled across the pressure plate, and inserted into the takeup spool.

The backing paper must wind onto the takeup spool by going under the spool, versus over the top. The backing paper is then wound further onto the takeup spool, until the arrow found on the backing paper lines up with a designated position on the film carrier. This procedure assures that the film is in the precise starting position.

Once the film is in place, reinsert the film carrier into the magazine housing and lock the housing compartment. The latching mechanism doesn't automatically lock when snapped shut, like 35mm SLR camera bodies.

Advancing the Film

With the film carrier secured within the housing, make certain the dark slide is fully inserted. Then use the film advance lever to advance the film until it stops. The frame counter is now on number one. This procedure advances the backing paper and film, until the film is in position to be exposed. Failure to do this results in the loss of exposures one and two, because you'll be exposing the backing paper and not film.

The film magazine is now attached to the camera body. Remember, the film magazine can be safely removed from the body in mid roll, so long as the dark slide is fully inserted.

The Exposure Process

During the exposure process track film usage closely, ten or twelve frames can be exposed very rapidly. The photographer should be told in an

unobtrusive manner when there are only one or two exposures remaining on the roll. At this time, the assistant needs to have another film magazine loaded. Have it in your hands and stand next to the photographer. If you sense the photographer might shoot a Polaroid, have the Polaroid holder loaded and immediately available. When the shooting stops, don't let it be because of you.

Unloading the Film Magazine

After the last exposure is made, the film must be advanced entirely onto the takeup spool. The film isn't rewound like 35mm film. Often the photographer does this, but do it yourself to be safe. You advance the film with a film advance lever found on the magazine. When the film is completely wound onto the takeup spool, the film advance lever has much less resistance. It's now safe to open the film back and remove the film.

When you open the film magazine, the free end of the backing paper is not secure. If the roll is dropped, it can easily unravel and ruin the film. The tail of the backing paper is sealed by using a paper tab, similar to that torn-off at the beginning of the roll. Moisten it, and wrap it around the film. Until you're more adept at this procedure, work close to the table to reduce the likelihood of any mishandling. Try to have a separate storage container for exposed film. It doesn't take long to accumulate four to five rolls. An empty, 50 sheet box used for 4x5 inch film is especially useful. Also, try to store exposed roll film in subdued light.

Film Processing

For any film, both you and the lab needs to know how it's to be processed. Immediately after the film is exposed is the time to include any pertinent information regarding its processing. Generally, properly exposed film is processed normally. However, film can also be pushed or pulled, and by varying amounts. In order to determine if the development process should be altered, a photographer might request a clip test.

Alternative Film Processing

A *clip* or *snip test* can be performed on both small and medium format roll film. Here, the processing lab cuts off a short length of film from either the beginning or end of the roll, as directed by the photographer. This portion of the film is then processed normally. Afterwards, the photographer views the processed piece of film and decides how the remainder of the roll should be *run* or processed.

A clip test with color transparency film might appear a little under exposed or dark, when processed normally. This can be corrected by push processing or *pushing* the remainder of the roll to lighten it up. Conversely, an over exposed or light clip test will dictate *pulling* the remainder of the roll.

The amount in which the development process deviates from normal pro-

cessing is measured in *stops*, for f-stops. For example, a roll that is under exposed by one-half, f-stops will be pushed, one-half stops, or written on the instruction sheet—*Push*, 1/2 *stops*. A roll that is over exposed by one-half, f-stops will be pulled, one-half stops and written—*Pull*, 1/2 *stops*. These terms regarding altering film processing are common to small and medium format roll film and sheet film. However, you don't perform clip tests on sheet film.

The Roll Film Holder

It is also possible to shoot medium format, roll film with a view camera. Roll film holders are available in a variety of formats for those view cameras having the International style back and locking system. These holders are very similar to the film magazines for medium format cameras, with regard to the loading and unloading of film.

Lenses, Filters, and the Compendium

Medium format lenses are handled much like those for 35mm camera systems. However, there's less tendency to frequently change lenses during a shoot. This is partly because there are simply not as many lenses to choose from, with respect to focal length. It's also due to the fact that medium format cameras tend to be used in a more methodical manner, than 35mm SLR's.

Lenses are attached and removed utilizing a bayonet style mechanism and a lens release button. An important note regarding Hasselblad lenses. You can only remove the lens when the camera has been cocked. Once cocked, depress the lens release button, and rotate the lens counter-clockwise until it stops.

When required, glass filters can be screwed onto the front of the lens. However, medium format lenses have a rather large diameter, front lens element. This means that owning a wide selection of glass filters can get very expensive. Consequently, a *filter frame* which holds interchangeable filters is far more cost effective, while providing access to a much greater selection.

Instead of purchasing an individual lens shade for each lens, medium format systems often incorporate what's called a *compendium lens shade*. This connects to the lens and resembles an accordion-shaped bellows. A compendium lens shade is extended or compressed depending on the focal length of the lens. A calibrated scale is provided to ensure the bellows is extended the proper distance. In addition, the compendium lens shade has provisions to accept various filters. The fine points about the compendium lens shade and filters will be presented in the chapter on view cameras.

Using a Tripod

The medium format camera is used with a tripod, more often than not. Unless instructed otherwise, begin by setting up the tripod to a height of about four to five feet, making sure it's level. Before attaching the camera, tighten all knobs related to the extension legs and tripod head. Attach the camera body using the mounting bolt found on the tripod head, much like a 35mm camera.

However unlike 35mm cameras, many medium format cameras require a larger, 3/8 inch diameter mounting bolt. Therefore, when the camera is to be mounted to a tripod head having the smaller, 1/4 inch bolt, a 3/8 inch to 1/4 inch *reducing bushing* is required. It's critical to remember this vital accessory when packing for location shoots.

An Interview with Michal Heron

rapher for almost twenty years and is primarily involved with editorial and corporate photography. She is based in New York City with most of her work taking her on location.

John Kieffer: In general terms, what do you feel are the most important personal attributes for an assistant?

Michal Heron: The thing that pops into my mind first is the attitude of the assistant, an attitude that nothing is too much trouble, an open willingness. This is worth it's weight in gold to me. The number one attribute and also the number one problem is attitude, the right attitude or the wrong attitude.

J.K.: What do you look for regarding photographic skills?

M.H.: I expect familiarity with the standard equipment that's used in the business. Assistants should have a good understanding of the most commonly used camera bodies and lenses, Polaroid systems, and strobes—the basic equipment. That I expect without question, because if I don't have an assistant that has those basic skills then I have a trainee.

Besides a familiarity with equipment, I want an assistant to have an understanding of lighting. When I explain the kind of lighting I want, they must understand what I'm talking about. They need to have a feeling for the quality of light and how to achieve it, especially when I'm working on location. Then I'm free to discuss other things with the client rather than having to instruct an assistant step by step. There's a very fine line there, the photographer wants to design the lighting, but wants an assistant who is able to carry it out.

Good assistants are knowledgeable apprentices. They already have considerable background and are assisting photographers to learn the business and to fine tune the photographic skills they learned in school. I don't have the time to train anybody, but I'm more than happy to share my experience with someone who is ready to learn from it. That's interesting and enjoyable. When using a good assistant, an assistant who contributes to me, I find that I enjoy the process of giving them information—the little hints and shortcuts. It's a way of sharing what I've learned in the business.

J.K.: Considering the amount you travel, what kind of photographic equipment do you use most often?

M.H.: I work primarily with 35mm and to a lesser extent medium format cameras. I use the Mamiya® RB-67 which I like for its rectangular format. I would say

it's 20% medium format and 80% 35mm. In my corporate work I do a lot of interiors which require strobe lighting. I also photograph people—one of my specialties is ethnic and cultural groups around the world, especially American Indians.

J.K.: Do you use a small, on-camera flash unit or a larger electronic flash system? **M.H.:** It's very rare for me to use on-camera strobes for a professional job because I do very few of the P.R. events that require on-camera strobe. I generally use a monolight system so there isn't a battery pack on the floor. I carry between 1200 to 2400 watt-seconds for most jobs and more for anything really big.

J.K.: Do you have a full time assistant or do you utilize free lancers, and how much do they make?

M.H.: I use freelance assistants on a regular basis and they make about \$125. per day. For someone who is relatively inexperienced they might command only \$100. per day.

J.K.: How do you find potential freelance assistants, or do they find you?

M.H.: I find assistants through other photographers. If another photographer has given an assistant my name, I will consider using him or her once I've checked their references. Most of the time I draw from a pool of regulars. If my regular assistants are busy, I will get names by calling photographer friends because I know I'll get a very accurate report.

It's important for assistants to understand that there is a pipeline, a bond among photographers, and they trust each other's recommendations. Photographers wouldn't dream of passing a mediocre assistant off to one of their colleagues. So the assistant who has performed badly for a photographer shouldn't assume it ends there. The photographer may not say much, (I sometimes just grit my teeth rather than waste my breath on someone who won't listen) but that one day of lousy attitude or sloppy work will bear bitter fruit.

J.K.: Do you interview prospective assistants after they've been recommended to you?

M.H.: That depends on a couple of things, the time available and the importance of the job. Ninety-nine percent of the time I will interview, although I have taken people cold in desperation.

J.K.: Do you look at an assistant's portfolio?

M.H.: I like to see a portfolio because it tells me who the assistant is technically and creatively. It isn't essential, but is certainly desirable.

J.K.: What do you look for in a portfolio?

M.H.: I would say overall professionalism. If someone is presenting themselves as a professional assistant, then they should have arrived at a stage in their career where they can present their portfolio in a professional way. This means clean, attractively presented, technically proficient, reasonably creative work—and no fast-shuffling excuses for dog-eared prints.

If I don't see professionalism in the preparation of the portfolio then I may be

uneasy. That person may let some of the small details slip and make my job less professional. I want to see that care has gone into the preparation of the portfolio, because I want that same care to go into everything they do on my job.

J.K.: What don't you like in an assistant?

M.H.: The death knell for me is the assistant who gossips about other photographers. For example, I remember driving to a location shoot with an assistant who was trying to dazzle me with gossip picked-up working with other photographers. He went into their personal and financial lives, their bad tempers, their mistakes on the job—and relayed it to me in a smug, gloating manner.

I don't want to hear about all that and it isn't the assistant's business to repeat it. Also, I know full well that I have to be on my guard because I have a viper in my midst. This is a person I cannot trust to be professional. Assistants are exposed to privileged information, so discretion is a critical personal attribute.

One of the most infuriating things an assistant ever did was to intrude when I was discussing a Polaroid print with a client. Without being invited to give an opinion, the assistant began commenting on the lighting and making suggestions as to a different way of doing it, a way contrary to the style I wanted. I was finally put in a position of having to be rude to the assistant while trying not to make it awkward for the client.

When interviewing assistants I set up ground rules, so they understand what I expect from them. I tell them very clearly that I don't want them to interrupt when I'm talking with the client. Interfering with my relationship with the client is every bit the equal of technical mistakes. On the other hand, I may consult with a regular assistant about solutions because I'm happy to make them part of the process.

You don't get the best out of an assistant by treating them as a lackey. You want them to feel they are contributing something important to the shoot. I'm delighted when an assistant picks up on something I've overlooked. It might be a detail in the Polaroid, such as a light stand in the edge of the frame or a piece of wire. That's what I feel they are there for, to help me by being another pair of eyes. I welcome that, but that contribution has to be done in a way that's helpful to the photographer and not disruptive.

J.K.: Do you feel female assistants are as capable as male assistants?

M.H.: Yes, absolutely. But if you're a woman looking for an assisting job it's important to confront the issue of physical strength. A female assistant should diffuse any possible bias by making it clear that she not only knows the technical aspects of the job, but also that she is strong and willing to lift heavy equipment.

J.K.: Do you hire women assistants?

M.H.: Of course. I have used both men and women assistants. But in fairness, when using a woman assistant I will let her know the kind of heavy loads that she'll be expected to handle. I think any good woman assistant is able to do that.

J.K.: Have assistants been responsible for any disastrous technical mistakes? **M.H.:** The worst technical mistake? There have been a lot of common technical mistakes, such as not making sure the power supply is properly adjusted after taking a meter reading, or the film not advancing in the camera. There are a million common ones and sadly they happen more often than they should. Mistakes can be the result of a certain casual arrogance that some assistants get about doing the simple tasks. You can't develop a blase or cavalier attitude just because you've loaded a thousand rolls of film.

By the way, that happened not more than six months ago with a very experienced assistant. It wasn't until I reached frame 42 that I realized I'd lost all the good expressions because the film wasn't advancing. Fortunately we were shooting professional models and not a corporate executive with a tight schedule so I could shoot more film. When things like that go wrong I usually cover for the assistant and quietly make it right.

Later, when I told the assistant that the film hadn't advanced, he never took responsibility or even acknowledged that he had caused me to lose some shots. Not to mention adding stress that I didn't need. If an assistant makes a mistake the first thing to do is to try to rectify it, but it's also important for an assistant to take responsibility for mistakes. Not to cover it with arrogance or bluff.

J.K.: Unfortunately we are all bound to make mistakes, but do you have any instances where the assistant saved the shot?

M.H.: There was an occasion when we were setting up for a portrait of a corporate CEO at his factory. We arrived at the facility at 6AM, found our location—a tough one with stainless steel everywhere—and fine tuned our lighting with a stand-in. The CEO breezed in, saw the angle we had chosen, and though it had been agreed on with the art director, he barked at us that he didn't want to be in the prearranged spot. In addition, he could only spare eight minutes.

At that time the assistant and I went into overdrive and he was absolutely extraordinary. We worked like a ballet team to put the set back together. This assistant had always been thorough and very dependable, but was not known to work very fast. In this case he rose to the occasion and really helped me save the shoot. It's what I expect from an assistant, to do what's necessary to get the shot.

The View Camera

he view camera is the camera of choice for many photographers and a necessity for certain kinds of photography. No camera is better suited for use in the studio and it follows that the assistant needs some proficiency in its use, at least in specific areas.

Key Characteristics

The view camera provides several advantages over the two smaller formats, the most obvious is increased film size. A 4x5 inch or 8x10 inch sheet of film yields higher quality, than a smaller size film. The larger size is also easier to evaluate and retouch, if necessary. Equally important is the ability to control both the plane of sharp focus and perspective.

Plane of Focus and Perspective

The *plane of sharp focus* is the portion of the image which is in focus or acceptably sharp. With a view camera, you can place the plane of sharp focus in the most useful position and maximize available depth of field. This can be parallel to the shooting surface, perpendicular to it, or anywhere in between.

Being able to control the plane of focus is critical to much of photography, especially product work. Here, the camera is often positioned close to the subject, which results in a very limited depth of field. It's not uncommon to have a depth of field measured in inches, even at f32.

Perspective is the appearance to the eye of objects, with respect to their relative distance and position. Controlling perspective allows the photographer to create the feeling of three dimensions or depth, in a two dimensional photograph. In architectural work, the photographer must make a structure appear natural or normal to the viewer. By properly manipulating the view camera, a building's vertical lines can be made to look vertical. If more appealing, the lines can be permitted to converge slightly. The divergence and convergence of horizontal lines can also be controlled.

The Camera Movements

Both perspective and the plane of focus are adjusted by using what are called the camera movements. The view camera allows for independent movement of both the film and the lens. The film and the lens can tilt forwards and backwards; swing or pivot to the left or right; laterally shift to the left, right, up, or down.

A 35mm SLR or medium format camera has the lens and film fixed parallel to each other. Being fixed, the camera can produce an uncomfortable amount of convergence among parallel lines. When pointing the camera upwards at a tall building, the resulting convergence makes the building look as if it's falling back. Also, the plane of sharp focus is fixed in a position parallel to both the lens and film plane. Hence, there is little control over its placement.

A thorough presentation of view camera technique can be found in numerous books and is not reviewed here. I suggest, at least a familiarity with the terms describing the camera movements. These are: swing, tilt, rise, fall, shift. You should also understand the Scheimpflug Rule, which defines how to control the plane of sharp focus. Until you've worked with the photographer a considerable length of time, you won't be responsible for adjusting the view camera.

A good way to strengthen your view camera technique is to note how the photographer has adjusted the camera's front and rear standards, then see if you understand why. Keep in mind, assisting is not one long question and answer session. Limited questions can be asked, but at appropriate times.

The View Camera

What follows is basic information that's of particular importance to the assistant. Most likely, you'll work with what is referred to as the studio view camera, as compared to the more compact, field view camera. Both styles function the same way, but the studio camera's modular design allows it to be used in a great variety of applications.

In its basic form, the studio view camera consists of the *front standard*, which holds the lens. The *rear standard*, which holds the ground glass and film. The two standards connect together with the accordion-shaped *bellows*. Using the front and rear standards, this unit is attached to a monorail. The monorail is then attached to a *rail clamp* or mounting base. It's the rail clamp or mounting base which screws onto the tripod head.

Camera Stands and Tripods

View cameras are supported on a camera stand or sturdy tripod. When asked to attach the camera to a stand or tripod, proceed carefully. You'll find that view cameras are more awkward than heavy.

First, make sure the tripod and tripod head are secure, no loose knobs. Then attach the rail clamp. This is done by screwing the rail clamp to the tripod head. Now, the monorail can be positioned in the rail clamp. The monorail serves as the foundation for the rest of the camera.

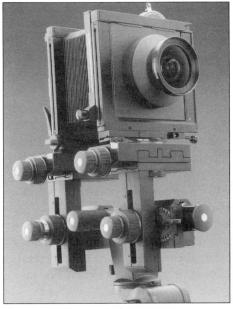

The Sinar P2 4x5 inch view camera Photo courtesy of Sinar Bron, Inc.

The Large Format Lens

Once the camera is attached to the tripod head, there's still some set-up work to be done. Most of it revolves around the lens. The lens itself is held in a flat, square *lensboard*. It's the lensboard, which is then fitted into recessed grooves found on the front standard. Once positioned, the lensboard is secured in place using a locking mechanism.

Though not standardized, this locking mechanism is usually simple in design and fairly apparent in how it operates. It will be found at either the top, or at both the top and bottom, of the front standard. The same mechanism is used to remove the bellows and ground glass. If perplexed as to its operation, ask for help. Errors can cause the lens to fall off or light leaks.

Preparing the Lens

Using a large format lens adds several steps to the set-up and exposure process. To begin with a lens always needs a cable release, one identical to those used with other cameras. However, the cable release attaches to the lens, not to the camera body.

When electronic flash is used, a sync cord or radio transmitter must connect the lens to the light source. The sync cord and its connection to the lens are identical to that found in small and medium camera systems.

Now is a good time to check the *shutter speed*. One-sixtieth of a second is a reliable choice, when the lens is synced to electronic flash or strobe. If natural light is all or part of the exposure, the shutter speed will be determined by the photographer.

Besides shutter speed, exposure is controlled by adjusting the *lens aperture* or *f-stop setting*. However with large format lenses, as the lens is *stopped-*

down, less light reaches the ground glass. When the lens is set at f32, the ground glass is fairly dark. Consequently, the lens must be *opened-up* to its maximum aperture for viewing, commonly f5.6. To make an exposure, it must be closed-down to the working aperture, f32, for example.

You're not done yet. The shutter must be *switched open* to view the ground glass and *switched closed* before exposing film. By looking through the front of the lens, you can see the shutter open and close as the switch is moved back and forth. And finally, the shutter must be *cocked* before it can be triggered. Both the switch to open and close the shutter and the lever to cock the shutter are located on the lens.

Summary of Lens Preparation

In summary, when you set up a view camera for *viewing*, the lens should be prepared as follows: attach the cable release and sync cord, switch the shutter open, set the appropriate shutter speed, adjust the f-stop for the largest aperture.

To make an *exposure*, you must switch the shutter closed, stop-down to the working aperture, and cock the shutter. Now, plunge the cable release to make certain the shutter works, and the strobes are firing. Then recock the shutter, pull the dark slide, and expose the film.

Compendium Lens Shade

The photographer will probably utilize a *compendium lens shade*. This kind of lens shade utilizes a bellows and attaches to the front standard, not directly to the lens. Lens flair caused by extraneous light can be a real problem. If it's there, lens flair can usually be seen reflected on the front lens element. Position the lens shade or compendium until the reflection is gone. Then look through the camera at the working aperture to make certain the lens shade isn't in view. In addition to a lens shade, black cardboard is often positioned close to the lens to block or *flag-off* stray light.

Filters

An important item associated with the lens is the filter. You've probably handled the glass filters that screw onto the front of the lens. These are used with the view camera, but less often. View camera lenses have large front elements, necessitating large, expensive filters. Photographers commonly rely on what are referred to as gelatin filters, such as *Wratten gel filters*.

Gelatin filters resemble a thin, flexible plastic. They measure either 3x3 inches or 4x4 inches. Although rather fragile, they offer several advantages. First, gelatin style filters are relatively inexpensive and come in a wide variety. The most common are the *color compensating* filters. These are available in red, blue, green, cyan, yellow, and magenta. In addition, each color also comes in precisely, varying strengths. The weakest, yellow color compensating filter is designated as, *CC025Y* and the strongest as, *CC50Y*. Color compensating filters are used to achieve the desired color on film. For example, if a film's emulsion is running a little cool, a magenta color compensating filter might be used, to make it neutral. These can also be

used when integrating several light sources, perhaps a building's fluorescent lighting with daylight balanced film.

Attaching the Filter

Gelatin style filters must be held in a *filter frame*. Most commonly, the frame clips onto the rear lens element of the large format lens. Placing the filter on the rear element requires a smaller filter and reduces lens flare. When positioning the filter, care must be taken to assure the filter lays flat and it doesn't develop any kinks or creases.

Gelatin filters are very delicate. They should be touched only along their edges, and cleaned with a soft brush. Absolutely no moisture must come in contact with them, or you'll see why they are called *gels*. Some newer, gelatin style filters are sturdier, but should still be handled with care.

Gaining access to a gelatin filter placed on the rear lens element can be difficult, especially after the camera is positioned. When practical, remove the lens and the filter can be handled. Unfortunately, when there's a compendium, sync cord, and cable release attached to the lens, this can be disruptive. Under these conditions, you can get to the filter by removing the bellows, at the point where it attaches to the front standard.

Another option is to remove the back of the camera holding the ground glass, and reach through the bellows. This is most practical, when a shorter focal length is used and the bellows is fairly compressed. Ideally, the photographer should not have to refocus after working with a filter. The bellows and ground glass are locked in place with the same mechanism used to secure the lens.

Focusing Aids

After preparing the lens, make sure there's a dark cloth or focusing cloth nearby. The *dark cloth* restricts unwanted light, and aids in viewing the ground glass. For focusing, the photographer needs a *magnifying* or *focusing lupe*. The lupe is used by placing it directly on the ground glass, then rest your eye on the lupe, similar to viewing a color transparency.

It takes time to feel comfortable viewing the ground glass. The image is upside down and backwards, and at first glance appears rather dark. However, for both the photographer and the assistant, viewing through the camera is the best way to critically review work performed on the set.

It's common to refer to the viewing area as the ground glass, but you are probably working with the fresnel lens. The *fresnel lens* snaps over the ground glass and provides a more evenly illuminated area. Because it's easily removed, the fresnel lens is also the best surface to place an acetate overlay or make marks with a grease pencil. These might be used to define the exact proportions or layout of a shot.

Sheet Film

One of the most time consuming tasks associated with the view camera is film handling. This encompasses the cleaning, loading, and unloading of

sheet film holders. To ensure proper processing, exposed film must be correctly identified and organized. Afterwards, it must be taken to the lab and picked-up after processing. The assistant often begins and ends the day dealing with film in some capacity. As film use increases, so does the time dedicated to film handling.

A thorough knowledge of the following film handling tasks is essential to all assistants. If you are not completely familiar with sheet film holders, I suggest you purchase a 4x5 inch format, sheet film holder and practice, practice, practice. Go to a professional processing lab and ask for discarded 4x5 inch sheet film. If necessary, buy a box of film. Fortunately, virtually all sheet film holders are universal in design. The standard 4x5 inch holder will fit any 4x5 inch format, view camera. In addition, 4x5, 5x7, and 8x10 inch film and their respective holders are handled identically, they just differ in size.

Preparing the Sheet Film Holder

Each time a film holder is used, it must be cleaned and loaded with film. Before you can begin cleaning, a few preliminary chores need to be accomplished. With time, you'll load film holders in many different places. Some photographers have special changing rooms for film handling. At other times, you'll be fighting for a small, clean space in a darkroom. By adhering to a standardized routine you eliminate errors.

Preliminary Tasks

It's essential to establish the type of film to be used and the amount needed. This information gives you a good idea of how many holders need to be prepared. Each holder holds two sheets of film. Once you've assembled the required number of holders, remove all unnecessary holders from the immediate area. When in an unfamiliar room, this reduces the chance of grabbing the wrong holder. Don't assume any film holder to be empty. Confirm this with the photographer. If in doubt, recheck the holder in the dark. You can often shake a holder and hear if a piece of film moves inside, but this is more akin to Russian roulette.

Film Requirements

Now is the time to make sure there's plenty of film at room temperature. Larger quantities of film might be stored in the refrigerator, and it takes one to two hours for film to reach room temperature. It's important to wait because condensation can form on the film's cold surface, when handled in a warm room.

Every film is given an *emulsion number*, indicating when it was manufactured and as a means of quality control. Verify that each type of film has the same emulsion number. This figure is printed on the side of the box and on the data sheet enclosed with the film. Photographers prefer to use the same emulsion for the entire shoot. This provides consistency with respect to film speed and color. If there isn't enough film of the same emul-

sion to finish to shoot, the photographer may not use it. Confirm one way or the other, before loading any holders.

Labelling the Holder

Oftentimes, the photographer or assistant needs to make pertinent notes on the film holder. These can be written in pencil on the small white label provided on the holder. Any irrelevant notes must be erased, before cleaning begins. A more common procedure is to place masking tape over this area. The tape can be readily removed after each use.

The masking tape or white band is useful for noting what film type is inside the holder. Color transparency film might be written as, *E-6*; black and white negative as, *B+W*; and color negative as, *C-41*. Details depend on the diversity of film to be used and the photographer's preference.

Identification Cards

Now make some identification cards, the white cards found in sheet film boxes are ideal. These cards are used to clearly identify the status of various holders and minimize any confusion. Remember, times can be hectic and you must eliminate any errors when working with film.

You may need to run an unexpected errand for the studio, the photographer continuing without you. At these times, the photographer must be able to quickly determine the status of all holders. For example, a card might read, *Loaded/E-6/Unexposed*. When there is a lot of film usage, it's easy to have a combination of loaded holders, and clean, but as of yet unloaded holders. The two can look identical. Label the second set of holders as, *Clean/Empty*.

A holder containing exposed film looks just like an empty holder. Differentiate the two as, *E-6/Exposed* and *Empty*, respectively. This is where an annotated Polaroid print is useful. When more than one type of film is used, blatantly clear labels are even more critical.

The Dark Slide

The film holder's dark slide does provide some information, but not enough. The top of each *dark slide* has a white pull-tab on one side, and a black pull-tab on the other side. The pull-tab which faces out and is visible, reflects the status of the film inside. A dark slide with the white tab facing out, indicates unexposed film. A dark slide with the black tab visible, indicates exposed film. *Remember*, white for unexposed film and black for exposed film.

When making an exposure, the holder is placed in the camera and the dark slide is removed entirely. After the exposure, the dark slide is reinserted, with the black tab facing out.

Cleaning the Film Holder

Once the necessary holders are segregated and marked with the day's film type, you can begin cleaning. Keep in mind that absolutely no dust is

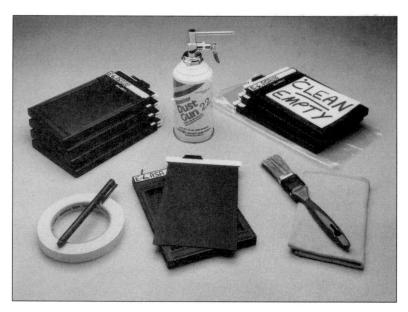

Equipment to clean and label sheet film holders.

permissable. Start by wiping off the work area, ideally with a damp sponge. Then organize the following items, a natural bristle brush, canned-air, two zipper-locking plastic bags, and a clean pair of hands. When holders are used exclusively in the studio they tend to remain fairly clean, but don't assume they are clean. All holders must be cleaned before each film loading.

During the following description, the top of the sheet film holder is where the two dark slides are first inserted into the holder. Also, the top is where the two white bands for notes are located.

Removing Dust

Begin the cleaning process by blowing or brushing off the entire holder, before removing the dark slides. This sequence reduces dust from being deposited onto the felt *light-trap*, as the dark slides are withdrawn.

Remove both dark slides, and set them on a clean surface. Now, pinch the holder along its outer edge, about one inch from the top. While the holder is held vertically, tap both sides with the solid portion of the brush. This is to dislodge any dust caught in the light-trap. Dust remaining here might fall onto the film, when the dark slide is moved in or out.

After tapping, brush out the inner area of the holder. Brush in one direction, from top to bottom. Then, horizontally along the bottom hinge.

While brushing, you can aid the process by blowing out the area with your mouth, as if whistling. Finish by using canned-air on all grooves and surfaces. When using canned-air, point the nozzle away from the work table. There's no point in disturbing air in the area where you will set your holder.

Next, thoroughly brush off each dark slide and blast it with air. Reinsert the dark slide completely, making certain the white pull-tab indicating un-

exposed film, faces out. Place the clean, but empty holder in a zipper-locking bag. The one gallon size will hold four to six holders.

Anti-Static Cloths

Some photographers incorporate the use of an *anti-static cloth*, especially in static prone environments. Static can physically damage film and also attracts dust. An anti-static cloth can be used to wipe off any of the holder's surfaces, and it's useful in removing an occasional smudge mark. When used, be on the alert for any stray lint. If static is a persistent problem in a studio, make it a practice to move the film and dark slide in and out of the holder, slowly.

Take Your Time

Even when you're rushed, it's not prudent to cut corners in the cleaning process. In the end, the person who cleans a holder bears responsibility for any dust marks. At times, when you have many holders to clean, you can fall into a monotonous routine. You begin to assume that just because you tapped, brushed, and used canned-air, that the holder is clean. Don't forget to look, especially when the brush has a tendency to loose its bristles. Holders must be spotless. Dust spots will appear as black marks on processed, color transparency film. When dust settles on the film, no light reaches the surface and that area isn't exposed.

Loading the Film Holder

Now that you've cleaned and labelled each holder, they can be loaded with film. But before turning out the lights, be sure you're well organized.

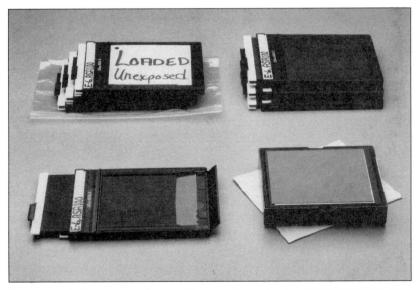

Arrangement of holders and sheet film in order to load sheet film holders. The film's notch code must be in the lower right corner.

Before the Lights Go Out

All cleaning items and unneeded holders should be far from even the most disoriented reach. Remove the holders from the plastic bag. Recheck that the dark slide's white pull-tab is facing out, denoting unexposed film.

As you restack the holders on the table, pull both dark slides out about, one-half inch. This small gap signifies that both sides remain unloaded, but won't let any dust inside. When both dark slides are reinserted entirely, you'll know both sides are loaded.

While facing the work table, position the stack of holders so that they are lying horizontally, the top of each holder on the left. Take the top holder and place it on the table between you and the stack. Unless space is very limited, avoid loading a holder while it's on top of the stack. If the stack is bumped and topples, it could lead to complications.

With the holders in place, turn your attention to the box of film. In this example, I will describe a new, unopened box of film. Begin by placing a rubber band around the box, to make certain it only comes open when desired. Then, cut the paper bands sealing the box. To open the box further, all lights must be off. This means absolute darkness, no safe light.

Before turning off the light, be sure the door is locked. If no lock exists, make it known to everyone that you'll be in the dark. In unfamiliar settings, it saves times to remember where the light switch is located. Hopefully, it's marked with a piece of phosphorescent tape.

If unfamiliar with the packaging for sheet film, visit a professional lab and ask for an empty box. Having spares is part of their job. Sheet film boxes consist of three interlocking lids, providing a reusable, light proof arrangement. Depending on format and film type, there are 10, 25, 50, or 100 sheets per box.

Lights Out!

Now, turn off the light. Remove the rubber band and put it on your wrist. As you open the box, insert one lid inside the other, so none are misplaced. New film is enclosed in a sealed, foil envelope. There are either 10 or 25 sheets per envelope. Tear it open and remove the film. The envelope isn't needed to ensure a light proof environment and is usually discarded.

The film is still covered top and bottom with sheets of white cardboard, the kind so useful in making the identification cards discussed earlier. These are retained with the film.

The Notch Code

It is now critically important to properly orientate the film, relative to the holders. This is done by using the film's notch code. The *notch code* consists of a series of small notches. Each film type has a unique notch code, and it's always located near the corner, on one of the short sides. Besides serving as identification, the notch code is used as a reference point for loading film. It allows you to load the film correctly, with the emulsion side up.

Place the box of film horizontally, in other words, parallel to the holders. Make certain that the notch code is in the lower, right corner. The notch

code is always positioned in the lower, right corner when the holder is lying horizontally and the dark slides are removed from the left. This placement allows the notch code to be read by your finger tip, even though the dark slide is removed only slightly.

Inserting the Film

With both the holder and box of film properly oriented, the film can be inserted into the holder with a minimum of handling. With your left hand,

Sheet film holder loaded with 4x5 inch sheet film. When the holder is positioned horizontally as in the above photograph, the film's notch code must be in the lower right corner to ensure the emulsion side faces out.

pull out both dark slides about another inch. Then, using your left thumb and index finger, hold open the small, hinged flap found along the holder's right side.

Using the thumb and index finger of the right hand, grasp the film along the edge containing the notch code. Touch the film surface as little as possible.

Now, insert the film under the holder's *film guides*. There are two sets of guides or grooves. The top one is for the dark slide and the bottom one is for the film. You must be certain you don't place the film in the grooves intended for the dark slide. The loading process is facilitated by positioning the thumb and index finger of the left hand, at the very beginning of the holder's film guides.

Once the film is under the film guide, use only your finger tip, and gently push the film in completely. By running your finger along the only edge of film remaining exposed, reconfirm that the notch code is located at the bottom right. Finally, slowly reinsert the dark slide, making certain it interlocks with the hinged flap. Turn the holder over and repeat the process.

When both sides are loaded, lock the dark slides in place using the small latches provided on the holder. With many holders, the small *locking hooks* are very loose, hence unreliable. If you expect an inordinate amount of handling, you can secure the dark slides with a rubber band, once the light is back on. This can be fitted lengthwise around several holders and helps to attach a Polaroid print.

After all the holders are loaded, rebox the unused film. Place the rubber band around it, so it can't be opened inadvertently. Now turn on the light.

Lights On!

With the light on, write on the lid how much film remains in the box. Place the holders in a clean bag and insert an identification card. The cleaning and loading process is complete. Now check to see if you're needed on the set.

The Exposure Process

When working in the studio leave all film holders in the changing room, until it's time to go to film. At that time, bring out only those holders required for that particular shot. Include the canned-air, so the photographer can blow off each holder, before placing it in the camera.

Usually the photographer operates the camera and makes the actual exposure. The assistant is often close to the photographer, helping the film handling process go more smoothly. You want to have the holders readily available to the photographer and be ready to write pertinent information on the holder, immediately after the exposure.

Once the film is exposed, it should be stored in a safe place, ideally back in the changing room. While on location, holders are often placed in a dedicated film case. Although holders containing exposed film are identified by the black pull-tab on the dark slide, they should still be kept segregated from unexposed film holders. When there's a Polaroid print related to a group of holders, attach it with masking tape or a rubber band.

Why You Identify Film

With proper preparation, you should be able to place some identification on a holder, soon after it's exposed. Because each sheet of film can be processed individually, it's often essential to know what's in each holder.

One complication that can arise, is having the exposure sequence become more involved than first planned. This results in using more holders than anticipated and having more to keep organized. For example, the photographer decides to bracket exposures more than usual, a filter is attached for one series of exposures and removed for others and there's a decision to try a variation in composition. Now, there is shot 1A and 1B, both with and without filtration, and each at several different exposures. Plus, there are four more shots that day.

Dynamic subjects can often complicate matters, because you never know exactly what you've got, until you see the film. This might be a model in

action or a freshly poured beverage. Here, the photographer may bracket relatively little and process only one sheet of film. The result will indicate how the other exposures will look, and whether there's a need to deviate from normal processing.

Time permitting, the photographer may process the film in two separate processing runs. It's reassuring to know that if anything goes wrong with the first batch, there's a backup. Obviously, you need to know what's in each holder to do this. And don't forget, as a free lancer you might be working in another studio the next day, and the photographer had better not have any questions.

Unloading the Film Holder

Before any film can be taken to the lab, it needs to be removed from the holder and placed in a film box. This box is then taped shut and properly labelled. Unload only one type of film into each box and all that film must be processed the same way.

First, you'll need an empty film box and a rubber band for securing it. Then clear away a working space, and stack the appropriate holders next to the open box. Now, lock the door and turn off the light.

Lights Out, Again!

Basically, unloading a film holder is the opposite of loading a holder. Slowly pull out the dark slide a couple of inches. Then remove the film by grasping its edge, making sure to pull it straight out from the holder.

Some holders are more difficult than others to get hold of the film's edge. You can try a finger nail under the edge, in order to lift the film. The key is to grasp only the film's edge. Leave the slide partially withdrawn, to verify that the holder is empty.

After the holders are unloaded, replace the two lids and attach a rubber band around the box. Now, you can turn the light on. If you expect to add more film to the box, keep the rubber band on it. If not, secure the box with four short pieces of masking tape. The taped box is ready for the lab, after it has a proper label.

Ensuring Proper Processing

Just as the assistant needs to know what's in each holder, the lab must know what's in the box and what to do with it. Therefore, the label must be clear and precise. Since boxes are used again and again, remove any old notes, so there isn't even a hint of confusion.

Some photographers have their own processing labels for boxes, if not, tape the white cardboard found in new boxes to the lid. At the top, write the photographer's name and phone number. This should be sufficient because the photographer will have an account with the lab.

The Different Film Types

Now, some information about the contents. Note the number of sheets, the format, type of film, and any specifics regarding it's processing. All E-6 processed, color transparency film is handled identically. These films include Ektachrome and Fujichrome, but not Kodachrome. Here, *E-6* or *E-6* processed film, will suffice.

Color Negative film is developed with a process referred to as C-41. It can be noted as C-41, or C-41 color negative. Black and white negative film must be specifically identified, because processing times differ depending on film type. The label might read, B+W, Plus-X film.

Both black and white and color negative material can be difficult to interpret, and a contact print is often requested. Here, the negative is placed directly on the photographic paper and exposed. The result is an unmanipulated print, the size of the negative. The contact prints made from a roll of film make a *contact sheet*. When contact prints are needed, write "Process and Contact" on the label.

Properly exposed film that is processed for the recommended time is referred to as normal processing. If this is the photographer's intent, the label should state, "Process Normal," regardless of film type.

As with roll film, if the development process is to be altered, the lab must know how and by how much. Film can be pushed or pulled, with the amount measured in stops for f-stops. For instance, the label might read: "Push 1/3 stop," or "Pull 1/2 stop."

Other Materials

You will undoubtedly be involved with photographic materials, other than film. You can arrive at the studio and be on your way to the lab before you even set your coat down. When sent to pick up something, know exactly what you're going for. Not all items are stored in the same place and getting two out of three isn't good enough. Often times, the lab will inquire if there's more. How do you know if you don't ask?

When dropping off material, try to get all the specifics. If questions arise, call the studio. The photographer is likely to have very definite opinions about every aspect of the photographic process.

The Changing Bag

You may be called on to work with a *film changing bag*. These provide a small, light proof environment. The standard changing bag looks like an oversized sweater. The waist area is opened and closed with a series of zippers. The bag's arms provide access for the user's arms. Since you can't take your arms in or out of the bag without letting in light, preparation is essential.

The biggest problem is dust, no matter how clean the bag and proficient your technique. This is largely due to the basic design. The top material is unsupported and lays over the work area. It moves anytime your hands move. Due to the inadequacies in the basic changing bag, there is another design. Newer models have an internal framework, making the bag into a

small tent. This provides a roomier and somewhat cleaner work environment.

Some partial solutions exist. Be organized, so as to minimize movement. Withdraw the dark slides as little as possible, and keep holders in plastic bags until needed. To keep the fabric elevated off your hands, you can hold some of it in your mouth, making a little tent. Try placing a five sided box inside, one slightly larger than an average shoe box will suffice. Set on its side, the box provides a less congested work area.

Another trick is to place the required materials in a new, plastic garbage bag. The garbage bag is then placed in the changing bag, basically a bag within a bag.

When you know there will be a need to utilize a changing bag, it's better to look for a small windowless room and cover the door. A combination of black cloth, push pins, and gaffers tape will handle most situations.

Summary of Responsibilities Related to Camera and Film ☐ *Gain an understanding* of the day's film requirements. ☐ Differentiate camera bodies, film magazines, or sheet film holders as to film type. ☐ Load camera bodies, magazines, or holders with the appropriate film. ☐ *Prepare* for the inevitable accumulation of exposed film, so it remains well organized. ☐ Anticipate the photographer's need for film by following the evolution of each shot and understanding the exposure sequence. ☐ Unload and reload camera bodies, film magazines, or holders as needed. Always have film immediately available during the exposure process. ☐ Annotate exposed film cartridges or holders, include a shot number and processing information. Correlate to a Polaroid print when possible. ☐ Monitor film usage, to ensure an adequate supply is available at room temperature. ☐ After the exposure process, establish which film is to be processed and how. Don't make assumptions. ☐ Attach the camera to tripod or camera stand. ☐ Attach a cable release and sync cord, if necessary. ☐ Be prepared to *change lenses* and attach filters, as needed throughout the shoot. ☐ Be prepared to remind the photographer of variations in the exposure sequence, with regard to changes in composition or filters.

Polaroid Instant Film

olaroid[™] instant film is an integral part of professional photography, not merely a convenience. It allows the photographer to make an exposure and see the results almost immediately. As shots become technically more demanding, coupled with little tolerance for anything less than perfection, its importance only grows. The assistant's responsibilities are intimately related to Polaroid instant film and it's one task photographers are quick to delegate. They may not feel comfortable having you load sheet film holders your first day with them, but Polaroid is all yours.

Why Use Polaroid Instant Film?

The phrase, the more that can go wrong, the greater the likelihood that something will go wrong, readily applies to photography. Most commercial jobs utilize a considerable amount of equipment, and Polaroid instant film helps confirm everything is working. A Polaroid print is often referred to as a *proof print*.

You begin with a camera, which is likely to be connected to a power supply. This in turn leads to several flash heads, each flash head having some form of light modifying device. Then, there are various fill cards to add light, and perhaps black cards to control unwanted light. Every component must function as desired. No one wants a surprise.

The use of electronic flash equipment or strobe greatly increases the need for Polaroid. This kind of lighting system produces a flash of light. Because of its short duration, its effects cannot be evaluated with the unaided eye. A Polaroid print provides an instant picture and instant feedback.

Often, it's the subtle differences in lighting that really make the shot, and much time and energy is spent in its refinement. As you'll see, each Polaroid print is numbered sequentially and pertinent information noted. The resulting series of Polaroid prints is literally a documentation of the shot, a tremendous learning experience for the assistant.

Checking Exposure

While helping the photographer evaluate the aesthetics of the lighting arrangement, Polaroid provides information on purely technical matters, such as the exposure. Photographers learn to interpret a Polaroid print in relation to the specific film they use. They determine through experience, that a Polaroid which looks a certain way will translate to a good exposure on their particular film. For example, a photographer knows when to expect to retain sufficient detail in the film, when there is little in the Polaroid print. Determining exposure beforehand, also limits bracketing and reduces film usage.

Checking Focus

Besides exposure, a Polaroid is used to check for focus. In other words, is the camera *holding* or *pulling focus*, at a specific aperture or f-stop? This can be done by simply evaluating the print for overall sharpness. However, there is a more critical procedure.

Some black and white Polaroid films, such as Type 55 and Type 665, provide both a positive print and a negative. When examined with a magnifying lupe, the grain of the negative provides greater resolution, in order to evaluate sharpness. The negative also tends to retain more detail, both in the shadows and highlights, as compared to the print.

However, the Type 665 negative needs to be thoroughly washed with water, before it can be viewed with a magnifying lupe. In fact, it's the backing material you removed to stop development. But before washing, it bears little resemblance to a conventional black and white negative.

The Best View in the Studio

In addition to the photographer, a Polaroid print is used by the assistant, client, model, hair, or food stylist. Objects differ in appearance depending on your position when you view them. Regarding photography, only one position or viewpoint matters, and that's the camera's.

When critically evaluating anything on the set, you must do so from the camera's position. You either look through the camera or stand directly in front of the lens. Unfortunately, this is often impractical. It may be physically impossible to squeeze between the camera and the set. And for the uninitiated, the upside down and backwards image of the view camera is foreign. Besides, not everyone needs to be hanging around the camera. Again, Polaroid is indispensible.

General Characteristics

Although many people utilize the Polaroid print, most tasks related to its production rest with the assistant. Polaroid is used with 35mm SLR, medium format, and large format view cameras. But regardless of the format, it's basically the same material and shares the same general characteristics. These properties greatly influence how you handle Polaroid instant film.

There are two basic kinds of Polaroid instant film; *color* and *black and white*. Both are available in a variety of film speeds or ASA ratings, and the specific films are designated as *Types*. Like other photographic materials, Polaroid must be exposed and then processed.

Processing Polaroid Material

After the Polaroid film holder is attached to the camera, Polaroid is exposed like any film. However, processing is initiated as the Polaroid material is removed from the specialized holder. Most simply, the removal action spreads developing chemicals over the print's surface, and the developing process begins.

At the appropriate time, the development process must be stopped. This is accomplished by peeling off, either the protective envelope or the paper backing from the print. The print's image surface will be rather delicate for several minutes, but you can still annotate it before handing it to the photographer.

The print's development is highly temperature dependent. As ambient temperature decreases, processing time must be increased. Timing the development process ensures consistent results. This is the most important reason for always wearing a watch with a sweep hand: Color Polaroid takes longer to process than black and white, making a watch even more important.

Type 55, a commonly used black and white material, provides both a 4x5 inch positive print and a conventional negative. At 75 degrees Fahrenheit, processing takes 20 seconds. However at 60 degrees Fahrenheit, development requires 40 seconds. *Type 59*, a comparable color print material takes 60 seconds, at 75 degrees Fahrenheit. When the temperature drops to 60 degrees Fahrenheit, development time must be increased to 75 seconds.

The Assistant's Responsibilities

Now that you know something about Polaroid material and how useful it is, what are your responsibilities? In general, to make certain it's always readily available. When taking an inventory of film, include Polaroid instant film. Many photographers refrigerate unopened boxes. Refrigerated film should be given two hours to reach room temperature, so plan ahead.

While in use, the Polaroid film holder should be kept loaded, with plenty of extra film nearby. A good assistant pays close attention to the photographer's actions, and to the progression of the shot. When the photographer is ready to expose a Polaroid, the assistant is normally near the camera with Polaroid ready. The assistant should also anticipate when the

photographer is likely to change from Polaroid to regular film, and then possibly back to Polaroid. This can be an important time saver in fast changing situations.

Annotating the Polaroid Print

By annotation, I mean make a few pertinent notes along the print's border. Exactly what you write will depend on the individual photographer and the stage you're at in the shot. If unfamiliar with the photographer, try looking near the light box or on the set cart for some previous Polaroid prints. You might also inquire as to any preference.

Usually, the photographer shoots several Polaroids during a shot, more difficult shots require more Polaroid prints. At the very least, each Polaroid print should be *numbered sequentially*. It's imperative to keep track of Polaroids and embarrassing to find one unnumbered, everyone wondering where it fits into the sequence. Numbering also helps the assistant track Polaroid usage, insuring there's always plenty available.

Other basic information includes the f-stop, the power setting for each light or flash head, and the shutter speed when appropriate. As the lighting set-up takes shape, major changes might be noted. A medium soft box may replace a smaller one, or perhaps some filtration is attached to the lens.

It's easy to note that a silver fill card was exchanged for a white one, however, a slight change in the position of a light may be difficult, if not pointless to describe. The assistant needs to use a little discretion, along with the photographer's preferences, when annotating Polaroid prints.

The last Polaroid in any sequence is usually marked *Final*. Some photographers like to annotate the final print fully, and then file it with related paper work. Other times, the final Polaroid is left relatively unmarked and given to the client.

You'll find that few pens consistently write on the print's surface. A fast drying, felt-tipped pen with indelible ink works best. The Sharpie® brand is a good choice. Some photographers also like to use grease pencils, in either case, they should be supplied by the studio.

Some types of black and white Polaroid prints need to be coated with preservative, to resist fading. This chore can usually wait, until the Polaroid isn't being viewed. The chemical needs several minutes to dry thoroughly and it's quite sticky in the meantime.

Feeling Rushed?

Often, there's little time to annotate the print. The moment it's finished developing, everyone wants to view it. Regardless of the demand, it must be annotated sooner or later. At the very least, put a number on the print, before handing it over. Under these hectic circumstances, record a few notes during the development process.

When using 4x5 inch Polaroid, make notes on the edge of the protective envelope. If it's a small or medium format Polaroid, write along the border on the back of the print. Be sure not to write or put pressure on the delicate, developing surface. When given the opportunity, transfer this information to the print.

Annotation of the Polaroid Print

Key to abbreviations

Shot 1: The first of several different shots associated with a job.

Shot1A: Changes in composition or filtration within a shot may be designated as Shot 1A or 1B.

FINAL: Denotes this as the last Polaroid of Shot 1.

This is usually exposed just before going to film.

#4: The fourth Polaroid exposed for Shot 1.

f32.0: The len's f-stop. Include shutter speed, if appropriate.

N/F: No filtration on the lens.

O5M: Denotes a O5 Magenta Color Correction filter is attached to the lens

2400 w-s Medium: 2400 watt-seconds of power going to a flash head, with a medium soft box.

1600 w-s Reflector: 1600 watt-seconds of power going to a flash head, with

a reflector.

Photographers may prefer "full power" or "2/3 power."

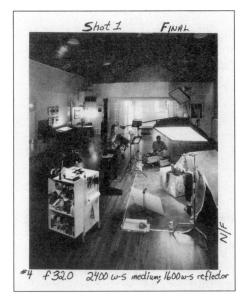

Polaroid print with Annotations

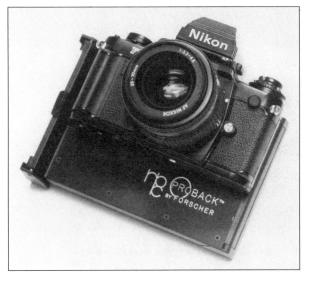

The NPC ProBack
attached to a
Nikon F3 35mm camera.
NPC Instant Camera Backs
are designed to hold an
eight sheet packet of
Polaroid instant film.

Photo courtesy of NPC PhotoDivision.

The Small and Medium Format Instant Film Back

Many small and medium format camera systems can utilize Polaroid instant film by attaching an *instant film back*. With most medium format systems, the camera's film magazine is removed and the instant film back or holder is readily attached. When an instant film back is used with a 35mm SLR camera body, the hinged film door is removed and the film back is attached. Although very similar in appearance and operation, film backs are manufacturer specific.

Regardless of format, the film back is designed to hold a packet of Polaroid instant film, containing eight sheets of film. Each sheet is sequentially numbered, one through eight, both on the back of each print and on the exterior pull tab. This arrangement aids in annotating the Polaroid print, and allows you to monitor Polaroid usage more easily.

Both 35mm SLR and medium format, instant film backs can be removed from the camera in the middle of a packet of film. This is accomplished with a stainless-steel dark slide. When fully inserted, the *dark slide* allows the film back to be independent of the camera. Once attached to the camera, the dark slide is pulled out and the exposure made.

Although the use of Polaroid instant film with small and medium format systems is very similar, there is one difference. The 35mm instant film back lets you make two independent exposures, on each Polaroid instant print. Each image measures 24mm x 36mm, and permits bracketing of exposures on the same print. Since 35mm SLR cameras utilize medium format Polaroid instant film, this procedure allows for greater usage of a relatively large piece of film.

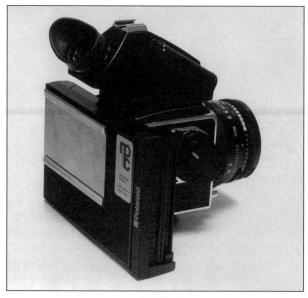

The NPC Instant Camera Back attached to a Hasselblad medium format camera. Photo courtesy of NPC Photo Division.

Loading the Instant Film Back

In the following description, the instant film holder is attached to the camera. Position yourself as though viewing through the camera. The film back is opened by releasing a latch found on the right side. The hinged door swings open, and the film packet readily slips into place. Make certain the paper pull-tabs found on the film packet, are situated on the right. Now close the door and latch it.

When a new film packet is placed in the holder, the top sheet of film is covered with a black piece of paper. This light proof, protective covering must be discarded, but only after the film packet is placed in the film back. It's removed using the same means used to remove and develop, an exposed sheet of Polaroid instant film.

Developing the Polaroid Print

Here are a few points to keep in mind, when removing either the protective paper covering or an exposed print to initiate development. Position yourself behind the camera. With your *left hand*, place the thumb under the bottom right corner of the film back. Next, place the left index finger on the top right corner. You are grasping at a point where the two halves lock shut. Now, make a pinching type action with these two left fingers.

The *left hand* is used to stabilize the film back and the camera. If not stabilized, the force generated from the pulling action used to remove the print will topple most tripod mounted cameras.

The *right hand* is used to remove the protective covering or exposed print. To do so, firmly grasp the protruding pull-tab with the thumb and index finger of your right hand. Make one continuous pull, using moderate force. The entire pulling process should last less than one second.

Be sure to pull straight out from the holder. If you pull slightly up or down relative to the holder, there's a chance of tearing the protective paper cover or print. This may result in some paper remaining caught in the holder, often affecting the next print.

Immediately after a print is pulled from the holder, begin timing its development. The development process is stopped by peeling off the backing material. The image surface is still rather delicate, but you can write pertinent information on the print's white border.

Polaroid for the View Camera

The general characteristics of 4x5 inch and 8x10 inch Polaroid instant films are similar. Both color and black and white instant films are exposed while held in a specialized Polaroid film holder, then processed following the same general principles. However, due to the disparity in size between the two formats, there are some distinctly different handling procedures.

Why Use Polaroid Instant Film?

In addition to the reasons given earlier, view cameras have several more. Most notably, large format view cameras provide a large image, commonly

4x5 inches and 8x10 inches. Larger size means a need for lenses of longer focal length. A 50mm focal length lens is considered normal for a 35mm camera, but a 150mm lens is normal for a 4x5 inch format camera. Longer focal length lenses provide less depth of field, when set at the same f-stop. Therefore, having adequate depth of field is not a given, as is often the case with the smaller format cameras.

The view camera's movements provide for moving both the film plane and the lens. Camera movements allow the photographer to position the plane of sharp focus and control perspective. This control is best utilized, if the photographer can verify that everything is as it should be.

The 4x5 Inch Polaroid System

Let's first consider 4x5 inch format Polaroid instant film and the *Polaroid Model 545 film holder*. Like the small and medium format systems, the Model 545 holder holds the film during exposure. The holder is also used to initiate the development process, as the film is removed from the holder. But here, only one sheet of film is placed in the holder at a time.

A few notes regarding 4x5 inch Polaroid instant film. Each individual sheet of film is enclosed in a light proof, paper envelope. This also contains the processing chemicals. Consequently, the envelope must be handled carefully, because you can inadvertently expose the film or disrupt the pod of chemicals.

In simple terms, the envelope containing an unexposed sheet of film is inserted into the holder. The envelope protects the film from light and is moved out of the way during the exposure process. Once exposed, the envelope is slipped back over the film. Then the entire envelope is removed from the holder, which initiates development of the print. Once development is complete, the envelope is peeled away from the finished print.

The Polaroid Model 545 instant film holder. (Top) An individual sheet of Polaroid instant film is inserted into the holder and the protective paper envelope is partially withdrawn. (Bottom) The back of the holder showing the control arm, and the Load (L) and Process (P) positions. The small film release lever (R) is also visible.

Loading the Model 545 Holder

More specifically, position the control arm found on the Model 545 holder to *L*, for *load*. Grasp the envelope along the edge and carefully insert it completely into the holder. Make certain the side of the envelope marked, "This Side Towards Lens," faces the holder's opening. You can hear a click, as the envelope locks into place. The holder is then slid into the camera, like any standard sheet film holder.

Now, turn your attention to the lens. Close the shutter, stop down to the working aperture, and reconfirm the shutter speed. Then cock and trigger the shutter. This test firing reaffirms that the lens is closed and the strobes are firing. Failure to perform this test firing can result in a ruined sheet of film.

Exposing the Film

After recocking the shutter, you are ready to proceed with the exposure. First, gently pull the protective envelope out from the holder until it stops, about six inches. The envelope acts as a dark slide, now the film is uncovered and ready to be exposed. Make the exposure. Once exposed, slowly reinsert the envelope into the holder, so it covers the film.

Developing the Film

After the exposure is made, the film is ready to be developed. At this point, remove the holder from the camera. Now, move the holder's control arm to *P*, for *processing*. Pull the envelope from the holder, using a firm continuous pull. The ideal duration for the entire pull is 1/4 to 1/2 seconds. With the aid of stainless-steel rollers, the removal process spreads developer over the film.

Once the film envelope is removed, timing begins. Development time depends on the kind of film and temperature. When appropriate, development is halted by peeling open the envelope and removing the print.

To remove the print from the envelope, grasp each of the two tabs with the thumb and index finger of each hand. These tabs are found on the tapered end of the envelope, opposite the metal cap. Now carefully peel open the envelope, all the way down to the metal cap.

Remove the print, being careful to keep its delicate surface free of chemicals. The print is now ready to be annotated and given to the photographer. Move the film holder's control arm back to L, and reload the Polaroid holder.

Removing Unexposed Film

Photographers often standardize on either color or black and white instant film. However, there are times when a change is necessary. A photographer may prefer color, then switch to black and white to utilize the negative. If you are quick to reload the holder, as you should be, you may need to remove an unexposed sheet and exchange it for another.

Removing an unexposed Polaroid film envelope is accomplished as follows. Place the holder's *control arm to L*. This relaxes the stainless-steel rollers. Then depress the small *film release lever*, *labelled R*. This releases

the holder's grasp on the envelope's metal cap. With the film release lever still depressed, gently remove the film envelope.

If the envelope's metal cap remains engaged within the holder, the film will be inadvertently exposed and must be discarded. This can be avoided by placing your thumb on the envelope near the metal cap, and gently pushing while the release lever is depressed.

Be advised, some color transparency film can be used with the Model 545 holder. These E-6, processed films are available from Polaroid and Kodak. Like Polaroid instant film, one sheet of film is contained in each envelope. Once exposed, the envelope is removed from the holder like an unexposed Polaroid. Later in a darkroom, the film is removed from the envelope and put in a box for processing. This film is most likely to be used while on location. It's especially useful when film usage is expected to be high, coupled with little opportunity to reload film holders.

The Model 550 Film Holder

The Model 550 film holder is designed to hold a film packet. Each film packet contains eight sheets of 4x5 inch format, instant film. The holder functions much like the instant film holders designed for small and medium format camera systems. The model 550 is held in the camera like a standard sheet film holder and utilizes a dark slide.

The 8x10 Inch Polaroid System

The Model 545 holder and instant film are quite compact and convenient, when compared to the 8x10 inch format system. With 4x5 inch Polaroid, everything that's needed, i.e., the positive print and the negative, are contained in the same envelope. Plus, both exposure and film processing are accomplished using the same holder.

The 8x10 inch Polaroid system is somewhat different, affecting both its loading and processing. Here, only the negative is placed into the specialized Polaroid holder. This holder resembles a sheet film holder, and the negative is exposed like any other film.

Afterwards, the exposed negative and an unexposed positive are placed into a specialized Polaroid processor. The processor moves both the exposed negative and unexposed positive print over a set of rollers, initiating development of the print. The 8x10 inch processor is most commonly an electrical unit, however, a manually operated unit is also available.

To ensure customer satisfaction, Polaroid Corporation provides considerable technical support. Detailed instructions regarding a product's use are supplied with each package of film. In addition, technical assistance is available through 800-prefix phone numbers. Finally, Polaroid publishes *Test* magazine, biannually. Refer to the appendices on equipment and periodicals for more information.

Summary of Responsibilities Related to Polaroid Instant Film

☐ Establish the <i>Type of Polaroid</i> film to be used.
\square Have an <i>adequate supply</i> of film at room temperature.
☐ Keep the Polaroid film holder <i>loaded</i> .
☐ Anticipate when the photographer is likely to expose Polaroid film At these times, <i>prepare the camera</i> and have Polaroid film immediately available.
☐ Expose Polaroid instant film.
☐ <i>Begin timing</i> the print's development, after it's been pulled from the holder.
☐ <i>Reload</i> single holders; <i>recheck</i> status of instant film backs.
☐ At the appropriate time, <i>stop development</i> by peeling off the envelope or backing material from the print.
☐ <i>Annotate</i> the Polaroid print.
☐ Attach an annotated print to exposed film. Record any specific processing information.

An Interview with Steve Umland

Steve Umland is a commercial photographer based in Minneapolis. He is known for shooting large scale advertising campaigns both in the studio and on location.

John Kieffer: Could you give me a little better idea as to the kind of photography you do?

Steve Umland: I do large production, advertising photography and the vast majority of my clients are advertising agencies. These campaigns have included Winnebago, Polaris Snow and Watercraft, Mercury Marine, and AT&T. I just finished a campaign where we had to build a large, ten by twenty-foot soft box and float it out over the top of watercraft from a houseboat. A lot of my work is very technical. I love natural light, but if the natural light isn't doing what I want it to do I supplement it with created light. Most of the time I shoot with a Linhof 4x5 view camera, but I also use Mamiya® 2 and 1/4 and Nikon® 35mm systems.

J.K.: What kind of person are you looking for in an assistant?

S.U.: I want somebody who is fired up and energetic about being an assistant. I want somebody who arrives in the morning with stars in their eyes, they're so excited to be in a studio doing photography that they want to pitch in and do whatever they can. I also need somebody who can be professional around the clients. They might ask the art director if he or she would like a cup a coffee, even though that may not be directly their responsibility.

I feel you can teach the assistant almost everything technical that they need to know. It's really nice if an assistant walks in and knows 4x5 cameras and strobe. I have Norman strobes and I might ask them to set the power supply from 1200 to 800 watt-seconds. They need to know that they can't pull the flash head cable out of the pack when the power is on. But those kind of things can be taught, so it's whether the personality fits. I spend a lot of time on the road and I have to feel comfortable with somebody. For example, recently I was out in Montana for four days shooting sunrises and sunsets, and if I'm going to be sitting in a car for six hours to six days I need to have someone I enjoy being with.

I believe, and I think I'm the contradiction, that the assistant is another set of Umland eyes. An assistant can really save my ass because I get really focused when I'm shooting. It's like I have blinders on. A good assistant is looking out for the big picture and will walk up behind me and tell me if there's a problem, like a reflection in the lens. The assistant also tells me in such a way that an art director can't hear. A lot of photographers feel that assistants are seen and not heard and I don't agree with that. I really believe that they are an integral part of the

team. Just yesterday I was on location and we had several options and I asked my assistant which one he thought was best and why. I think assistants work better if you make them a part of what you're doing.

J.K.: You mentioned that you can teach many of the technical skills, but when you are approached by an assistant what technical qualifications are you after?

S.U.: Most assistants walk in with a portfolio and as I look through it I ask them which camera format they like to shoot. I tend to gravitate towards somebody who likes large format. If an assistant's portfolio is mostly 35mm editorial I have to wonder why they want to work with me. Basically, I'm a large production advertising photographer and I use large format. I'll also ask them if they like natural light or strobes, and what kind of strobe they can operate.

J.K.: Do you place much importance on the assistant's portfolio?

S.U.: I feel the portfolio is just something to look at while I'm talking to them. I have never hired an assistant on whether they had a good or bad portfolio because it doesn't mean anything to me as far as an assisting position. However, I do expect assistants to work on their own portfolio when they are working for me. If an assistant comes in and works for me, but doesn't work on their personal work I question why they're assisting. I also kick my assistants out after one year.

J.K.: I take it that you have a full time assistant?

S.U.: For the last fourteen years I always had at least one and often two full time assistants. But as of three months ago I stopped doing that. My first assistant wanted to go to Europe for two months and I said sure, I'll use freelance people while you're gone. But I'm just amazed, I love using free lancers. They come in the studio fired-up and energetic. Another advantage is that if I don't like them I can get somebody else the next day. At this point I'm not sure if I'll go back to using somebody full time.

J.K.: What is the day rate for a freelance assistant in Minneapolis?

S.U.: It's \$100. to \$125. a day. You can get somebody who is just coming out of school for \$80. a day.

J.K.: Are most of the assistants that approach you graduates of a photography school?

S.U.: I would say that most of them are graduates, maybe 60 to 70 percent.

J.K.: What's the best way for an assistant to get in to see you?

S.U.: They can call me. I usually won't hire anyone who I haven't talked to and seen their book. I bet I have two to three people call a week. I also have a second shooter here in the studio and I might ask him for a recommendation. So if I do need someone that person already has a track record at the studio.

J.K.: Upon graduation, are most of these aspiring assistants knowledgeable as far as what assisting involves?

S.U.: No, absolutely not. I think most photographers coming out of school aren't taught about being a good assistant. Assisting is something that you have to have inside of you, the desire to work for someone else and do a good job for them. I

think 95 percent of the schools produce such poor photographers that it's really sad. I had one assistant who worked for me for three months. Afterwards, he wrote a letter to his school saying he had spent four years at their school getting a photography degree and that he learned more in three months by assisting for a photographer.

I've had lots of assistants ask me whether they should go to a photography school or assist, and it's not a question that I can answer. It's an individual decision. Some people need to be in a school environment to learn, while other people don't need school at all, but just need to be exposed to the business. I feel the schools are totally inadequate in teaching potential photographers to go out into the marketplace. They teach nothing about the business end of photography.

Assistants are shocked and amazed when they see me politically work with a client to try to move them in my direction. They get out of school with stars in their eyes, thinking that all they have to do is make pretty pictures and people will pay them money. But shooting the pictures is no more than ten percent of the business. That's sad, but that's the way it is.

J.K.: Since you feel that the schools are lacking, do you feel that assisting is a better way to make the transition to professional photography?

S.U.: I think it's a totally individual decision. If someone feels they don't have the background, they can certainly get it by assisting. In addition, I feel they should assist with a lot of different photographers. On the other hand, there are individuals who come out of school who are psychologically ready to go be photographers. The decision has to come from within, but once the assistant makes that decision to turn pro, they make bad assistants because their head isn't into being an assistant.

I know I made a very poor assistant when I graduated from school. I assisted the last couple of years in school and also right out of school, and I'm the first to admit that I was the worst of assistants. I was totally convinced that I was a better photographer than everybody I assisted for. Instead of trying to get into the shoot and into the photographer's head, I'd wonder why the photographer was doing something a certain way. An assistant needs to be mentally into the shoot to help the photographer. After all it's the photographer's shot, not the assistant's.

J.K.: You said that you were a bad assistant because you felt you could do it better yourself. Did you keep your opinions to yourself and do you have any ground rules concerning what degree you want the assistant to interact with the client?

S.U.: I tell the assistant that if they have something to say and contribute don't hold back, but talk to me. I also give a tremendous amount of responsibility to my assistants. They are responsible for exposure and they run the front of my camera. This is because I want to be as focused as possible on producing the image.

Before I go out on a shoot I like to sit down with my assistants and look at the layout together. I draw diagrams on how I plan to do the lighting and where the camera is positioned. So when we get out there, they have an idea of what I want

to do. Later when we're on the set I not only tell the assistant to do something, but why I'm doing it. That gets them involved in the shoot. Afterwards, when we get the film back from the lab my assistant and I go over it together.

J.K.: With all the strenuous location work you do, do you have any preference in hiring male or female assistants?

S.U.: I've used both male and female assistants, however it can enter into who I select. I don't have any problems with using a woman in the studio, but on location when I'm lugging sixteen cases through airports I need someone who can really carry the load. As I mentioned I often use very large soft boxes and if they caught by the wind I need someone with strength to control them.

Another problem I run into is that clients don't want to pay extra for an additional room for a woman. On almost all my location shoots I go with two assistants and I get one room and they share the other. This isn't feasible if I take a female assistant.

J.K.: Since you take free lancers on location so often, how do you handle insurance?

S.U.: Free lancers are considered independent contractors in Minnesota. However regarding workmen's compensation, if an assistant is not self-insured, which most assistants are not, I have two options. One is to require a certificate of insurance from the assistant when they show up at the studio, but this is unrealistic. Or you can do what I do. I make an estimate of what I feel will be the number of free lancers I'll use. Then the state uses this figure to put on a monthly surcharge on top of my premium.

J.K.: When on location, do you pay your assistants the same as in the studio? **S.U.:** I usually kick it up. However, if I can guarantee them six straight days of work we may work out a flat fee. On the other side of the coin is the fact that I pay for all living expenses. I don't believe in per diems for the crew and I feel that whatever they want they get. If they want to go into the bar and drink \$100. to \$150. in booze or have filet and lobster every night, that's OK with me. I feel that's compensation for being away from home and working so hard on location.

J.K.: Can you recall any major mistakes caused by an assistant?

S.U.: It happened when I was just out of school. I had a small studio in Los Angeles and I was shooting for Sunkist oranges. At the time I didn't trust assistants and when the shot was almost where I wanted it, I went into the loading room to load film holders. When I walked out the art director told me that my assistant had approached him. The assistant had said that the next time he had a shot like this to come to him, and he could do it cheaper. I almost caught the assistant before he got out the door. That is the biggest social faux pas an assistant can make, trying to take your clients away from you right in the middle of the shoot.

As far as problems, I've had packs blow-up because assistants pulled out the

flash head cord without powering down, but you know that's just life. An assistant is going to make mistakes. One time I was doing a four-wheel ATV ad campaign and had worked hard for about three days before there was a lull in the action. An assistant asked if he could take one of the vehicles for a spin. Unfortunately he rolled it on a gravel road, but the worst part was that he lost a lot of skin and was hurting real bad. I felt so sorry for him, and he still worked for another two days.

J.K.: Of the assistants that you work with, what percentage make a successful transition to professional photography?

S.U.: I'd say maybe ten percent. I've been told the photographers list for Minneapolis has about four to five hundred photographers, but I can probably name only about the top ten. This number must include photographers doing work at all levels. But it's a tough field, no doubt about it.

J.K.: You've mentioned shooting cars, motorcycles, boats, about everything that moves, do you still use a view camera for moving subjects?

S.U.: Sure, that's why I carry those large soft boxes and use strobe. In fact that's how my first snow mobile campaign came about. The client wanted me to stop a snow mobile. They said nobody could stop a sled, but I stopped it. I built a huge bank of lights and the snow mobile came roaring through the frame and I nailed the shot. After I pulled the Polaroid I handed it to the art director, but he said it was too frozen, so I had to put some movement back into it. On a large subject like that I carry about 20,000 watt-seconds of power.

J.K.: Do you usually bring your assistants from Minneapolis, or do you find them at the site?

S.U.: I bring them with me. Every once in the while I'll find a second assistant at the site, but I only do this if I have a lot of logistical problems. For instance, I was out in Los Angeles and I had a lot of running around to do. I'm a member of ASMP and I'll call out and get a recommendation from an ASMP member. This works well because the assistant will usually have their own car and they know the area. However, I'll usually only do that if it's a bigger market like LA, Chicago, and New York.

J.K.: Any parting advice for aspiring assistants?

S.U.: I'd love assistants to get back into the love of photography. I got into this business because I love photography. So many of the assistants I see now don't seem to have that passion. When I got out of school I wanted to be an assistant and I didn't care how much it paid me. I would assist with somebody because I wanted to watch them shoot and I wanted to learn. But now I meet assistants who walk in the door and ask about my pension plan and insurance coverage. I see assistants who are coming out of school and want \$100. per day and they deserve \$25. It turns me off, but it's a trend I see. I'm more than happy to pay a fair price, but if 80 percent of the conversation is about money I'm probably not going to hire them.

Artificial Lighting

very large proportion of assisting jobs involve the use of artificial lighting. Or more precisely, lighting supplied by the photographer. By providing the light source, the photographer gains a level of control over the photographic environment. The choice of light source and how it's manipulated, is influenced by the assignment and current trends.

Artificial lighting and assistants go hand-in-hand. There are several reasons for this. To artificially light something requires equipment. Most professional lighting systems consist of heavy power supplies and numerous flash heads. Devices to modify this raw light are equally important. Soft boxes, umbrellas, reflectors, and fill cards are used routinely. All of it supported with various stands and clamps.

And of course, the photographer needs a continuous supply of Polaroid instant film, to evaluate changes in lighting. The amount of lighting equipment and the time spent working with it, are not fully appreciated by those unfamiliar with professional photography.

Compare and Contrast

There are two basic kinds of light sources available to the photographer. These are electronic flash and tungsten. The two systems are very different in many ways and are best discussed separately. But to appreciate their unique qualities, a little compare and contrast is in order.

Electronic flash equipment, or strobe produces a daylight balanced light.

It's referred to as daylight balanced because the flash of light resembles natural daylight. Although difficult to discern with the naked eye, daylight is basically blue in color and has a *color temperature of 5500 degrees Kelvin*. For daylight balanced film to reproduce daylight so it looks natural to the eye, the film needs to be fairly warm or yellow in color.

Tungsten lighting is produced from a continuous light source, usually a quartz or incandescent lamp. It has a yellowish or warmer light, and it's color temperature is 3200 degrees Kelvin. When using tungsten lights, you use tungsten balanced film. This film has a cool, or blue color to it. Using tungsten film with electronic flash, results in an overly blue cast to the film. Using daylight balanced film with tungsten lighting, results in a very yellowish cast to the film.

Besides color temperature, the two kinds of lighting are different in another basic way. Electronic flash systems produce very little heat when they flash. This allows light modifying devices to be placed around the flash head, and to be positioned close to the subject.

On the other hand, a tungsten light remains on continuously and the high wattage lamp quickly gets very hot. This heat restricts the use of many light modifying devices and limits how closely the light can be positioned to the subject. Ultimately, this influences lighting technique and styles. Regardless of light source, its control is arguably the most critical aspect of excellent photography.

The Electronic Flash System

Currently, electronic flash or strobe is the lighting of choice for the majority of professional photographers. The electronic flash system presented here, is very different than the on-camera flash unit associated with a 35mm SLR camera. This is a modular system, consisting of a power supply, flash heads, and assorted light modifying devices. An approach which provides great flexibility, allowing it to be used in almost every lighting situation.

The Power Supply

The heart of the system is the power supply or power pack. To this, you connect one or more flash heads. Basically, the power supply is a large battery or *capacitor*. It's plugged into an electrical outlet and when switched on, the capacitor charges. After the capacitor is fully charged, it can be discharged. The stored electricity is released through the flash head in one very brief, but powerful flash of light. The capacitor then recharges.

The amount of electrical energy or light, a particular power supply can produce is designated in watt-seconds. A *watt-second* is the work done by one watt, acting for one second. Therefore, larger power supplies produce more watt-seconds of energy in the form of a flash.

The number of watt-seconds is the most important figure, regarding power supplies. Small power supplies deliver a maximum of 800 watt-seconds per flash. Moderate units range from 1600 to 2400 watt-seconds. Power supplies producing 4000 watt-seconds are very powerful.

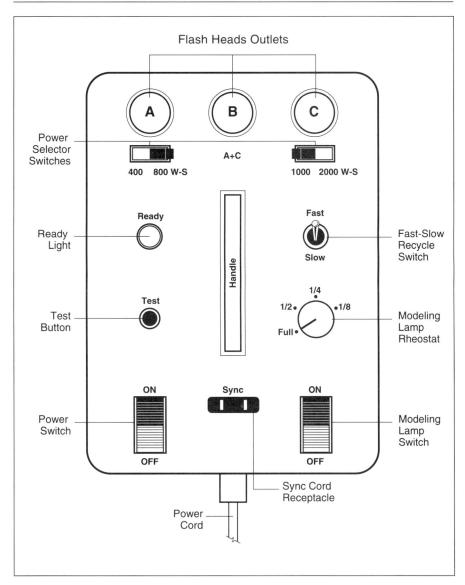

Power supply for electronic flash system.

Operating the Power Supply

The key features regarding the operation of a power supply are quite similar among the varying manufacturers. The power supply is plugged into a standard electrical outlet. All power supplies have an *on-off switch*, and when switched on, the capacitor charges. This takes several seconds, and the capacitor is fully charged when the ready light comes on.

For the assistant, the ready light is one of the most important items on the pack. First, it signals that the capacitor has fully charged. In addition, when the capacitor discharges or fires, the ready light goes off. It comes back on when the capacitor recharges. The time it takes to recharge is the *recycle time*.

The Recycle Time

Tracking the recycle time using the *ready light* is critical, especially when working with a fast shooting photographer. Even though the power supply hasn't fully recharged, it will still fire. Unfortunately, the resulting flash won't be at full power. The photographer can shoot fast and furious, but the film will be under exposed.

Out pacing the power supply's recycle time is possible with most roll film cameras, and even more so when a motor drive is used. Observe the cadence at which the photographer routinely advances and exposes the film. When it becomes faster than the power supply's recycle time, the photographer must be told to slow down. During breaks in the action, the photographer will often ask whether the pack has been recycling fast enough. Be sure you know it has been.

Factors Affecting the Recycle Time

Several things affect the length of the recycle time. Most packs have *fast* and *slow recycle switches*, often designated with the figures of a rabbit and turtle. As you'd expect, the fast recycle setting makes the pack recharge more quickly. The slow recycle setting can be useful in older buildings, by putting less strain on the electrical system and reducing the likelihood of blown fuses.

Another factor influencing the recycle time is the power setting, relative to the pack's total power output. For example, when a 2400 watt-second (w-s) power supply is adjusted to deliver 400 w-s to a single flash head, it will recycle almost immediately. When set to deliver a full 2400 w-s, the pack may require three to four seconds to recharge.

Finally, the use of excessively long extension cords can lengthen the recycle time. This extra wire translates to greater resistance. I've discussed the recycle time with the ready light because they're universal. But in addition to the ready light, audio signals are found. In other systems, the flash head's modeling light becomes dim or flickers, until the power supply has recharged.

Adjusting the Power

It's essential that the power supply can be adjusted to deliver varying amounts of power to the flash head. Although all packs are rated in watt-seconds, determining the power setting is far from universal. Also, a power supply can accomodate from three to six separate heads. Many times, additional heads just complicate the situation.

The simplest arrangement is when one flash head is plugged into one socket, and a single switch is used to adjust the power. When set at maximum, the unit might deliver 2000 watt-seconds of power to the flash head. When switched from 2000 w-s to 1000 w-s, power is reduced by fifty percent or one f-stop. Conversely, switching from 1000 w-s to 2000 w-s doubles the power or increases it by one f-stop.

The assistant may need to adjust the power at anytime. Reducing the output from 2000 w-s to 1000 w-s can be as easy as flipping a switch. But with some packs, you must then discharge the power supply of its 2000 w-s,

and let it recharge to 1000 w-s. If you don't, the first exposure will be over exposed by one f-stop. When in doubt use the test button to discharge the pack, after decreasing the power. However, increasing power from 1000 w-s to 2000 w-s doesn't require this step, just wait for the ready light to come back on.

The number of flash heads plugged into the power supply also influences the power output. Again, imagine one flash head attached to a power supply, set at full power or 2000 w-s. However, when two heads are connected to the pack, the total power must be divided between the heads, possibly 800 and 1200 watt-seconds. Adjusting power among several heads is accomplished by plugging the flash heads into the appropriate sockets, coupled with the use of switches.

On rare occasions, a power supply can be too powerful. Perhaps 400 ws is the lowest setting, but the shot calls for a mere 200 ws. You can often decrease the power further, by connecting a second flash head to the same power supply. This results in 200 ws going to each flash head. The unused flash head is placed well off the set, so it doesn't affect the shot. Some refer to this procedure as *bleeding-off* power to a second head.

The design of the power supply and the procedure used to adjust its output varies with manufacturer. This can influence how the assistant annotates the Polaroid print. When working with some packs, noting that "1000 watt-seconds" is going to head number one, is most logical. With others, it makes more sense to note the power relative to maximum power, such as "full power" and "half power." Still others might dictate, "full power" and "full -1 stop."

Synchronizing the Power Supply to the Camera

A power supply must be designed to discharge while the lens shutter is open. The duration of the flash is less than 1/500 of a second, and the shutter might remain open 1/60 of a second. These two events must be synchronized.

There are several ways to synchronize the shutter and power supply. The most common is to physically connect the two with a sync cord. The *sync cord* is connected to the power supply's *sync cord receptacle*, using what resembles a household electrical plug. The sync cord's other end is connected to a socket, on either the camera body or lens. Regardless of camera format, this connection is the same.

Attach the sync cord to the camera or lens by carefully pushing the sync cord plug directly into the socket. The sync cord and this connection is one of the more fragile links in the system. To minimize the pull on this delicate connection, drape the remaining cord over a tripod handle. Or better yet, loosely tie a loop in the sync cord and suspend that from the tripod.

Once the sync cord is attached to both the power supply and camera, set the lens shutter speed to the appropriate *sync speed*. A setting of one-sixtieth of a second is a safe choice. When the shutter speed is set too fast, it may not capture the entire flash. When the shutter speed is too slow, light from the strobe's modeling lamp may influence the exposure. If the shutter has an X-M setting or sync terminal, use the one designated X, for electronic flash.

Before leaving the camera area, position the sync cord so it's protected from traffic. In heavily congested areas, it may need to be taped to the floor. Due to their fragile nature, most photographers pack a spare sync cord when going on location. It's your responsibility to make sure it's in with the gear.

The Master and Slave Power Supply

As stated, the lens shutter is connected to the power supply by using a sync cord. This power supply is now designated the *master pack*. However, often more than one power supply is utilized. Under these circumstances, each additional power supply is referred to as a *slave*.

Each slave power supply must also discharge at the appropriate time. This is accomplished with a flash slave. A *flash slave* is a small, light sensing device, which is plugged into the power supply's sync cord receptacle. When the master power supply is triggered, the resulting flash of light is detected by the flash slave and the slave power supply triggers.

Testing the System

After any flash slave is plugged in you must verify that it's working. To test that a flash slave is functioning properly, turn on both the master and slave power supplies. After their ready lights come on, go to the master pack and find the test button. This is often designated with a bolt of lightening.

Depressing the master pack's *test button*, causes it to discharge and its flash head to fire. If the flash slave is detecting light, the slave power supply discharges. Monitor the ready light on the slave power supply. Immediately after the power supply discharges, the ready light goes out.

If the slave power supply fails to discharge, make certain the flash slave is receiving plenty of light from the master pack. These are sensitive devices, but they do impose limitations on where the power supply is placed. If the flash slave is receiving sufficient light, but still doesn't fire, unplug the flash slave, rotate it 180 degrees and plug it back in. Most flash slaves will function only when inserted into the sync cord receptacle, one of the two possible ways.

There are times when it's impossible to position the slave power supply, in such a way that the flash slave detects sufficient light. Under these circumstances, the flash slave can be connected to the end of any extension cord, then placed in an effective location. This technique is especially useful on architectural shoots, utilizing many well hidden power supplies.

If you encountered any difficulties in getting any of the power supplies to discharge, avoid rearranging them once positioned. And, never move any power supply fitted with a flash slave, just before going to film. Flash slaves are another essential item that must make it to the location site. They are often left plugged into the sync cord receptacle, so be careful during the transportation process.

Radio Transmitters and Receivers

Because of the inherent limitations imposed by physically connecting the shutter to the power supply the sync cord is often replaced. The most common means is with a radio transmitter and receiver, also called a *radio* *slave unit*. Here, the transmitter is connected to the lens shutter with a short sync cord. The transmitter then hangs from the tripod. Next, a receiver is connected to each power supply, via the sync cord receptacle. As the photographer trips the camera's shutter, a radio signal is sent from the transmitter to the receiver, and the power supply discharges.

Although radio slave units are relatively easy to operate, a few points need to be remembered. First, they require batteries and the units must be turned on and off. Also, most radio transmitters have more than one channel. You must switch the transmitter and each receiver to the same channel.

Safety

Keep in mind that power supplies store and quickly release, a considerable amount of electrical energy. To state that electrical equipment should be kept clear of water is almost too obvious, but it's amazing at the conditions studio photographers can conjure up and location photographers encounter

Be aware that there are procedural differences between manufacturers, as to their exact operation. Before plugging in a power supply, make certain it's turned off. Do not discharge the capacitor, until it has fully recharged and the ready light is on. Also, with many units it's a good idea to power down, when connecting and disconnecting flash heads. When in doubt, ask.

The Flash Head

It's time to turn our attention to the flash head. Each flash head is connected to the power supply with a *cable*. The connection is specific for each manufacturer, necessitating the use of the same flash head and power supply. Cables are quite sturdy, but you shouldn't coil them too tightly or allow gear to be set on them. Extension cables are available, but they reduce power going to the flash head. If required, inform the photographer so the power setting can be increased accordingly.

The Flash Tube and Modeling Light

Each flash head consists of two different light sources, the flash tube and the modeling light. The *flash tube* produces the daylight balanced flash of light, that's used to expose the film. The bulk of the power supply and its adjustments are related to the flash tube. These include the capacitor, ready light, fast-slow recycle, sync cord receptacle, and power settings.

The *modeling light* is a tungsten lamp. It's situated next to the flash tube and is designed to remain on continuously. The modeling light provides a general idea as to how the flash will look on film. Most are sufficiently powerful that they're the only light needed to focus the camera and work on the set.

To be of greater value, modeling lights are often controlled with a *modeling lamp rheostat* or *dimmer*. Found on the power supply, this dial lets the photographer adjust the lighting ratio between two modeling lights. But more importantly, the rheostat allows the modeling lamp to be set to a very low level. While still useful, a lower setting generates less heat.

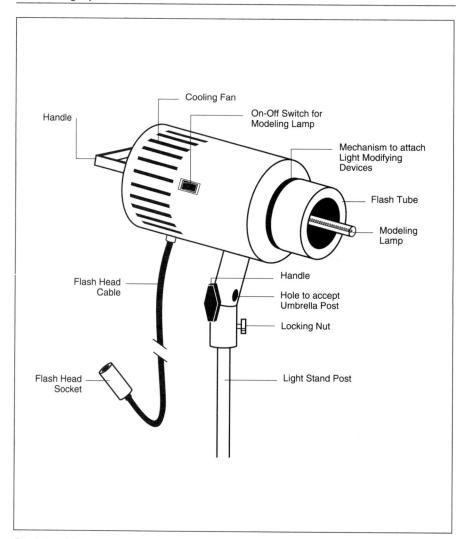

Flash head for an electronic flash system.

The Cooling Fan

To dissipate heat most flash heads have a cooling fan. Excessive heat is a potential danger, when using light modifying devices that restrict air flow. These include smaller soft boxes, snoots, and reflectors with colored filters or diffusion material attached.

Don't assume the cooling fan to be completely effective. If you sense that heat may be a problem, monitor the situation. The modeling light may need to be kept very dim, or kept off most of the time. When there isn't a cooling fan, you must be even more careful. At the end of the shoot, turn off the modeling light. Let the fan run, so as to cool down the entire flash head.

Care and Handling of Flash Heads

It should be apparent that all photographic gear must be handled carefully, flash heads even more so. Though fairly rugged, they're largely glass. A modeling lamp is expensive, but a flash tube is extremely expensive. Limit working with unprotected flash heads. At the very least, attach a small reflector.

If a modeling lamp or flash tube fails to work, turn off the power supply. Then, using a towel so as not to touch the glass directly, make sure it's firmly seated. Using a towel is important because oils from your fingers can become deposited on the flash tube or modeling lamp. These oils can create uneven heating and a shorter life span. It's inevitable for equipment to get bumped around and lamps can work loose.

Multiple Flashes

Under most conditions, the modeling light can remain on for the entire shot. It has no affect on the exposure, unless the photographer is using a very long shutter speed. When necessary, the modeling light can usually be switched off, either at the power supply or at the flash head.

Conditions requiring modeling lights to be turned off, usually dictate that all nearby lights are also turned off. Here, the photographer might require *multiple flashes* or *pops*, in order to produce enough light to properly expose the film. The photographer opens the shutter and the assistant uses the test button to discharge the power supply. Refire the pack only after the ready light has come back on.

The total number of flashes is critically important. Too many and the film is over exposed, too few and the film is under exposed. When more than a couple of flashes are required, keep count aloud. This helps you keep track and signals the photographer when to close the shutter.

Minor Points

Here are a few minor features associated with flash heads. Most of the time flash heads are inserted onto the end post of a light stand, then secured in place with a thumb screw. A second knob is used to tilt the head to the desired angle. When in use, these knobs must be tightened to prevent the flash head from changing position or falling off the stand. Flash heads are designed to accept a wide range of light modifying devices. These, and related items will be discussed later.

Monolights

There is an electronic flash system that differs from the one just presented. This is the monolight. Here, the power supply and flash head are combined into one unit. Monolights resemble a standard flash head, only larger. Although these units have less output than systems containing separate power supplies, they can be more convenient. Adjusting the power output is simplified, and the cable connecting the power supply to the flash head is eliminated. Otherwise, the two systems are quite similar in principle and operation.

Summary of Responsibilities Related to Electronic Flash Systems

☐ Obtain a general idea of the <i>lighting requirements</i> for the shot.
$oldsymbol{\square}$ Position the <i>power supply</i> in an unobtrusive spot, close to the set.
☐ Connect the power supply to a grounded electrical outlet, first making certain it's <i>turned off</i> .
\Box Put the <i>flash head</i> on a light stand, then connect it to the power supply
☐ Attach the light modifying device specified by the photographer.
\square Place the light at the approximate position on the set.
☐ Connect the <i>camera</i> 's <i>shutter</i> to the power supply's sync cord receptacle, via the sync cord.
$oldsymbol{\square}$ Set lens shutter to the appropriate $sync\ speed$, usually 1/60 of a second
☐ Switch on the power supply and modeling light, making certain the <i>ready light</i> comes on.
☐ <i>Test fire</i> the system to be certain each flash head is firing. Observe both the flash head and ready light.
☐ When more than one power supply is being used, make certain the <i>flash slave</i> is operating, and the slave power supply is discharging.
☐ Position yourself at the appropriate power supply, during the <i>flash metering process</i> . Discharge the power supply using its test button.
☐ Generally, tend to film related responsibilities during the exposure process. Occasionally reaffirm <i>that all flash heads are firing</i> .
☐ If the shutter is to remain open during the exposure process, turn off the modeling light. If <i>multiple pops</i> are required, remain near the master power supply, and discharge the power supply using its test button.
☐ Throughout the day, monitor flash heads for <i>excessive heat</i> . Adjust modeling lights accordingly, using the rheostat or the on-off switch.
☐ Expect to work with lighting equipment and related hardware, throughout the day.
☐ After the film is exposed, turn off the modeling light and allow the fan to <i>cool the flash head</i> .
☐ When cool, place a <i>flash tube protector</i> on the flash head, loosely coil the cable, and store it.

On-Camera Electronic Flash Units

There's often less need for assistants on jobs utilizing the 35mm SLR camera. One factor that greatly increases that need is a reliance on artificial lighting. It may take the form of the powerful electronic flash systems just discussed, or it might mean working with the *small flash units* that attach directly to the camera.

Due to the relationship between a camera's film size and lens focal length, small format cameras provide more depth of field than large format cameras, when lenses of comparable focal length are set to the same f-stop. Consequently, 35mm SLR cameras require less light to make an exposure, and can utilize on-camera flash units. One reason for using smaller format cameras is their overall portability and ease of handling. Small, on-camera flash units are designed to keep them that way.

The Different Kinds of Flash Units

Smaller on-camera flash units are far from universal in design and operation. This is partly due to the tremendous variability in 35mm SLR cameras, in general. There are *manual flashes*, somewhat analogous to the larger electronic flash systems. While *automatic flash units* control the flash, and hence the exposure. Still others are designed to interface only to specific cameras. These *dedicated flash units* have the potential for even more features.

This variety, coupled with the fact that you will work with them less often, makes the learning process more awkward. What is presented here are the areas of operation most important to the assistant. Like any equipment, the photographer makes the decisions concerning the flash unit's setting. The assistant must know enough to make sure these settings remain as desired.

Operating a Flash Unit

On-camera flash units connect directly to the 35mm SLR camera's *hot shoe*. Flash units can also be supported on a handle mount or held by the assistant. Any distance is bridged with a sync cord. When more than one flash unit is incorporated into the system, several cords and adapters are needed. Be sure you understand the arrangement of all cables.

These items seem particularly vulnerable on smaller flash units. When the assignment calls for plenty of activity, sync cords and their connections need to be checked and rechecked throughout the day. This is most important when the assistant is holding a flash unit. If necessary, loose connections can be taped closed. It's also possible to tie a square knot, in such a way that the connection is protected within the knot.

The assistant must track the *recycle process*, because the unit can flash while still recharging. Unfortunately, the flash won't have sufficient power, resulting in under exposed film. It's easy for the photographer to outpace the recycling time. It becomes even easier as the batteries begin to run down and recycling time increases. In addition to a ready light, flash units often use an audio signal. Most commonly, a buzzer remains on during the recharging process.

Determining the Exposure

Like larger flash systems, there are ways to adjust the power output. However, smaller flash units are rated by a *guide number* (GN), not watt-seconds. The larger the guide number, the greater the power. A guide number of 70, represents a lower powered flash, while a flash unit with a guide number of 150, is fairly powerful. By performing a calculation, the flash unit's guide number lets you determine the proper exposure.

There are three variables: film speed, lens aperture, and flash to subject distance. Dividing the flash unit's guide number by the desired lens aperture, results in the correct flash to subject distance. Conversely, dividing the flash to subject distance into the guide number, results in the correct lens aperture setting. Performing exposure calculations supply basic information, but the use of a flash meter and Polaroid instant film is far from excluded.

Automatic Flash Units

The simplest arrangement is when an automatic flash unit has only one setting. Here the lens aperture is determined by film speed, and faster films allow for smaller apertures. To increase versatility some automatic units offer a choice of f-stop settings, versus one determined by film speed. While more sophisticated units allow you to vary the power output when switched to the manual mode. The assistant should note how the controls are set and make sure they remain that way. Incorrectly set switches cause errors in exposures.

For an automatic flash unit to control the exposure, it must be able to sense the flash of light reflected off the subject. The unit then turns off the flash at the appropriate time. This is accomplished with an *exterior photo cell*, located on the front of the unit, and internal thyristors. However, for it to function, the photo cell must remain unobstructed and be positioned so as to detect reflected light.

The photo cell is of little concern when the flash unit is attached to the camera or a handle mount. It's a different situation when held by the assistant. There are several important points to remember when hand holding a flash unit. As mentioned, the exterior photo cell must remain unobstructed, and be pointed towards the subject to detect the returning flash.

At the same time, the flash must be positioned so it produces the proper lighting effect. Balancing these placements requires concentration. But there's more. The assistant must note that the flash is firing, and that it's fully recharged before the photographer makes another exposure.

Batteries and Battery Packs

To produce light, flash units require a battery. This can be a disposable battery, or a specialized rechargeable battery pack. Whichever is used, the flash unit must be switched on. This causes the battery to charge the capacitor. Once fully charged, the ready light comes on.

Any battery powered system has the potential to run down, quickly putting a halt to shooting. To increase capacity, rechargeable battery packs are

often used with smaller flashes. *Supplemental battery packs* provide more flashes and shorter recycling times.

Some form of indicator is used to inform the assistant how much of a charge remains on the battery. When necessary, these units are recharged utilizing standard electrical outlets. However, specialized items are used in recharging, so inquire as to their need before leaving the studio.

During busy shoots, make note of potential opportunities to recharge. If the need arises and a suitable situation presents itself, set up quickly. Recharging might require every minute of your lunch break. If you find yourself working in a cold environment, try to keep the battery pack warm. Cold batteries are less effective.

Light Modifying Devices

Relatively few light modifying devices are utilized with small electronic flash units. Those that are, often consist of small reflectors. These attach directly to the unit, and bounce or direct the light more effectively. Diffusion material can also be placed over the flash, in an attempt to soften the light. Small soft boxes and umbrellas, similar to those associated with larger systems are used infrequently. Many light modifying devices absorb light in the process, thus reducing a rather limited light source even further.

Summary of Responsibilities Related to On-Camera Flash

■ Establish with the photographer how the flash unit is to be adjusted, and make certain all switches remain as desired.
☐ Understand all <i>sync cord connections</i> , and monitor these throughout the day's shoot.
☐ Before going to film, turn the flash unit on and observe the <i>ready light</i> .
☐ Monitor the actual flash of light, in addition to the ready light, during the <i>exposure process</i> .
$\hfill \square$ \hfill \hfill Hand \hfill automatic flash units so you don't obstruct the photo cell.
$\hfill \Box$ Position automatic flash units so the $\it photo\ cell$ can detect the reflected light.
☐ Monitor the <i>low battery indicator</i> . If necessary, recharge the supplemental battery pack or replace the batteries.
\square <i>Turn off</i> flash unit when it's not needed.

Tungsten Lighting

Electronic flash represents one of the two basic types of artificial light sources. The other is tungsten. Although tungsten lighting is less popular among today's still photographers than electronic flash, it does offer unique qualities. These differences influence how it's used and the assistant's responsibilities.

In many ways, tungsten lighting is easier to operate than strobe. Basically, the light consists of a *light bulb* enclosed in a metal housing. This unit plugs into a standard electrical outlet. There isn't a separate power supply, and few if any adjustments. What little there is, involves the lamp or light bulb.

Besides being far simpler to operate than electronic flash, there are other advantages. A tungsten light source is much less expensive to purchase. In addition, a continuous light source makes it easier to evaluate the lighting arrangement. What you see, is what you get. Even so, the assistant should expect to use Polaroid instant film. The constant light also eliminates the need for a sync cord and flash slaves for additional power supplies. Fewer components means less to go wrong and less to transport to a location site. Just remember to bring spare light bulbs and plenty of extension cords.

The Tungsten Lamp

There are two basic kinds of tungsten lamps, halogen and incandescent. Both produce a warm, yellowish light and have a color temperature of 3200 degrees Kelvin. Like most household light bulbs, tungsten lights are rated in watts. However, photographic lights are much more powerful, usually ranging from 250 watts to 1000 watts.

The fact that these high wattage lamps remain on for long periods has several implications. The most important is heat. Tungsten lights get hot, hence the common name, *hot lights*. Heat influences how they're handled, the selection of light modifying devices, and what can be photographed.

Operating a Tungsten Light

A tungsten light is fairly easy to operate. Usually, a switch turns the unit on and off. But to handle it safely means taking a few precautions. Before turning on a tungsten light, place it on a stand. The light gets hot almost immediately, and can be difficult to handle or safely set down.

A tungsten light is also very bright, an instant intrusion on the set. So have it properly positioned, making sure it's kept well away from flammable materials. A pair of leather work gloves can be indispensible when the job is reliant on tungsten lighting. Being able to clip the gloves to your belt is another plus.

Controlling Tungsten Light

The overall shape of the housing unit does much to control the tungsten lamp. Those designed to illuminate a large area are often referred to as *flood lights* or *broad lights*. Those with a concentrated beam are *spot lights*. Lights capable of adjusting from a flood to a spot are called *focusing lights*.

To control the light further, various styles of *barn doors* and *leafs* are available. Many of the light modifying devices utilized with electronic flash can't be used with tungsten lights, at least not in the same way. It could be disastrous to enclose a 1000 watt halogen lamp within most soft boxes, or tape a colored filter over it. Although some soft boxes are specifically designed for tungsten lights, tungsten lights still require adequate ventilation. Diffusion material and colored filters must be positioned well in front of the light source, often supported in a filter frame.

Applications

The specific assignment can dictate whether electronic flash or tungsten is used. Due to the relatively long shutter speeds associated with tungsten lighting, it's very difficult to freeze unwanted motion. However, this can be an advantage. Whereas the brief duration of a flash freezes movement, a tungsten light can be used to convey a sense of motion. This is because a long exposure is combined with a constant light.

Architectural photographers often employ tungsten lighting. They may not have any control over the lighting found at a site, or it may involve a very large area. Under these circumstances, it can be more practical to add more of the same kind of light, rather than trying to integrate several different kinds. A combination of color compensating filters are routinely part of the solution, but require still longer exposures.

Although tungsten might not be incorporated into the lighting arrangement, it's still used in the studio. Tungsten lights can aid in focusing, especially of view cameras. The light produced by a strobe's modeling light, isn't always sufficiently bright to critically focus the camera. In addition, surfaces lacking texture or sharp edges, often require even more care when focusing.

Lens selection can also add to focusing problems. A 300mm, f9, large format lens lets in less light and is more difficult to view, than a wider angle 150mm, f5.6, lens. To aid in focusing, position the light in front of the camera, so it doesn't interfere with viewing the ground glass. Once on, remain near the light. It'll probably need to be turned off soon afterwards. Finally, the heat produced from tungsten lights can speed the drying process of paints and glues. However, don't place it too close to the treated surface and change its position frequently.

The Photographer's Assistant

Working with Light

ighting is so critical to good photography, that it's difficult to overstate its importance. While assisting, you'll be exposed to a diversity of lighting styles and equipment. However, to best work with light, it's important to gain a better understanding about how light behaves and it's different qualities. The proper use of the light meter is part of the process, another is the choice of light modifying device.

Qualities of Light

The photographer is responsible for the exact positioning of a light modifier, but the assistant is often involved with its placement. To help understand the photographer's intent and why something is being positioned a certain way, it's important to be familiar with an important law governing light. This states, the angle of incidence equals the angle of reflectance.

In simple terms, light hitting a surface at a certain angle will be reflected from that surface at the same angle. For example, a billiard ball striking the cushion at 45 degrees, will bounce off at 45 degrees. To most accurately review the results, position your eyes as near to the camera lens as practical.

There are two important terms referring to the quality of light. These are specular and diffuse. The size of the light source, relative to what is being lit, controls these qualities. The smaller the light source, the more specular the resulting light. Conversely, The larger the light source, the more diffuse the light.

Specular light tends to yield very sharp shadows, and is sometimes re-

ferred to as hard or harsh. The light from the midday sun on a cloudless day is very specular. The opposite of specular is *diffuse light*. Here the light source is very large, and the resulting shadows are less well defined. The quality of light might be described as soft. The sun hidden behind a homogenous cloud cover produces very diffuse light.

Light Modifying Devices

The ability to shape light, in order to produce the desired affect, is often the photographer's most valuable asset. In an attempt to control and modify light a photographer employs many different techniques. One aspect is the selection and use of various *light modifying devices*. These include reflectors, umbrellas, soft boxes, and fill cards.

If you're not familiar with the more common light modifying devices, I suggest you browse through an assortment of professional equipment catalogs. Equipment catalogs contain a tremendous array of equipment and information, related to lighting. Few photographers utilize all of it. Most develop a certain style or area within photography that's best served by certain equipment.

There are several categories of light modifying devices. Almost all can be used with professional electronic flash systems, but only to a limited extent with tungsten lighting. Tungsten doesn't allow the same degree of flexibility, especially when it comes to attaching accessories to the light itself. Fortunately, most basic assisting responsibilities are identical, regardless of the light source.

Reflectors

The most basic light modifying device is the reflector. This bowl shaped accessory comes in various sizes. With electronic flash systems, reflectors are designed to be *interchangeable*. They attach directly to the flash head, using some form of bayonet style or latching device. The exact mechanism is specific to each manufacturer, necessitating that the reflector and flash head be from the same manufacturer.

On the other hand, most tungsten lights are not designed with interchangeable reflectors. You purchase a light which provides the desired angle of coverage. This is a viable approach because tungsten lighting is much less expensive than an electronic flash system.

Reflectors are so fundamental, they're found in every studio. An unaltered reflector helps contain the light and redirects it in the form of a broad circle, usually 50 to 100 degrees wide. When only a reflector is attached the resulting light is very specular in nature.

Photographers are always altering the bare flash tube, a *point source*, in order to produce a more diffuse light. Therefore, reflectors are often used in association with some other light modifying device. Reflectors are also placed on the flash head, to protect the flash tube and modeling lamp. If flash tube protectors are available, reflectors can be hung on a wall or stacked on a shelf.

Umbrellas

Umbrellas are another common lighting tool. They produce a more diffuse light, when compared to a flash head with a reflector. Umbrellas are inexpensive and very effective at lighting large areas. Umbrellas vary in size, shape, and material. However, most are octagonal in shape, with a reflective white or silver interior surface. Some umbrellas are made with a translucent white material. Instead of reflecting the light, it passes through the material, somewhat like a soft box. Regardless of the exact configuration, all umbrellas are attached to the light the same way.

Using an Umbrella

To use an umbrella, place a medium sized reflector on a flash head. These reflectors often have a one inch diameter hole, to accomodate the *umbrella shaft*. The flash head is attached to the light stand, so it faces towards the inside of the umbrella. The light is reflected or bounced back out, and in the process becomes more diffuse.

The umbrella is opened up like an umbrella used for rain. It's then attached directly to the flash head. A hole is provided on the flash head, just above the point where it connects to the stand. The umbrella's shaft is slid through this hole and secured in place using a thumb screw. It's important not to over tighten this screw, as the shaft is easily dented.

To find the point along the shaft at which to attach the umbrella to the flash head, locate the largest grouping of dents along the shaft. Or, turn on the flash head's modeling light and position the umbrella so that light fills the umbrella's dome, but little escapes beyond the its edges.

The modeling lamp can remain on while using an umbrella. However, excessive heat usually limits its use with tungsten lighting. When not needed, the umbrella is collapsed and stored in a protective sleeve. This keeps it clean, tear free, and allows it to be hung up for storage.

Diffusion Material/Colored Filters

Diffusion material is translucent white in color, but varies widely as to the type of material. Most often, it's a flexible plastic sheet coming in long rolls about one yard wide. Diffusion material can also be nylon fabric, even something as simple as a bed sheet or tissue paper. The amount of diffusion material needed depends on the photographer's solution. *Colored filters* are made from a transparent, flexible, plastic material. They come in a wide variety of colors and are generally used in smaller pieces. However, both materials are handled the same way.

Using These Materials

Diffusion material and colored filters can be held in a filter frame, or more simply, taped directly over the reflector's opening. When attaching either material this way, make sure it covers the entire reflector. It must yield an even effect across the entire angle of coverage. To ensure adequate ventilation, it shouldn't be a tight fit. When practical, leave gaps between the material and the reflector to assist in cooling.

Once the material is attached, it's important to monitor the flash head

for excessive heat. These materials will melt. If the modeling lamp can be controlled with a rheostat, it's often best to keep the modeling lamp at a lower setting or turned off when not needed. Concern is even more critical, when using a flash head without a cooling fan. When monitoring for heat check the adhesive tape, it can fail at the worst time.

At times, a small reflector called a *snoot*, is used. It has a very small opening, which emits a form of spot light. Due to its restrictive design, overheating is a real problem. And almost guaranteed, if diffusion material or a colored filter is taped over its small opening. Here, the modeling lamp should remain on only when the light is being positioned.

At the other extreme, a large *light bank* can be quickly and inexpensively fabricated from diffusion material. You simply suspend a large piece of diffusion material from a cross bar. The cross bar is supported by two heavy stands. Lights with reflectors are then placed behind the material. This arrangement produces a fairly diffuse light.

Diffusion material and colored filters are also used with *tungsten lights*. But due to the heat, the material is placed well in front of the reflector, held in a metal filter frame or supported by a light stand. Because of this increased distance, larger pieces of material are required to ensure adequate coverage. Most diffusion material and filters are quite flexible. They are easily rolled up, then placed in a cardboard mailing tube for storing. Unlike lens filters, these can become quite ragged and yet be functional.

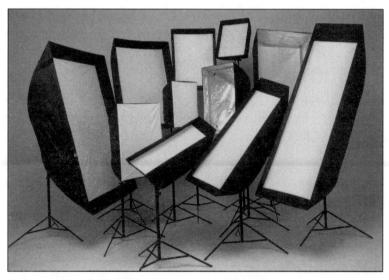

An assortment of soft boxes. Photo courtesy of Chimera Photographic Lighting.

The Soft Box

The soft box is one of the most popular lighting tools. It's designed to produce a very large and evenly distributed light source. The resulting light is diffuse in nature. A soft box resembles a dome shaped tent. The flash

head is positioned at the "tent's" apex and is directed inside. The tent's interior walls are made from a reflective material, usually silver. The exterior walls are of black fabric. What would be the tent's floor is made from white diffusion material. Whereas an umbrella bounces light, you direct the light through the diffusion material when using a soft box.

A soft box can be square, rectangular, or circular in shape. The translucent, light emitting area measures approximately one by two feet in a smaller box, and four by six feet in a larger one. A long, narrow soft box is often called a *strip bank*.

A soft box can be a permanently constructed unit, either professionally manufactured or built by the photographer from foamboard, diffusion material, and tape. However, the most common soft box is the *collapsible unit*. It's light weight, quickly assembled, very transportable, and fairly inexpensive.

Assembling a Soft Box

A collapsible soft box consists of the fabric tent portion, four flexible wands, and a mounting ring. To assemble, work at the small opening where the flash head will be positioned. First, slide each wand into the sleeve found along the inside corner of the soft box. Then, the free end of each wand is inserted into one of the four holes in the *mounting ring*, often referred to as a *speed ring*.

When finished, the soft box is quite rigid. The mounting ring is now attached to the flash head, using the same mechanism used to attach a reflector. When possible, build the soft box first, then attach it to the flash head. This is because there is considerable stored energy in the four wands. It's always possible for a wand to slip, while you're inserting it into the mounting ring. A mishap could easily break a modeling lamp or flash tube.

Before you begin to break down a soft box, remove it from the flash head. Pull the four wands out of the mounting ring and leave the wands in the fabric sleeves. Now, wrap the fabric around the wands, positioning the white diffusion material in such a way that it remains clean. The soft box is stored in a long, narrow stuff sack. When space permits, soft boxes often remain assembled.

Mounting Rings

A few additional notes about mounting rings or speed rings. Some rotate, others are stationary. *Rotating mounting rings* allow the box to rotate 360 degrees around the flash head, while *stationary mounting rings* hold a soft box in a fairly fixed position. When using a stationary ring, a rectangular soft box must be assembled in either the horizontal or vertical orientation, as viewed after it's placed on the light stand or boom. You can't simply rotate the box if it's built horizontally versus vertically.

Some bigger soft boxes accommodate more than one flash head. Hence, there are mounting rings that hold two or three flash heads. Although their overall use is quite similar, they do become rather heavy and very cumbersome. A sturdy light stand or boom is mandatory, possibly reinforced with a shot bag.

Filters and Soft Boxes

Colored filters can be used with soft boxes. The filter is positioned fairly close to the flash tube, then taped to the flash head. The filter must be positioned far enough from the modeling lamp so heat can dissipate. Yet close enough so that an even color is produced, a distance of about five inches from the flash tube is about right.

Fill Cards

Some of the simplest, yet most useful light modifying devices are *fill cards*. They work by modifying and redirecting light. Although fill cards are usually fashioned from inexpensive cardboard, they prove invaluable, regardless of the light source or the type of photography. The assistant should expect to handle all shapes and sizes of fill cards.

Most fill cards are made from some form of *mat board*. An advantage to using mat board is that fill cards can be cut to the necessary size. Another material to be aware of is *foamboard*, such as the brand name Foam-Cor $^{\text{m}}$. Foamboard is a combination of internal foam, backed by white cardboard. The result is a rigid, yet very light weight product. These properties make it ideal for large fill cards.

Choosing the Correct Fill Card

The following basics will help you to work with fill cards more effectively. Generally, a larger card reflects more light. To direct more light to a larger area requires a larger card. In an architectural application or a shot of a large product, a fill card might measure a full four by eight feet. On the other hand, a small still life may require a card measured in inches.

It takes a certain rapport to know exactly what a photographer wants when all you hear is, "get me a fill card." By observing the evolution of the set and lighting arrangement, you should have an idea as to where the fill card is needed. If not, ask. Then look for a card the same general shape, but somewhat larger than the area you wish to fill with light.

For example, to add fill light on a long, narrow object, plan on using a long, narrow fill card, perhaps about 50% larger than the area to be lit. Keep in mind, this is a starting point. Because you can never be exactly sure what the photographer wants, return to the set with a couple of logical choices.

In addition to size and shape, color is important. White is the most common, as it accurately reflects the color of the light source. Other common colors include, gold and silver. Shades of gold are used to add warmth to the reflected light. This color might enhance the appearance of a certain food or a person's complexion.

A silver card produces a more brilliant fill light, and mirrors even more so. A silver card can be used to place silver colored highlights on silverware or chrome objects, compared to the white highlights produced by a white soft box or a white fill card. When fill cards are used with highly reflective surfaces, they need to be clean.

Most studios accumulate an assortment of fill cards. These are often stored vertically in boxes or on shelves. Larger ones are commonly found leaning

up along the wall. New fill cards are cut from mat board using a straight edge and utility knife. A clean cut makes for easier positioning.

Positioning the Fill Card

Every fill card must be *precisely positioned*. Its placement is determined by the photographer, but it's often the assistant's responsibility to position it. Before returning to the set with a fill card, think about how you intend to finish the job and grab the required hardware.

The photographer will work with the card, until it's positioned as desired. At this time, you want to be able to quickly slide in the appropriate support. *Moderate sized cards* and *larger* are usually connected to a light stand with one or two spring clamps. *Smaller cards* can be propped up against a small stand, block of wood, or a can of spray paint.

Remember, fill cards are usually positioned very precisely, and considerable ingenuity can be required to secure the card in place. When there's a lot of activity around the set, an extra clamp or masking tape is prudent. Use masking tape sparingly, especially when it's going to be attached to the card's good surface. Fill cards are meant to be reused.

Use discretion when deciding a little extra security is in order. A card's position is often refined as the lighting arrangement evolves, so wait until you feel the card isn't likely to be moved or replaced. An assistant needs to be efficient. One way is not to do more things than necessary.

Light Absorbing Devices

The opposite of a white fill card is a black card. Whereas a white surface reflects light, black absorbs light and acts like a *light sponge*. A photographer must often control stray light from falling onto the set or the lens. Here, a black card or flag is positioned to block unwanted light.

When *lens flair* is the problem, you can see the light's reflection on the outside lens element. Clamp a black card to a lightweight stand. Now position the black card between the lens and the problem light, keeping it about six inches from the lens. Move the card until the light's reflection is gone. Then look through the camera, to confirm the card isn't visible in the frame.

When *flagging* stray light from reaching the set, position the black card close to the light source. Black seamless paper is also a useful way to control unwanted light. Due to its size, it can be a practical solution when large areas are involved.

Black Velvet

At times, areas in the camera frame need to go completely black. This can be accomplished by using *black velvet*, the ultimate light absorber. Black velvet can be used to control light, but it can just as easily be considered a background material. This cloth reveals no surface at all, and creates the illusion of a black void.

Black velvet is most effective when it's free of wrinkles and lint. A perfectly flat surface can be made by stretching the material across a piece of plywood, and securing it with push pins. Lint can be removed using the

sticky side of masking tape. To ensure a wrinkle free material, black velvet is best stored hanging in loose folds or rolled up, not folded flat. If wrinkles persist try a humidifier. Don't iron it.

Summary of Responsibilities Related to Light Modifying Devices

☐ Obtain the <i>light modifying device</i> specified by the photographer from the storage area.
☐ Select the appropriate <i>hardware</i> in order to position the device. These include: mounting ring, stand, blocks, tape, clamps.
☐ <i>Monitor heat</i> generated by either the modeling lamp or tungsten lighting, especially when using small soft boxes, snoots, and reflectors covered with diffusion material or colored filters.
☐ Periodically, reconfirm that the <i>adhesive tape</i> is still securing filters and diffusion material.
☐ Follow the evolution of the set and the lighting arrangement to better understand the <i>photographer's needs</i> , with regard to light modifying devices.
$oldsymbol{\square}$ Expect to be involved with all aspects of lighting throughout the day.
☐ Be careful not to disrupt any light modifying device.
☐ When light modifying devices are not used, attach a <i>flash tube protector</i> to the flash head.

Light Meters

Light meters aid in determining the proper exposure. To do so, there are two ways a light meter can measure brightness. The *reflective light meter* measures the light reflected off the subject. Here, the meter is pointed at the subject when measuring. A camera's built-in meter is of the reflective type.

An *incident light meter* measures the illumination falling on the meter itself. In this way, the meter receives the same light which falls on the subject. Now, the meter's photo cell is fitted with a translucent diffusion dome and then pointed towards the camera when measuring. Most hand-held meters are designed to be able to take both reflective and incident readings.

Although meters are often thought of as being either the reflective or incident type, another category is needed. One kind of light meter is designed to measure a more or less constant light source. Often referred to as an *ambient light meter*, it can be used to measure natural light and artificial sources, such as tungsten. Here, you dial in the film speed, take either an

incident or reflective measurement, and you get a combination of shutter speed and f-stop for a proper exposure. Unfortunately, this kind of meter can't measure electronic flash.

The Flash Meter

To measure the illumination produced from electronic flash equipment, you need a *flash meter*. Most flash meters can measure both flash and continuous light. What follows are key points concerning the the flash meter's operation, and how the assistant is involved with the metering process.

Operating the Flash Meter

A hand-held flash meter is usually used as an *incident meter*. The meter's light sensor is covered with a diffusion dome, providing a fairly wide angle of view. When the photographer positions the flash meter, it's worth noting the meter's position. Not only to learn, but you may need to replicate it. When called on to take a meter reading, the assistant must place the meter as the photographer had it. If not, it's very difficult to compare results.

The incident flash meter is usually placed close to the subject's surface, with the diffuser pointed towards the camera lens. For example, when metering for a head and shoulders shot, position the meter close to the model's nose.

All flash meters need to be turned on, using either an *on-off* switch or by depressing the measuring button. Then you must dial in the *film's ASA number* and the *camera's shutter speed*. The only remaining variable is the lens aperture or f-stop, which is displayed after the metering process.

Unless the exposure integrates both flash and a constant light source, such as daylight, the exact shutter speed is less important. It must not exceed the shutter's sync speed, yet be fast enough so ambient light isn't recorded on film. One-sixtieth of a second is a commonly used sync speed.

The Cord and Non-Cord Modes

There are two ways to set the meter when measuring a flash. These are designated as the cord and non-cord modes. When switched to the *cord mode*, a sync cord connects the flash meter to the power supply. Depressing the meter's *measuring button* causes the power supply to discharge. Soon afterwards, the measurement is displayed in f-stops. The cord mode is also used when a radio transmitter is connected to the meter.

In the *non-cord mode*, the meter isn't connected to the power supply. You depress the *measuring button*, and the flash meter is made ready to measure the next flash. At this point, taking a meter reading usually becomes a two person operation. The photographer positions the meter and the assistant goes to the appropriate power supply.

The assistant goes to the master power supply, when every flash head should fire. If only one of several flash heads is to be metered, unwanted heads and power supplies must be turned off. Remember, turning off the modeling light doesn't turn off the flash tube. At the photographer's signal, the assistant discharges the power supply and the meter displays its measurement.

There are several advantages to the *non-cord mode*, especially when an assistant is on the set. In this mode, the sync cord doesn't need to be removed from the camera in order to take a meter reading, and reattached afterwards. Often, it's more efficient for the assistant to walk from pack to pack than to constantly rearrange sync cords during the metering process.

The Assistant's Responsibilities

When it's likely you'll be using a flash meter throughout the day, try to anticipate when the photographer is about to take another reading. Sensing that a meter reading is imminent, keep close to the set. When the photographer grabs the meter, head to the appropriate power supply. Many times the photographer will take several measurements, perhaps to determine the amount of light fall-off across the background. Observe the photographer's subtle cues, indicating it's time to pop the strobes again.

It's not uncommon to work with photographers who rarely use a flash meter while in the studio. They've become familiar with their specific lighting system and how it performs under more common lighting conditions. However, few have such confidence while on location. Therefore, you need to make certain the light meter is in the camera case.

Summary of Responsibilities Related to Light Meters

Confirm that the light meter is set properly. Check ASA and shutter speed settings.
☐ Determine whether the flash meter will be used in the <i>cord</i> or <i>non-cord mode</i> .
☐ When in the <i>cord mode</i> , attach the flash meter to the master power supply with a sync cord.
☐ When in the <i>non-cord mode</i> , plan to be positioned at the appropriate power supply during the metering process.
☐ <i>Anticipate</i> when the photographer is about to take a meter reading and react accordingly.
☐ Make certain only those lights to be metered will fire.
☐ <i>Observe</i> how the photographer positions the meter.
☐ When in <i>non-cord mode</i> , wait for the photographer's signal before discharging the power supply.
☐ When in <i>cord mode</i> , reattach sync cord to the camera after metering.
☐ Regardless of mode, remember the meter reading.
☐ Turn off the meter when finished.

An Interview with Todd Droy

odd Droy is a commercial photographer based in Denver. Most of his work is performed in the studio and is used for advertising or brochures.

John Kieffer: Could you elaborate a little as to the kind of photography you do?

Todd Droy: The majority of work I do could be described as table top, I shoot more things than people. Probably 80% of my work is shooting a wide range of objects in the studio. One day it could be a high tech shot for Hewlett-Packard, the next a beverage shot for Coors Brewery. The majority of the time I use artificial light, this is mostly electronic flash, but I also integrate some tungsten. When conditions warrant on location, I'll use available light and supplement it with artificial light.

J.K.: Since you spend much of your time in the studio shooting smaller objects or products, what camera format do you work with most often?

T.D.: Because so much of my work is table top, I prefer a 4x5 inch view camera and on occasion I require an 8x10. When shooting people I use a Hasselblad and a couple of times a year I dust off my 35mm.

J.K.: For your kind of photography, what do you look for in an assistant's personality?

T.D.: One of the first things I look for is how they present themselves, their overall level of confidence. When I talk to them or look at their book, I look for enthusiasm and I try to sense whether they're excited about photography. I'm not as concerned about the work in their book, but to see if they're excited. This excitement usually translates into working harder in the studio.

I like an assistant who isn't too self-centered because an assistant is there to help me. Some assistants come into the studio with about forty pictures in their book, and they could weed it down to about three or four. When I ask about that, that their book is too long, some haven't got any idea about which ones they would take out and which ones really belong. I usually show these people the door because they haven't got a clue, and they, aren't nearly critical enough of their work. It's rare to see work in an assistants portfolio that tells you they're good enough to shoot, most of the work is from school and you can really tell.

I also like assistants to be friendly and at ease. You can tell when they are tense, usually it means they're relatively new at assisting, but I like someone who can relax and talk to me. At times it's hard to put a finger on it, but by the end of the interview I've usually decided if I'm going to try someone or not.

J.K.: What do you look for as far as technical skills?

T.D.: Since I work so much with a view camera I really want to know that they

can load sheet film. Fortunately, most assistants that come in can. I also think they should be able to load a Hasselblad®. That's what I use, so I don't care about the others. I also like to see 4x5 in their book, so I can tell if they understand the camera movements. It's not that most of the assistants are going to be operating the view camera, but if I mention pulling focus, I want them to know what I mean and how it can be achieved other than just by closing the lens way down.

I also ask about what other equipment they are familiar with and how they respond often tells me if they know what's important for an assistant. Assistants have certain responsibilities and good ones know what they are without me telling them.

A knowledge of strobe lighting is certainly important because so much of artificial lighting centers around it. I met with an assistant yesterday who had a fine arts background and very little knowledge of strobe. He had a fairly high day rate and I asked him why I should hire him when for a few dollars more I could get a very experienced assistant. When I suggested he should lower his day rate he took offense to it. I also suggested he could be a second assistant in the studio as a way to learn some of the basics and he wasn't interested. He won't work here.

Many years ago when I started assisting in Chicago a photographer said he'd like to use me, but he'd pay me less until I could be of greater help in the studio. The photographer offered me three days a week for \$35 per day compared to the \$60 which I was asking and what was the going rate at the time. I took it because I was fresh out of school and didn't really know what assisting was all about. It wasn't long before it was up to the standard day rate.

J.K.: You've alluded to interviews, do you interview all your assistants?

T.D.: I don't think I've ever hired an assistant without meeting them first. At the very least, I want to avoid getting stuck with someone who doesn't know his or her place, especially while there's a client around. I also like to see the look on their face when I suggest that they can empty the trash if there is down time on the set. If they get turned-off by that then I don't need them here. An assistants responsibilities can get spread pretty thin.

J.K.: When you interview assistants do you set any ground rules as far as how you want the assistant to interact with the client?

T.D.: No, not at all because I can usually intuitively tell during the interview whether they can act responsibly. I'm not always right because I did have an art director tell me he was approached by my freelance assistant for some shooting work when I was away from the set. When I do use an assistant for the first time I try to use them on a smaller, less demanding job. It can be hard to tell beforehand if an assistant is going to be able to sense when to be right over my shoulder and when not. It's always kind of scary trying someone new on a big project, there are just too many things going on.

J.K.: Are you worried the first time you send an assistant in the darkroom to load your sheet film holders?

T.D.: Sure, I think some assistants are put off when I show them what I expect, as far as cleaning film holders. I expect clean holders, and fortunately I haven't had anyone make a major mistake either loading or down loading film. I want an assistant to take the necessary time whenever handling film.

J.K.: When looking for assistants, do most find you or do you ask fellow photographers?

T.D.: Most of the time assistants call me and I probably get a call a week from a new assistant and more when school lets out. It's only when I'm at the bottom of my list that I call a photographer for a new name.

J.K.: What is the best way for an assistant to meet with you?

T.D.: I get a lot of resumes, but they don't help me that much. I know a lot of assistants mail resumes and then call, but I think it's probably more effective to just call me and and try to meet with me. Basically if I don't have a face to link to a mailing it doesn't mean anything to me. When assistants do call me I may not meet with them for a month or it may be that day. But I tell them not to give up.

After I meet with someone it's probably best to leave me a business card to file. It has just enough room to write a few notes ranging from "good potential" to "bad attitude." I had one assistant who would follow-up by mailing something, I thought this was a good idea because then you don't need to keep bothering the photographer on the phone as much. Sometimes it's pure luck, their card or short note thanking me for an interview might come just at the time I need someone. There is a delicate balance between keeping in touch and calling the studio too much.

J.K.: Considering that photography can be physically strenuous, do you have a preference for male versus female assistants?

T.D.: When I interview women assistants I ask them if they can lift power supplies and heavy cases. Most of them say they can, now if they can or not I won't really know until I try them out. But at least they know I asked and that I expect it of them. If I know I'm going on location I do prefer a guy. For instance, if I'm working in the studio and I notice that a woman has a problem hanging a heavy canvas background then I might make a mental note not to take her on location.

I do know a woman assistant who is as strong as any guy, and she made it a point in the interview to mention her capabilities. She also mentioned that when she began assisting, a photographer commented that she seemed to be having problems with some of the equipment and at that point on she began lifting weights.

J.K.: What do you think about assisting as a way to learn more about photography and as a means of breaking into photography?

T.D.: I don't think there is a way around assisting. Even if you are an exceptional photographer you can still benefit from assisting. In fact you can still be learning after two years. You learn more than just how to make an exposure or use a power pack, but all the nuances of how a shoot goes.

Today so much of running a photography business is non-photographic, more than most people want to know. Yet most people who go to school still come out and need to learn how to run a studio. Sure you need to know how to make good photos, but there's much more. Even if you feel anxious to open your own studio, you'll ultimately advance much quicker when you do finally open up the doors of your own place if you've assisted.

J.K.: Could you elaborate on some of the non-photographic aspects to be learned from assisting?

T.D.: You can build a base of photographic resources. There is more than just the lab, you can learn which modeling agencies are good to deal with and where to buy equipment, supplies, and rent props. You also get a chance to meet stylists, art directors, and designers. So later on when you do open up your own shop, you have an idea as to what they do. Eventually, when you're on your own it's fair game to call on those people.

J.K.: Of the individuals you've worked with who have been successful as assistants, what percent do you think made a successful transition to professional photography?

T.D.: Well of course it depends on your definition of success. It's only a guess, but I'd say about forty, maybe fifty per cent end up making photos for a living. However, not more than five to ten per cent are making nice pictures, but that's a subjective judgement. I think many people get into photography because they think it's a fun way to make a living. Some of these people are weeded out in school, and even if they make it to assisting they still might not make it. Some just never have the creative ability, the good taste, or the technical knowledge to make things look good with artificial lighting. I was working with an assistant in Chicago and he was a great assistant, always on top of things, but he's not that good of a photographer.

J.K.: Do most of today's assistants come from a photography school?

T.D.: I would say that most have come from the local two year photography school and a few from Brooks.

J.K.: So is the road to success going to be go to a photography school and then assist a couple of years?

T.D.: If I was interviewing an assistant today and I could tell from their book that this individual works hard and has really been trying to learn a lot, I would respect that person more if he didn't go to school. Because I could see that he wasn't just cranking out school assignments and that he had a lot of initiative and drive. School has just become the common path, but not necessarily the best one and certainly not the only one. College was good for me because it gave me the time and opportunity to focus on photography. It allowed me to be in an environment with other enthusiastic students where there is an interchange of ideas.

J.K.: Do you have any parting advice for aspiring assistants?

T.D.: You've probably heard it before, that there are too many photographers and not enough jobs, but I can't change that. I do think that if you have reasonably good photographic taste, are a hard worker and persistent, you can make it. But these kind of people would probably make it in whatever they pursue. As competitive as photography has become, I don't think a photography studio will ever amount to anything as far as a business if you go at it half way. You have to go at it pretty much flat out with the realization that you'll put in a lot of hours.

Photographic Hardware

uch of the time, a set is built or the shooting environment is modified for a specific shot or series of shots. The speed in which something must be constructed and its inherent lack of permanence, profoundly affects how things are accomplished. Many tasks are painstakingly done to perfection, only to be undone shortly afterwards. Not having the luxury of time, you're more likely to build something utilizing stands and clamps, as compared to wood, nails, and glue. The proper and often ingenious use of photographic hardware is an integral part of assisting.

Stands

The most fundamental piece of photographic hardware is the stand. *Stands* come in various shapes and sizes, in order to serve many functions. You'd expect to use a stand to support a flash head, but stands are used to hold almost anything. You'll find that stands quickly become an integral part of virtually every set.

Selecting the Proper Stand

When the photographer asks you to get a stand, your choice depends on its intended use. Here are some considerations. First, how heavy is the object that needs to be supported? Stands range from small and light, to big and heavy. Lighter weight stands are easy to handle, but are restricted to lighter tasks. However, they tend to be more compact, an advantage in confined working conditions.

The typical *light stand* is considered medium weight. As the name suggests, it's ideal for supporting a flash head, but it's also used for countless other tasks. As objects get larger and tasks more demanding, still heavier stands are available.

After establishing the size and weight of whatever is to be supported, you should know where it needs to be positioned. First, how high or low does the stand need to go? A *back light stand* is designed to provide support at ground level. Whereas a medium weight stand might not go any lower than three feet, it may extend to eight feet or more. When something such as a soft box needs to be positioned well over the set, a *boom* supported on a sturdy stand is required.

Realize that sets quickly become crowded and access restricted. When trying to sneak in a small fill card, even the smallest stand may be too large. Be creative, look for a can of spray paint or block of wood from the workshop. Photographers always have an odd assortment of such things.

Finally, your choice might depend on what's left. As the set comes together, more and more stands tend to be used. Most photographers don't have an endless supply of stands, so use discretion by not taking the last medium weight stand for a simple fill card. Once something is in place, it can be difficult to make exchanges. This strategy is particularly important on location. Here, you can't always bring everything in the studio, though many photographers try.

The Proper Use of Stands

Stands extend in height using some form of *telescoping action*. After a section is extended, it's secured by tightening a *locking* knob. Most photographers don't like you to over tighten these knobs, and they'll let you know about it if you do. The assistant is in a difficult position. The last thing you want is a stand to slip, but you don't want to over tighten it either. Most locking knobs hold quite effectively. However, be leery of older stands, especially small ones. These often require more force to tighten securely.

When not needed, a stand can be collapsed and hung for *storage*. When hanging a stand from a hook, do so by utilizing the bottom most locking knob. This practice allows other knobs to be loose without causing a mishap. Most stands have several telescoping sections and an equal number of locking knobs. Stands suspended using the top locking knob can fall, if any of the lower knobs become loose.

Stands require few accessories. However, the stand's *end post* or *stud* where the light attaches, can be of several different diameters. Both 3/8 inch, and the larger 5/8 inch end posts are common. When a stand's end post measures 3/8 inches and a flash head has a 5/8 inch diameter opening, an adaptor is required. Establishing the need for various adapters is particularly critical before heading out on location.

Additional Support

There are times, when any stand might benefit from some added support. Compact stands are often utilized on cramped sets. Here, even a slight bump can dramatically reposition whatever the stand is holding. After a

small stand is put in place, secure it. Use gaffers tape to attach a couple of the stand's legs to the floor.

When more clout is needed, as with larger stands, use a shot bag. These nylon bags are filled with either lead shot or sand, and weigh from five to twenty-five pounds. When practical, position the *shot bag* well down on the stand's centerpost to lower the center of gravity. If you can't, the bag's malleable nature allows it to be draped over the stand's leg.

A pair of stands are often used to support a crossbar. The resulting horizontal crossbar then holds various background materials. Under these circumstances, the stands are extended quite high and additional support is prudent.

Booms

When something needs to be suspended over the set, a boom is used. A *boom* is a metal pole that attaches to the top of a stand. The connection allows for a sort of teeter-totter action, providing easier positioning. A flash head is commonly connected to one end of the boom. At the opposite end is a *counterweight*, to counter balance the flash head.

Working with Booms

You need to be very careful when working with a boom. Especially when either attaching or removing the counterweight or the flash head. At these times, you can't work with one without considering the other. The connection used to attach the boom to the stand controls the pivoting motion of the boom. Loosening a *lever* allows the boom to swing freely. Tightening it locks the boom at the desired angle.

Before attaching the flash head, position the boom horizontally and lock it in place. Now secure the counterweight to the boom, so the weight is very close to the stand's center post. Counterweights are very heavy, and attaching fifteen pounds to the end of an eight foot boom produces tremendous leverage. If the counterweight is moved to one end of the boom before the flash head is attached to the other, the unbalanced stand will most likely fall over.

Now insert the flash head onto the end of the boom, and secure it by tightening the light's locking knob. Once the flash head is attached, *don't* let go of the boom until it's evenly balanced. To balance the boom, slowly move the counterweight towards the opposite end of the boom.

To fine tune the weight's position, loosen the lever used to lock the boom in place. Slowly move the counterweight until the free swinging boom rests horizontally, then retighten the lever. A *properly balanced boom* is much easier to handle. Finally, a counterweight also serves as an excellent shot bag. They readily attach to the base of a stand's center post and certainly weigh enough.

Extension Arms

There are smaller versions of booms, known as extension arms. Some have

joints or elbows for even greater functionality, and are referred to as *articulated arms*. Both are used for smaller objects, perhaps to support a prop, fill card, or help position a model's hand.

Smaller booms and articulated arms are usually extended somewhat horizontally when in use. They're secured in position with locking knobs. As gravity pulls the arm downward, the locking joints will have a tendency to either tighten up, or loosen up. Be sure to place the arm in a self-tightening position.

Safety Precautions

At this point, there is a *lead counterweight* suspended on the end of a long metal pole. In addition, it's black, held at eye level, and in the dark. A few precautions are in order. First, try to position the stand and boom so it's out of the main traffic pattern. Usually, one side of the set has less activity.

When a boom must be in the middle of things, try to make the counterweight more visible. Taping a white paper towel to it should suffice. It's expected that the photographer and assistant will be careful while working on a dark set, but don't assume the client has such awareness.

Clamps

Clamps serve so many functions, it's impossible to construct a set or lighting arrangement without using them. They range from small, clothespin-sized clamps, to powerful devices requiring both hands to open. Some are

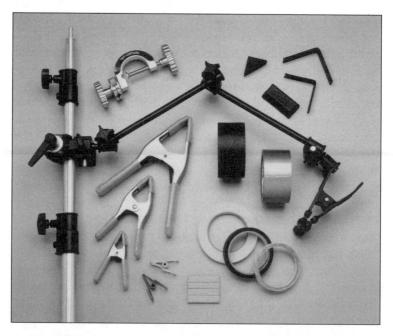

Photographic hardware including: light stand, articulated arm, tape, temporary adhesive, clamps, and items to position objects on the set.

general purpose, while others serve specific functions. There are far too many different styles to mention them all.

Some of the most useful general purpose clamps are commonly referred to as *A-clamps*, *spring clamps*, or *pony clamps*. When closed, these springloaded clamps form the shape of an A. They're routinely used to secure fill cards to stands and background materials to either a cross bar or a sheet of plywood. Other clamps might be fitted with an end post, in order to support a light or attach an articulated arm.

Using Clamps

A few observations regarding clamps and their use. Generally, larger clamps can hold larger and heavier objects. Many clamps exert considerable pressure, so make certain they won't damage anything important when put to use. Most clamps have rubber protected ends, to reduce this problem. If not, a piece of cardboard can be placed between the clamp and surface.

When you intend to put up a background or the photographer requests a fill card, make it a habit to grab a couple of the appropriate clamps on your way back to the set. If you find yourself working on a ladder or requiring the use of both hands, clamps can be attached to your clothes until needed.

Adhesives

Another indispensible group of tools are adhesives, especially *adhesive tapes*. They're fast and easy, and there are many different kinds. The choice depends on the application. The most common is *masking tape*. It holds just well enough, and can usually be removed without disrupting the surface. Besides being inexpensive, you can also write notes on it. Additional uses for masking tape are mentioned throughout the text.

Photographic tape is very similar to masking tape, except that it's opaque black. Its flat black surface is ideal when the tape must appear black on film. It's also the tape of choice for many portfolio materials. However, photographic tape is fairly expensive, and it should be used when specifically required. Similar to photographic tape is white artists tape. This is ideal for labelling sheet film holders.

Not to be confused with photographic tape, is *gaffers tape*. This is a two inch wide, cloth tape, and usually has a black surface. It's very strong, yet can be removed from most surfaces without leaving any sticky residue. Since it's a fairly expensive material, use only when necessary.

A lesser quality, but still very useful tape is grey *duct tape*. Because it's inexpensive, it can be used in large quantities. Unfortunately, it does leave some gummy adhesive after it's removed. Even with this drawback, duct tape is ideal for quick fixes or taping down extension cords in congested locations.

Double-stick tape is of value, especially for studio product photography. It resembles cellophane tape, but has adhesive on both sides. It's particularly useful in positioning light weight objects. Also of value in similar situ-

ations is a *temporary adhesive*. These are clay-like or waxy materials, commonly referred to as fun-tack or tacki-wax.

Assistants often find themselves in situations requiring three hands. If you know you'll need tape, tear it off beforehand and stick it to a nearby light stand or your pant leg. Most rolls of tape can be fitted over your wrist.

An excellent adhesive that's gained wide acceptance, is the *hot glue gun*. A plastic adhesive resembling a candle is placed in the glue gun. The gun heats the candle, until it melts. You then use the gun to apply the melted plastic to the appropriate surface. As the plastic hardens, it acts like glue. The key is to let the glue gun become very hot, and not to touch the melted plastic until it has cooled, usually a couple of minutes.

Miscellaneous Hardware

The following items are most likely to be used by studio photographers. These are non-photographic items, but invaluable none the less. A sheet of *plywood* commonly forms the platform, onto which many background materials are placed. The plywood shooting table is often supported by *saw horses* or *milk crates*.

Very often the product, a prop, or a fill card needs to be tilted at a specific angle. You can expect to find an odd assortment of things to try. These might be a collection of wood blocks in an array of sizes and shapes, or a few tape covered bricks.

Summary of Responsibilities Related to Photographic Hardware

object to be supported, and where it must be positioned.
☐ To minimize trips to and from the set, <i>establish exactly what's needed</i> to complete the job. Consider stands, booms, clamps, tape, and ingenuity.
☐ Although easy to overlook, an assortment of photographic hardware is required for <i>location shoots</i> . Adaptors to connect flash heads to stands are especially critical.
☐ If conditions warrant, utilize <i>tape</i> or <i>shot bags</i> , to add support to stands.
☐ Alert clients to the boom's <i>counterweight</i> by attaching a white paper towel.
☐ Consider photographic hardware when trying to anticipate the photographer's needs.

Surface Preparation

ssistants are actively involved with the preparation of a wide range of surfaces. These surfaces are found on the subject, props, and background. They might need to be cleaned or altered to reproduce most favorably on film. Whatever the surface, you should evaluate several factors to do the job right. Remember, an assistant must balance many responsibilities. Consequently, it's imperative to work at being efficient without cutting corners.

Primary Considerations

Before you begin to prepare a surface, you should *determine the level of perfection required*. This depends on a couple of things, one is camera format. Generally, as film size increases the tolerance level decreases. Also, how close to the subject are you working? The closer the camera, the more apparent any imperfections.

It's also good to know the final size of the reproduction. As a piece of film is enlarged, so are imperfections. These factors help explain why product photography requires such meticulous surface preparation. Large format view cameras are used to photograph relatively small objects.

In addition, the assistant needs to know what will be in frame and the approximate camera angle. Ask the photographer, or review the layout. When photographing a box shaped object, only three of six sides can ever

show. You've already cut your work in half. Once you've established which surfaces are to be prepared, proceed with caution. This holds true for both easily replaced items and a one of a kind prototype. Your efforts must not adversely alter the object's surface.

Whether working in the studio or on location, the entire set must be clean. While on location you must tread lightly, as you're more than likely an intruder. When at someone's work place or on private property, ask permission before moving objects. Being considerate from the beginning, ultimately makes your job easier.

Cleaning

The most common way to prepare a surface is to clean it. To be safe, keep these points in mind. Try to work away from the set when practical. Select a part of the surface well out of frame, a *test area*. Begin any cleaning process by using the least strong means, whether it's a solvent or an abrasive. Carefully change to a stronger approach as needed. Clean a larger area than necessary, a *buffer zone*. Finally, monitor the area during the exposure process.

Preliminary Stages

When practical, do most of the cleaning off the set. You want to ensure that any mishap doesn't damage a prop or the background. If the object must be kept on the set, consider placing a *drop cloth* or soon to be discarded fill card around the object's base. One misplaced drop of fluid can ruin some materials.

Some solvents have *noxious fumes*, working well away from the set makes the shooting area a healthier environment. As solvents become stronger, try to work in a ventilated area and use gloves. Unfortunately, ventilation can be hard to come by. Studios are often built with a certain degree of security, which translates to a lack of windows. To *reduce fumes*, use small amounts of fluids and recap the container immediately. Also, place saturated rags in a plastic bag. You might consider using the darkroom. It has a sink, an exhaust fan, and a door to contain fumes.

You don't want to clean more than necessary. However, you must clean an area larger than what's expected to be in frame. It's not uncommon for the initial crop to expand, so give yourself a *buffer zone*. In addition, when photographing a relatively small area, a clean buffer lessens the chance of dust resettling onto the subject area.

Obviously you don't want to disrupt something on the set, but be particularly leery of electronic equipment, like computer keyboards. It's a good idea to clean them thoroughly, very early on. Often, a specific display is needed for the video display terminal. Unfortunately, touching any key with reasonable pressure can change the display. Most likely, there will be someone on the set operating the software. When that person leaves the studio, stay away from the keyboard. As a side note, don't unplug the computer for any reason, without permission. The display and who knows what will be lost.

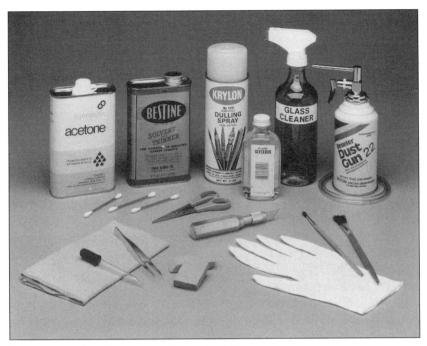

Commonly used surface preparation materials.

Liquid Cleaners

Before using any liquid cleaner, examine the surface. Liquids can dramatically alter some surfaces and should be applied cautiously to porous materials, such as wood, fabric, and paper. As a precaution, start by using the cleaner of least strength and in a test area well out of frame.

Generally, the safest liquid cleaner is *water*. Closely followed by *glass cleaner*, then the brand name household products, such as Fantastik or Formula 409. All of these are likely to be kept in a spray bottle. Nearby, you can expect to find paper towels or lint-free cotton cloths. For cleaning smaller surfaces, cotton swabs are ideal.

When water, glass cleaner, and the common household products don't do the job, it's time for another change. For persistent marks try *rubbing alcohol*. If not successful, switch to the stronger solvent *Bestine*, a rubber cement solvent. Both rubbing alcohol and Bestine are fairly odorless, and readily evaporate.

Next, comes *acetone* or nail polish remover. This is a powerful solvent, evaporates even more quickly, but has extremely strong fumes. When using acetone and its stronger relative phenol, be very careful when applying them to untested surfaces. Both solvents can readily dissolve some plastics. Again, use small quantities and in well ventilated areas.

Review Your Work

In addition to removing dirt, you need to produce a surface free of any streaks. As simple as this sounds, it can take considerable expertise. It's particularly easy to leave streaks on high gloss surfaces. Once the surface

is clean, get a paper towel or cotton cloth. Apply a small amount of cleaner to the towel, then gently buff the surface. Carefully review your efforts from several angles, particularly the camera angle. Make sure the surface is free of streaks, lint, and scratches. If you find scratches or imperfections that you can't remove, tell the photographer. You might be shown an ingenious solution. Anyway, the sooner you can deal with a problem the better.

Commonly Encountered Surfaces

As the assistant you'll be responsible for much of the surface preparation, especially cleaning. Your skills will be put to the test on a wide range of materials. However, the following surfaces are encountered on a routine basis. These are: plastic laminates, seamless paper, assorted metals, vinyls, and fabrics.

Plastic Laminates

Some of the most popular surfaces are the plastic laminates, such as $Formica^{\mathsf{M}}$ brand materials. Often thought of as something for counter tops, these laminates come in hundreds of colors, patterns, and textures. The four by eight foot sheets are an ideally sized background material for small product photography.

Plastic laminates are readily cleaned with glass cleaner and a paper towel. Waxy or gummy residuals can be safely removed with rubbing alcohol or Bestine. When cleaning, examine the surface for scratches. While working with it and storing it, be particularly careful not to scratch it.

Seamless Background Paper

Another commonly used material is seamless background paper. This is a heavy weight paper that comes in long rolls, usually measuring nine feet wide. Although sturdy, the surface to be photographed must be handled with *extreme care*. Once marks and imperfections occur, they are difficult, if not impossible, to remove.

It's best to remove dust from seamless paper using *canned-air*. Attempts to wipe the dust off will cause it to smear. When canned-air is ineffective, try using a small paint brush, while blowing gently. No matter how diligent, marks can appear. Next, try a *gum erasure*, using very gentle strokes. Because of its delicate nature, seamless paper is often discarded after one or two uses. It's a good idea to save some of it, as it makes an excellent drop cloth.

When an object must be cleaned while resting on seamless paper, be careful. Especially, if it involves liquids. Place something along the object's base to catch any drops, they will inevitably discolor the paper's surface.

Seamless paper has the advantage of being able to cover large areas. Large enough that you may need to walk on its surface, while working on the set. If this surface will be in the shot, remove your shoes. In addition, clean fill cards can be placed over the paper as a protective layer. When photographing a model's entire figure, it's helpful to place masking tape on the bottom of the shoes. This keeps the paper clean, longer. Both Formica brand ma-

terials and seamless paper are common backgrounds. Their storage and handling will be discussed later.

Metallic Surfaces

The assistant also works with a variety of metallic surfaces, such as chrome, aluminum, and stainless steel. There are specific metal polishes on the market, but these tend to leave a filmy residue. This layer often predisposes the surface to streaks and smudges. Try *rubbing alcohol* or *Bestine* to remove these oils. Then buff the surface with a very absorbant, lint-free cloth.

After cleaning, handle metal objects while wearing white, cotton gloves. If a metallic surface is too shiny or reflective, it can be further treated with dulling spray. This imparts a somewhat matte finish.

Rubber and Vinyl Surfaces

Rubber and vinyl surfaces can be treated with specific conditioners, such as *Armor-All*™. Although effective, their use often results in a shiny or glossy sheen to the surface. Mild soap and water is an effective combination, and produces a less reflective matte finish. The choice is the photographer's. As you'll see shortly, several aerosol sprays can be used to place a highlight on black surfaces.

Fabric and Carpet

Another material is fabric. Since cleaning fabric often means removing any loose threads, a small pair of scissors is a necessary tool. Lint can be removed with a special lint brush, the sticky side of tape, even tweezers.

A small *fabric steamer* is often used to eliminate wrinkles. It's filled with water, plugged into an electrical outlet, and steam is produced. Steamers should be held fairly vertically, while in use. This tends to keep drops of water from hitting the fabric. The smaller units take awhile to produce steam. So during busy days keep the unit plugged in, filled with water, and ready to go. This helps eliminate inconvenient down time.

One commonplace fabric is *carpet*. To clean it, an obvious solution is to use a vacuum cleaner. Unfortunately, you don't always have access to one. If not, you might have to resort to using the sticky surface of masking tape. A photogenic surface can be created by *raking* the carpet with a stiff piece of cardboard. The raking action readily removes irregularities, such as foot prints, and yields a smooth surface. During the process of rearranging furniture, little divots can be left in the carpet. These are made less pronounced by raking them with a plastic fork.

The Other Extreme

Yes, you may even be called on to dirty an object. As before, proceed with caution. It's better to slowly build a layer, than to overdo it and have to remove some. Here are a few substances to keep in mind. Generic dirt can be made by rubbing pencil shavings onto clothing. Also, the fine dirt which collects in parking lots is very effective. A heavier grime can be found on any car engine, but first give a grease pencil a try. These also come in various colors.

Monitoring the Exposure Process

Even during the short time it takes to expose the film, it's critical to *monitor the set for dust*. At this late stage, canned-air is very effective, but it mustn't disrupt anything. For situations requiring a more controlled blast of air, check the set cart for a piece of flexible tubing for the nozzle. Once attached, this tubing allows for exact placement of the air. When extra caution is in order, try using a small, artist's paint brush or tweezers.

The worst time to bump something, is part way through the process of exposing film. Working on the set at this time takes real concentration coupled with an awareness of where you are, relative to everything involved with the set. You must avoid lights, fill cards, stands, and props as you weave in and out.

Painting

Most studios have a few shelves in the workshop dedicated to paint. Over time, an assistant will apply paint to a whole range of surfaces. But regardless of the type of paint, how it's applied, and the kind of surface, *perfection* is the overriding word. This means no streaks and no irregularities. Applying paint requires skill and patience. Here are a few guidelines to make the job more successful.

General Guidelines

When practical, work in an out of the way place. This reduces the chance of dust falling on the wet surface, while minimizing fumes on the set. Next, prepare the surface so it's clean and dry. Paint can be applied several ways; however, once you begin there's no turning back.

Usually, it's best to start at one end of the surface and work your way to the other. This lets you paint along a *wet edge*, thereby producing a more homogenous surface. Painting from top to bottom is also preferred, so that any drops of paint fall on the unpainted surface. Once paint begins to dry, don't touch it. You'll invariably leave marks. This is true, whether it's finger prints or brush marks.

Many times, an object is painted well away from the set, and must be returned to the set before it's dry. Here is where some preplanning pays dividends. Determine how you'll get the item back to the set, without disturbing the nearly dry surface. This is one reason to paint an area, only slightly larger than required.

The *drying process* can be quickened by placing a tungsten light about four feet from the surface. Monitor the drying process and occasionally change the light's position to ensure uniform drying. Don't get impatient, excessive heat can ruin the surface. You can also use fans and hair driers, but the paint should be nearly dry so dust doesn't stick to the surface.

Kinds of Paint

You're likely to work with two basic kinds of paints. These are the *latex* paints, such as those covering most household walls, and *aerosol spray paints*.

Each kind of paint has its own unique characteristics. These traits strongly influence how each paint is handled, and to what surfaces it's applied. Consequently, latex and aerosol spray paints are discussed separately.

Latex Paint

Latex paint must be stirred before use, and is applied with either a *brush* or *roller*. Before prying the lid off the can try to find a cardboard box, one large enough to hold both the paint can and brush. The box will catch most drips and makes the painting process more portable. When applying paint with a *brush*, use back and forth strokes. Keep the brush strokes on top of, and parallel to, one another. If it's a wood surface, paint parallel to the grain.

Rollers are an advantage when large surfaces must be painted. Since rollers tend to drip paint, some sort of drop cloth is mandatory. When using a roller on rough or porous surfaces, take extra care to ensure the paint is covering completely. Try working in small sections, moving the roller in various directions, as if drawing a star. Then, immediately finish with long parallel strokes to create a smooth surface.

Latex paint is cleaned from rollers and brushes with warm, soapy water. If you need to keep a wet brush or roller on stand-by, wrap it in aluminum foil. Then place it in a plastic bag. This will keep a brush serviceable for several days.

Aerosol Spray Paint

A second group of paints are the aerosol spray paints. These tend to be quicker to use and faster drying than latex paints. Be careful when selecting a work area, due to the aerosol nature of spray paints there can be some *drift*. Then, prepare the surface as you would for any paint. Prior to spraying, shake the can vigorously for about one minute. Then direct the nozzle away from the surface, and begin to spray. If there's any inconsistency in the spray paint, it's usually at the beginning.

When the paint is flowing well, direct the spray onto the desired surface. Hold the can vertically, about eight to ten inches from the surface. It's best to apply spray paint using a broad, sweeping motion. Don't apply too much at any one time. If the paint begins to run, you've applied too much and lost your chance for a perfect surface. Thin layers dry quickly, so be patient. Spray paints usually need to be reshaken during the application process.

Miscellaneous Aerosol Sprays

There are a variety of aerosol products used to alter surfaces. Although they aren't spray paints, they're applied in much the same manner. A common product is *dulling spray* or *matte spray*. This is sprayed on highly reflective surfaces, such as aluminum, chrome, or glass. It reduces glare by producing a matte-like sheen. Here, an even surface is essential. Therefore, apply very light layers, and slowly build the level of dulling spray. If you apply too much, it has to be completely removed and the process started over.

At times, only part of the surface needs to be treated, perhaps the chrome label found on a product. Here, you need to cut a *mask*. To do so, get a large sheet of paper and cut a piece from its center, the size and shape of the

chrome label. Placing the mask over the label protects those surfaces not requiring dulling spray. When surfaces permit, attach masking tape along the edges of the object to be sprayed. The tape provides some leeway when cutting the mask, and makes for a better application.

Spray adhesives are used on a variety of photographic materials. On the set, spray adhesives are helpful in attaching backing material to flimsy items, to add rigidity. Spray adhesives are handled like other aerosols. However, once applied, the surface becomes a magnet for dust and fingerprints.

There are aerosol sprays, including some antiperspirants, which produce a fine, white powder. These products can be used to place a highlight on certain black surfaces. Even talcum powder can be applied with a brush. More exotic aerosols include artificial snow and green foliage.

Summary of Responsibilities Related to Surface Preparation

	Discuss with the photographer which <i>surfaces need to be prepared and how.</i> Surfaces may be cleaned, painted, or otherwise treated.
	Establish the <i>level of perfection</i> required. Consider camera format, image size, and final size of reproduction.
	Try to accomplish most surface preparation while objects are <i>off the set</i> . Especially, when noxious fumes are present or there's the potential to disrupt other surfaces.
	When using a solvent, abrasive, or paint, begin with a test area. If cleaning, start with the <i>least strong method</i> .
	Prepare an area larger than required to provide a buffer zone.
	While preparing surfaces, look for any <i>imperfections</i> which may be potential problems. Notify the photographer.
	Critically review your efforts, especially from camera angle.
0	Recheck all surfaces immediately before exposing film, and during the <i>film exposure process</i> .
	If you must work on the set between exposures, be extremely careful not to disrupt anything.

Background Materials

s you should have sensed by now the word background is really a misnomer. The background is as important as anything else. Its cleaning was discussed in the chapter on surface preparation. However, the background must also be properly positioned and treated carefully throughout the shot. Afterwards, it must be removed from the shooting area and stored.

Generally the photographer, art director, or client selects the background or *backdrop*. The choice being dictated by the parameters of the shot. After that, it's usually the assistant's responsibility to position it appropriately. Before rushing in, think. Here are some important considerations and basic handling procedures regarding the more common background materials.

General Guidelines

Upon arriving at the studio, a likely start to the day's activities is to set up the background. Often, the pace is such that questions seem out of place. When the background material requires the efforts of two people, just follow the photographer's lead. If you're on your own, a basic understanding of the shot is essential. Review the layout or ask the photographer, it's impossible to make proper decisions without some information.

Understanding Your Objective

The photographer may ask you to set up a four by eight foot sheet of black plexiglass. Before you can begin, you must have a basic understanding of what needs to be accomplished. For example, if you're photographing a

product, how big is it? Does it require the use of the entire surface, or should you find one small section that's perfectly free of scratches?

If viewing the *layout*, determine whether the background needs to be positioned horizontally or vertically. Don't forget the *camera angle*. This determines the height the background must be supported off the floor, in order to place the camera at a comfortable working position.

Just as likely, you may be asked to suspend a piece of painted canvas for a portrait. Again, some basic information is a must. There's a difference in background requirements when photographing a person's entire figure, as compared to a head and shoulders shot. This understanding is important because once a background is in place, the set evolves on it and around it. Mistakes here can place limitations on the rest of the shot.

Preparation

After gaining some sense of your objective, preparation is in order. First, clear away the main shooting area. Next, make certain the required tools are immediately available because many commonly used materials are heavy or very awkward. When mishandled, they can be ruined or damage other equipment.

If you get in over your head when working with a background material, don't hesitate to call for help. This slight embarrassment is nothing compared to falling off a ladder or dropping a delicate background. Remember, handling full sheets of plywood and plexiglass is difficult for everyone.

Plastic Laminates

Plastic laminates such as *Formica*™ brand materials are some of the most common background materials. Review the chapter on surface preparation for additional information, regarding the care and handling of many materials. Briefly, plastic laminates are easily cleaned using a paper towel and window cleaner, taking special care to insure no streaks remain. Also, it's easily scratched, so handle carefully.

Handling Plastic Laminates

Plastic laminates are most often available in four by eight foot sheets. Even though a full sized sheet isn't all that heavy, don't be deceived. Plastic laminates and related materials like plexiglass are very unwieldy, and their sharp corners can easily tear a soft box. Before removing it from storage, determine how and where it's to be used.

A plastic laminate is usually placed on top of a plywood table for added rigidity, and clamped in place. The plywood rests on saw horses or crates, whatever provides the desired working height. Make sure these supports are correctly positioned and several A-clamps are at hand.

Slide the material out from storage, keeping other objects from touching its good surface. After placing it on the plywood, clamp the edges to the plywood. Clamps help flatten the surface, and the plywood adds considerable stability.

A Common Application

Formica-like materials are often lifted or swept upwards at the back. This forms a concave surface often referred to as a *sweep*. If this is your intent, first secure the front edge of the Formica to the plywood surface, using several strong A-clamps. The front edge being the one closest to the camera.

Next, you need to elevate the opposite end to a height of several feet, so a concave surface is formed. This is accomplished by clamping the end to a crossbar, supported by two heavy stands. Medium weight stands should be stabilized with shot bags. There's considerable stored energy in this material, much like a compressed spring. If a clamp slips or a stand moves, watch out.

Storing Plastic Laminates

Full sized sheets are stored one of two ways. One way is to *roll it up* widthwise, and secure it with a rope. Photographers store it this way, when studio space permits. This procedure does reduce scratching, but may affect the flatness of the surface. A more common method is to store it unrolled. The flat sheets are placed one next to the other, like a deck of cards. This stack is then positioned upright, as if in a bookcase. Plexiglass, foam board, large fill cards, even plywood, might be found interspersed between laminate sheets. The trick is getting the material in and out of this stack safely, while not damaging its surface. Here, discarded seamless paper can serve as a protective layer. When taped over the surface, it alleviates the problem.

Seamless Paper

Seamless paper is as common a background material as the plastic laminates. It's available in a variety of colors with white, black, and shades of gray serving the widest range of uses. A roll measuring nine feet wide by twelve yards long is standard. The paper is wound onto a cardboard core, similar to a roll of paper towels. To use, a crossbar is slid through this core, and the crossbar is supported horizontally between two stands. In some studios, a crossbar is suspended from the ceiling by an arrangement of ropes and pulleys.

Hanging Seamless Paper

A few things are worth remembering, when hanging seamless paper. You must handle this material with *extreme care*, at all times. It's particularly vulnerable to creases and dirt, and once damaged it's rarely salvageable.

When you retrieve a roll of seamless paper from storage, it's likely to be taped shut to prevent it from unraveling. Leave it that way. On your way back to the set, grab a couple of A-clamps and a roll of masking tape. To keep your hands free, clamps can be attached to your pant leg or a stand. The roll of masking tape can be worn as a bracelet. Better yet, small pieces can be taped to your clothing or a stand, ready for immediate use.

After laying the seamless paper on the floor, thread the crossbar through

the paper's core. Now position the two medium weight stands, so the cross-bar can be readily attached. There's a hole at each end of the crossbar, insert this over the top of each stand.

Once the crossbar is attached, alternately raise the stands to a height several feet above the top of the subject. Before untaping the seamless paper, check to see that the crossbar is level. This ensures the seamless paper unravels properly and doesn't develop creases.

Carefully remove the tape securing the paper. Then position yourself near one end of the roll, and slowly unravel the paper. Being close to one end, lets you clamp the roll of paper to the crossbar, so it can't unravel further than desired.

Applications

When the seamless paper is used for a head and shoulders shot, the free end needn't reach the floor. Under these circumstances, place a few small A-clamps on the paper's free end. This minimizes any movement and produces an even surface.

At other times, the paper is suspended vertically, then swept out onto a plywood table or the floor. The idea is to produce a smooth sloping surface or *sweep*. To do so, the paper must lie evenly from side to side. Once positioned, tape down the edges of the paper. The more traffic around the set, the greater the need for tape. If people must walk on the paper, have them work in their socks or put tape on the bottoms of their shoes. An alternative is to lay clean sheets of cardboard over the paper.

After the shoot, seamless paper may or may not be rerolled. Regardless, tape down the free end and then remove the roll from the crossbar. Seamless paper must be *stored vertically*. If not, it tends to develop flat spots, a condition which can ruin the surface.

Plexiglass

In most respects, plexiglass is stored and handled like the plastic laminates. However, plexiglass is usually translucent white and less commonly, black. This means light can be directed through the plexiglass, much like diffusion material. Yet it's much more rigid, so objects can rest on its surface.

Handling Plexiglass

Plexiglass is often swept into a *scoop*, and a product placed on its surface. Then a flash head is positioned underneath, so the light is directed through the plexiglass. In order to produce an evenly lit background, the plexiglass must only be supported along its edges. Under these circumstances, the plexiglass is held by some sort of metal framework.

If the plexiglass begins to sag, additional support can be obtained by placing a small stand under the material. Then extend the stand, until a level surface is produced. This plexiglass support can be difficult to construct and premade equipment is available. These are commonly referred to as shooting tables.

Additional Materials

There are other materials which serve dual functions, and consequently are discussed elsewhere. *Black velvet cloth* and *diffusion material* can be used as a background, but because they both function as light modifying devices, they're discussed in that section. *Fabric*, including carpet, might serve as a background, but is discussed in the chapter on surface preparation.

Summary of Responsibilities Related to Background Materials

_	the background material correctly.
	When working with heavy or awkward materials, have the required <i>hardware</i> immediately available. This includes: tape, clamps, and stands.
	Make certain there is <i>adequate space</i> on the set, so you minimize the chance of damage to the material and other equipment.
	Position the <i>supports</i> for the background material. These include: sawhorses, crates, stands, and crossbars.
	Remove the background from storage, and position it on the supports.
	Properly prepare the background material's surface.
	<i>Be careful</i> of the background material, when positioning props and the subject on its surface.
	After the shoot, remove the background and return it to storage.
	Return all related hardware to its proper place.
П	

An Interview with Carl Fischer

Carl Fischer is a commercial photographer based in New York City. He is involved in a broad range of photography primarily for use in advertising.

John Kieffer: Could you give me a better idea as to the type of photography you do at your studio?

Carl Fischer: Most of the work we do is advertising, and about 20% editorial as well. Most is what is called illustration: portraits of people, scenes, sets, and still lifes. But over time I've become interested in special effects, sometimes called concept photography. I was an art director originally and I still become involved in the ideas behind the pictures. Overall I could be called a generalist, I do many different things.

J.K.: In general terms, what do you look for most in an assistant?

C.F.: Over the years I've had good ones and bad ones. I find it difficult to judge someone at an interview. You have to make a calculated guess. I prefer someone who has had some experience, only rarely someone just out of school.

We're looking for someone who is intelligent, diligent, a decent person. We find that techniques can be learned. We have our own system of doing things and we teach that system to assistants when they start. The best assistants have been those who have adapted to our system. Not that assistants haven't improved on it at times and made good suggestions—they have. The poorest assistants have been people who are set in their own way of doing things and won't change. I would say Horatio Alger types make the best assistants.

J.K.: Do you interview assistants and look at a portfolio?

C.F.: When we're looking to hire someone, yes. When we're not, we ask for resumes and keep them on file.

J.K.: Do you have a full time assistant or hire free lancers?

C.F.: We have both. We have assistants on staff and we hire freelance people.

J.K.: When looking for an assistant, do you put more emphasis on the individual or the fact that they graduated form a recognized photography school?

C.F.: The most emphasis is put on the individual. We take it for granted that if you've graduated from a photography school you probably know the rudiments and we are not too concerned about that. If someone did not go to school we want to make sure that he or she knows the basics, like which side the emulsion is on.

J.K.: What do you look for in a portfolio?

C.F.: The portfolio is not always an indication of the person we're looking for. At the minimum we want to see someone who has done an elementary amount of darkroom work because assistants load cameras, develop black and white film, and make prints.

J.K.: What is the day rate for an assistant in New York City?

C.F.: Day rates in New York go from around \$125 to \$150.

J.K.: Have you had any disasters or near disasters caused by an assistant?

C.F.: A year ago, we were cleaning out the darkroom and found a Nikon developing tank hidden in a corner. We opened it up and found a roll of film inside. An assistant (who, by the way, had subsequently been fired) apparently had trouble loading or processing the film and had hidden it. We had a vague recollection of an inexplicably lost roll. That's where it was. He never told us about his difficulty.

We count on assistants making mistakes, that's why they're assistants. We have a lot of backup procedures so it's hard for an assistant to goof, unless he's really incompetent, lazy, or frightened, as the example given.

J.K.: That redundancy, did it develop as your personal approach to photography or because you felt you had to do that when working with assistants and the increased chanced of errors?

C.F.: Both. I never had the useful experience of working as an assistant myself. I came from art direction directly into photography. Because of that lack, I reinvented the wheel. I invented all kinds of clever procedures that had previously been invented. I made a lot of mistakes doing my own work, and the advantage of that is that I remembered those mistakes and I developed procedures so as not to make them the next time.

J.K.: What is your feeling regarding assisting as a way to learn photography and break into the field?

C.F.: I think it's the best way to learn advertising and editorial photography. There are so many skills that have been developed over the years, from setting up lighting to working with the machinery that we have available to us. I missed being an assistant, I learned a little bit being an art director and visiting a lot of studios. I kept my eyes open and noticed the clever things that photographers did: how they stacked background paper, and the like. I think being an assistant in more than one studio is a useful experience. One learns all the skills other photographers have developed over the years. I strongly recommend that when people get out of school they work as an assistant for several years. I missed the experience of being an assistant.

J.K.: Do you have any instances where an assistant saved the day or came up with an ingenious solution?

C.F.: Assistants have frequently done that. Good assistants are invaluable on a shooting. There are times when we travel to California, then drive a hundred miles and have about fifteen to twenty minutes to take a picture of some personality. Then we'll drive and fly back. So we all work for only about a half hour while the project takes a day or so. During that fifteen minutes or half hour of a shooting there's a lot going on and that second set of eyes can be invaluable. Assistants have a different view of what's going on than the photographer, and good assistants see things that are going wrong. A smart assistant doesn't just mechanically

load the film backs and feed them to you, and take meter readings. A good assistant knows what's going on and frequently makes valuable contributions.

J.K.: How long do your assistants tend to work with you?

C.F.: It varies, usually two to three years.

J.K.: Did most of them stay in New York and pursue the same kind of photography or did some have completely divergent views and go off and do their own thing?

C.F.: Over the years, and I've been in this business a long time, about everything that can happen has happened. I've had assistants from Europe, one from Italy and one from Germany. They both went back and opened their studios and both are successful. I've had assistants who went into other kinds of photography. One is working with the Metropolitan Museum of Art doing photography of art work. Most have tried to become photographers and set up their own business and my guess is that only about twenty percent of them have succeeded.

J.K.: Have you had any experiences of unethical behavior from an assistant? For instance, duping your work and showing it as their own, or approaching clients that they met while assisting with you, showing their portfolio, and suggesting they could do the same job for less.

C.F.: To my knowledge no one has duped any of my work and shown it as their own. I know that assistants who have worked for me have shown their work to clients that they've worked with here. I don't find that unethical, by the way. I feel that is legitimate. After all, if they are going in business on their own, who else are they going to see? After they leave the studio they are allowed to see the kind of people they've been working with as an assistant. Do they work for less? Of course they work for less. That's the free market system.

J.K.: In New York City, what is the best professional association for an assistant to become involved, the APA or the ASMP?

C.F.: The APA if your interests are in advertising. I know APA in New York has assistant seminars, assistant weekends, and assistant visits to photography studios.

J.K.: Is there anything you'd like to add regarding assistants or the field of photography in general?

C.F.: You haven't asked about women versus men. There was a time when women assistants said that they were discriminated against, and I believe that was the case because some of the chores of assistants are to carry around heavy cases, climb up ladders, and do physical work. However, I believe that the women that we've had on staff have all been able to do that sort of work. Yes, there are heavy cases to carry, there is physical labor involved, but nothing so horrendous that a woman could not do it. The best assistant I've ever had, by the way, was a woman. Afterwards, she went on to do still life photography very successfully herself. And there do seem to be a lot of women assistants around now, so I presume that any discrimination that once existed is now gone.

There are however, very few black assistants available—we had to search around to find one. I don't know why this is, but I doubt in this enlightened business that it represents discrimination.

Studio Departments

hotographers work in what is commonly referred to as a studio. While studio photographers are the most dependent on the studio, even location photographers benefit from having one. There's a considerable amount of equipment and preparation for almost any photographic assignment. Studios vary in size and sophistication, but there's a common theme. You need to be able to construct a shooting environment, prepare the subject and props, expose the film utilizing artificial light, tear down or strike the set, and store all the material.

The hypothetical studio presented here is divided into different areas or departments. These can be found in some form or another in most studios. The purpose in utilizing departments in the text is threefold: to elaborate on what sort of things are used in the studio, how they're used, and where they might be found.

Learning the Studio

A freelance assistant must become familiar with a new studio very quickly. One of the best starting points is to pay attention to the studio's layout during the interview. Then, upon arriving for work, find the *basic departments* discussed here. You'll end up asking fewer questions, and be in a better position to respond to the photographer.

I'm not suggesting you locate these departments by roaming through the studio, opening closed doors. Most can be found by simply standing in the

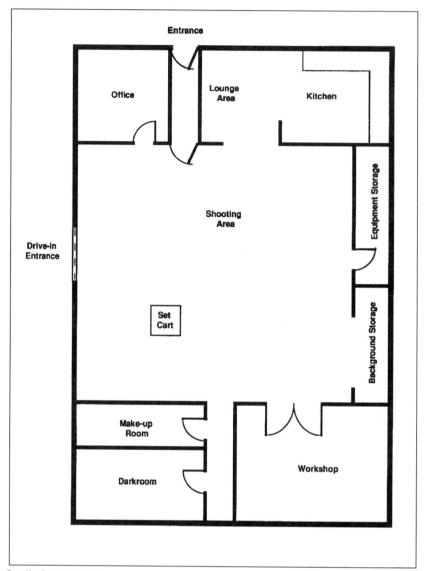

Studio Departments

studio's main shooting area, and looking at what's in front of you. Also, when you're sent for something make a concerted effort to remember what else you come across. It might be the very next item needed. This kind of learning takes effort, but ultimately makes your job easier.

After you've found something, you must remember where it belongs. You'll be responsible for putting it away. This is even more important for photographers who call on the services of several freelance assistants. Here, a lack of organization would soon lead to chaos, because the assistant may not be around the next morning to help find something. When photographers spend time looking for misplaced equipment, their last thoughts about you are negative.

When you first work with someone, it's expected you'll need more di-

rection. Learning the studio quickly is one way of *taking the initiative*, with little chance for negative consequences. You might feel it's much easier to just wait to be told, but the photographer won't think so. Photographers rehire those assistants they feel work well with them. Being efficient and not requiring constant direction demonstrates a good working relationship.

The Shooting Area

A large, open section in the studio functions as a *shooting area*. The set consisting of a background, lighting, props, and subject is painstakingly assembled and positioned here. Shortly afterwards, it's taken down and removed. Although almost everything is stored somewhere else, most of it makes its way out onto the shooting area floor, at one time or another.

Even with all this activity, studios remain well organized because everything has its place. When not in use, the main shooting area remains relatively free of equipment. What you're likely to find are permanently constructed soft boxes, a camera stand, large booms, and the set cart.

The Set Cart

It's useful to have a work place close to the camera or set, so commonly used items are readily available. In the studio, these items are likely to be kept on the *studio cart* or *set cart*. Exactly what's kept here depends on the photographer and the nature of the work performed. A set cart has a small working surface, assorted drawers, shelves, and hooks. It's also built on casters, so it can be positioned where needed.

The set cart is often wheeled close to the camera because it may hold related items, such as a cable release, flash slave, and sync cord. It's also a logical place to set the Polaroid instant film, its holder, and possibly a pair of L-shaped croppers. In addition, view cameras require a focusing loupe and dark cloth.

When it's time to go to film, the set cart is a good place to keep film magazines, sheet film holders, and canned-air. If changing lens filters is part of the exposure sequence, the photographer is less apt to forget if you place them on top of the set cart. As you see, the set cart isn't the place for coffee cups.

While working with background materials, remember the set cart. Assorted clamps, miscellaneous adapters, and a whole range of adhesive tapes can be found here. As work progresses, more tools are needed. Everyone has a scissors, utility knife, and a straight edge. You might need to trim a fill card or remove an errant thread.

Preparing and Positioning Objects

You can also expect to find plenty of things related to *surface preparation*. These include: small paint brushes, cotton swabs, erasers, and paper towels. Once clean, objects are often handled with white, lint-free gloves.

Besides preparing an object's surface, the assistant is often responsible for *positioning* it on the set. Again, expect to find an assortment of tape, small blocks, tweezers, maybe a hot glue gun. But, one of the most useful materials is a waxy or clay-like substance, commonly referred to as tackiwax or fun-tack. This temporary adhesive is both pliable and sticky, very useful in positioning lighter objects.

Bring It with You

Before leaving for a location shoot, many photographers transfer some of these materials into a multi-drawer case or *tackle box*. To help make certain the photographer is prepared, it's necessary to know what is scheduled for the day. With this information, check the set cart for necessary odds and ends.

The Workshop

One of the most important areas is the workshop. The space allotted and the materials found here are determined by the type of work performed in the studio. For example, a large drive-in studio provides the photographer with the opportunity to shoot almost anything. However, to realize this potential requires a considerable investment in support material.

On the other hand, a photographer situated in a small, second floor walkup requires a relatively modest workshop, primarily due to the inherent limitations imposed by a lack of accessibility and space. Finally, a photographer specializing in food will be best served by committing more resources to the kitchen area.

Many of the items found in the workshop are the same ones used to maintain a home. Yet, they are indispensible in creating the illusions found in photography. When in the hands of a set builder, photographer, or skilled assistant, the results as seen on film can be amazing. You'll find: hand and power tools, assorted paints and cleaners, building supplies, and aids specific to photography.

The Kitchen

Photographing food is a skill all its own. To prepare an appetizing food dish is one thing, to prepare one that looks equally delicious on film is quite different. In larger markets, photographers can specialize in food photography, and these studios have more elaborate kitchens. However, food photographers often call upon the services of another specialist, a food stylist.

The *food stylist* is responsible for the selection, preparation, and arrangement of the food or beverage. To this end, stylists utilize an array of small tools and other aids, not found in most studios. Under these circumstances, the assistant might help carry in the stylist's equipment, but food related responsibilities are left to the stylist.

When a stylist isn't present for a food shot, here are some items likely to

be found in the kitchen. Besides basic cooking and eating utensils, you might find an *atomizer* to mist food, or an *eye dropper* to position beads of water. More robust drops are made by mixing glycerin in water to the desired consistency. Colored dyes can be used to enhance or concoct a beverage.

Of course, there are acrylic ice cubes and artificial snow. But there are also granules, that when mixed with water resemble crushed ice. Still others produce steam to enhance the appearance of a hot cup of coffee. After a food shot there's often copious amounts of food. However before you dig in, find out what's in it, on it, and holding it together. It looks great, but might be inedible.

The Assistant and the Kitchen

Most likely, the assistant will use the kitchen in a more utilitarian manner. You might make coffee in the morning, or get together a few items to complement a take-out lunch. Photographic shoots are usually full day affairs. In addition to you and the photographer, an art director or stylist might be on the set. It's not uncommon for the photographer to provide some sort of refreshment.

At some point in the day, the assistant may be called on to straighten up the studio. A kitchen is a logical place to look for general purpose cleaners and trash bags. These kinds of tasks are secondary to those directly related to photography. You don't want your hands in dishwater when the photographer is ready to shoot film. Prioritize.

The Lounge Area

Many studios have a sort of lounge area. It can serve to keep people entertained and away from the set, or allow clients to get some work done while out of the office. I mention this area because it usually has a *telephone*. The assistant may or may not be responsible for answering the phone. This task might fall on the studio manager or the photographer's representative, if there is one.

However, when it's just the photographer and assistant, answering the phone is the assistant's responsibility. Freelance assistants are often viewed as employees by others on the set, and your overall demeanor can reflect on the photographer. Therefore, try to sound professional over the telephone.

When answering the phone, state the studio's name and then your first name. It's customary for any business to give its name, and no one will mistake you for the photographer. Also, ask who's calling. This turns out to be an effective screening tool for some unsolicited sales calls.

At times there can be many people on the set, try to learn their names. Besides allowing you to be more effective on the set, you'll know who gets the phone after you've answered it. The photographer may opt for you to take a message. Always get at least a name and phone number, write it down, and make certain the photographer knows where to find it.

Commercial studios try to maintain a low profile, and you should help

keep it that way. When people unrelated to the studio come to the door or call on the phone, be discrete by not volunteering unnecessary details. In fact, it's even a good idea to dispose of trash in plastic garbage bags. Studios have a lot of expensive equipment, and they're often located in the lower rent districts. In short, most photographers are justifiably paranoid about being burglarized.

The Make-up Room

When a photographer is directed towards photographing people, there's likely to be a make-up room. This is usually reserved for the stylist, and unless you're changing careers from cosmetology to photography, you have little need to be in here.

When all that's available is a bathroom, make sure it's clean. Since stylists transport several cases of equipment, remove unnecessary items, and replace them with a chair and ample lighting. It's a good idea to introduce yourself as the assistant, you might be needed to find something. Keep in mind however, you're the photographer's assistant, not the stylist's.

The Darkroom

Except for the camera, few things are associated with photography more than the darkroom. Usually a darkroom is for processing film, but it might also be a smaller changing room. A *changing room* is a darkroom dedicated to handling sheet film holders. The use of a darkroom to load and unload sheet film is presented in the chapter on view cameras.

Here, I wish to discuss the darkroom as it relates to film processing. Most commonly, this involves processing black and white negative material, and making black and white prints. These particular skills may not be put to use, at least not as much as you first thought. You will encounter E-6 film processors, and the need to print color negatives, even less often. If you lack familiarity with either of these procedures, it's not much of a handicap.

The Freelance and Full Time Assistant

As a freelance assistant, you can get by without spending much time in the darkroom. In fact, you may prefer it that way, because working the occasional darkroom job can be frustrating. First, it takes time to become familiar with a new darkroom, both the equipment and its arrangement. You can find some pretty confusing arrangements of the enlarger light, timers, safe lights, and overhead lights. Unfortunately when questions arise, you're all alone and in the dark.

Besides equipment, there are subjective decisions concerning cropping, dodging, and burning. In addition, different papers and developers have their own characteristics. When it's all said and done, it's less expensive to send it to a custom black and white lab. If the lab can't satisfy the photographer, it's doubtful the freelance assistant can.

You're more likely to work in the darkroom as a photographer's full time assistant. Under these circumstances, more time can be spent instructing the assistant as to the photographer's preferences and standards.

It shouldn't be necessary to restate: you don't say you can do something, if you can't. This is especially important concerning film processing. You can't recover incorrectly processed negative or color transparency material.

Acquiring Darkroom Skills

There's been no attempt to instruct any aspect of film processing. You can learn basic black and white processing and printing from the following *resources:* books, rental darkrooms, photographic workshops, community colleges, and continuing education programs. Used enlargers, capable of printing 35mm negatives are readily available at very reasonable prices.

Equipment and Background Storage

As demonstrated, photographers utilize a considerable amount of photographic equipment, and all of it needs to be well organized, while remaining readily accessible. Assorted hooks, like those used on peg boards, are often located on the walls bordering the shooting area. Hooks are ideal for holding lighting hardware, such as flash heads, reflectors, mounting rings, and stands. More expensive items, like power supplies and cameras, are best stored in locked cabinets. Camera stands, large soft boxes, and booms are often set in an unused corner.

Every background material needs to be be properly stored, in order to remain serviceable. Large items including four by eight foot sheets of plexiglass, foam board, and plastic laminates are commonly stored together in vertical stacks, much like books. Rolls of seamless paper must be stored vertically, and are often in the same general vicinity.

The Photographe	r's Assistant			

Photographic Specialties

s the photographer's assistant, you have the unique opportunity of being introduced to a wide range of photographic experiences. Many of your responsibilities remain unchanged, regardless of the exact photography. However, others need to be tailored to the specific assignment. The following is presented to highlight some of these differences, and how they might influence your work.

Product Photography

In many ways, much of commercial photography can be viewed as photographing a product. A building, or even a person can be considered a product. But here, I would like to address some specifics regarding studio product photography, where the emphasis is on the product. Someone specializing in small products is often referred to as a *table top* or *still life* photographer. A person might be in a product shot, but usually not as the focus of attention.

Commonly, relatively small objects are photographed using a view camera. To the uninitiated it will seem as though an inordinate amount of time is dedicated to preparation, but this kind of work requires precision and perfection. The result is that there's much to be done by the assistant. Plus, there's usually a budget to hire one.

For the assistant, product photography means a knowledge of sheet film handling responsibilities, including Polaroid instant film. The chapters on surface preparation and background materials are equally essential. And of course, expect to spend considerable time with every aspect of lighting.

Working in the Set

As any shot develops, the shooting area tends to get more crowded. Place a view camera close to the set, and the congestion just gets worse. Yet at the same time, the need to be more precise increases dramatically, both in the placement of objects and your movements.

First let's talk about you, the assistant. Be careful. You do this by being aware of what's on the set, your body position, and the fact that your actions can destroy a considerable amount of effort. If you must bump something, do so in the first ten minutes. As the set evolves, any disruption becomes potentially disastrous.

You can find yourself working with any number of people while on the set. When practical, avoid handling objects directly over a small set. A still life arrangement is often held together with little more than tape, and dropping something might compromise the shot. This is especially true when handing something to someone. Regardless of who drops it, it's your fault. Who's the photographer going to look at, you or the client who's paying for the day's shoot?

Communicating with the Photographer

The assistant often works under the photographer's direction, in order to position various objects. These might be the orientation of the product, the placement of a fill card, or the location of the soft box. To be most effective, you must understand the photographer's instructions.

Understanding requires a common basis of communication. Misunderstandings can be compounded because the photographer is often situated behind the camera, viewing an image which is upside down and backwards. In addition, as placement becomes more critical, only the slightest movement may be adequate. You must sense what is meant by "a little." It may be an inch or a millimeter. If unsure, proceed slowly.

You might find the photographer's phraseology confusing. If so, try to address your questions in the following manner. When a photographer asks you to move something to the right, assume it's to the photographer's right. Or ask, "do you mean, *camera right*?" This specifies, to the right as viewed from the camera. You can then use the terms: *camera left, away from camera*, and *towards camera*.

Other terms you're likely to hear are: in frame, and out of frame. To move something, *out of frame*, means to move it towards the closest edge, but not completely out of the frame. Conversely, *in frame*, tells you to move it towards the center. You're more likely to respond correctly to the photographer's intent, if you pay attention to what's taking place on the set. By observing, you often know what the photographer is trying to accomplish.

People Photography

Many professional photographers prefer to photograph people. This can mean a conventional portrait of a business executive or a picture of a worker on the production floor. Both photographs might also be for the same annual report and shot on the same day.

The photographer is just as likely to utilize the services of *professional models*. They may be modeling clothes in what's commonly thought of as a fashion shoot. However, there are many other photographic jobs requiring professional models. Although not glamorous, they are demanding. A model is often positioned with a product, possibly using it. Even with few props, a model can be used to convey an image or attitude about a product or service.

The selection of the appropriate model is an important aspect of the photographic message. Photographers and advertising agencies often work through modeling agencies, to arrange and meet with potential models in what's called a *casting call*. This lets the photographer review the model's portfolio and possibly take a Polaroid print. Afterwards, a selection is made.

General Considerations

When photographing people, the assistant's responsibilities can vary widely. So expect to adjust your interactions, depending on the circumstances. Early on, establish whether there's a stylist on the set. If there is, your involvement with the person to be photographed is limited.

Stylists are responsible for the model's hair, make-up, and clothing. The stylist should arrive on the set virtually self-sufficient. However, you should be more familiar with the studio, and an offer to find an appropriate chair or extension cord is not out of line.

Generally, let the photographer direct the action, followed by the art director, client, or stylist. In other words, keep quiet. After two or three individuals lend their expert opinions, additional comments can be counter productive. This doesn't mean you're not involved and you shouldn't be concerned, but it's often best to address your concerns directly to the photographer.

Regardless of who's on the set, there are a few things you can do. Refrain from offering the model anything to eat or drink. Models are there for their appearance, and even a slight mishap with a beverage or food caught between their teeth could be disastrous.

Once the model is in position, look closely for loose threads or hairs. Also, see if everything looks right. Are there any prominent, misplaced creases? Clothing, such as a business suit, is best positioned after the individual sits down.

Nonprofessional Models

You'll be involved with photographing people who aren't professional models. These individuals usually require more direction. At the same time, any advice needs to be given tactfully. Most people become very self-conscious in front of the camera, so let the photographer do most of the talking.

There are several areas where the assistant can be helpful. You'll often

stand in as the model, while the lighting arrangement evolves. If a Polaroid print is available, show it to the model. Nonprofessional models usually don't realize what's really important to the shot.

Inexperienced people commonly strike a pose, then move after the photographer makes each exposure. To alleviate the need to continually reposition the person, let the individual know approximately how much film will be exposed. Most can't imagine why a photographer would ever shoot a dozen exposures. Also, suggest that the model find a way to remember their position. Masking tape placed on the floor makes a good reference point, but it really comes down to making a concerted effort to remember how and where the body is positioned. Unfortunately, until now the person has never had a reason to think about it before.

Hand Models

At times, only a part of the body is in the shot. Generally, the tighter the crop and the closer in you're photographing, the greater the need to return to an exact position. In many of these shots, the emphasis is on the hands. Because this is difficult work, coupled with the fact that photogenic hands are not commonplace, specialized hand models exist.

When the shot calls for the use of a *nonprofessional's hand*, like the assistant's, keep these points in mind. Any pronounced veins become even more so on film. When possible, keep the arm elevated. This reduces blood flow to the hand and allows the veins to appear more normal. When circumstances permit, try to have the hand model remain seated, as it's easier to stay relaxed.

Consider constructing some form of *support* for the arm, like a short boom fitted to a light stand. This helps position the hand and the pose can be sustained with less effort. You can't have the hand begin to sweat or shake. So for those really close shots, refrain from offering or imbibing coffee.

Model Releases

When the photographer finishes exposing film, have the model sign a *model release form* (see page 192 for sample). This one page form outlines the conditions under which the photographer can use the photographs. It applies to both professional and nonprofessional models, who appear in any photograph intended for commercial use. If the photographer is covering a public event or photographing a wedding, model releases are not required.

Exposing Film

The photographer often selects a medium format camera to photograph people. This format provides a large film size and allows the photographer to shoot at a fairly fast pace. With much of product or architectural photography exposing film is anticlimactic. However, this isn't the case when there's a person in the frame.

People move and have innumerable facial expressions. Not knowing exactly what's on film, until it's processed, makes the act of exposing film inherently exciting. It also means the photographer shoots more film, just to eliminate any nagging doubt about not having the shot.

When the photographer finally goes to film, the assistant has sole responsibility for many tasks. Therefore, the assistant's role regarding the model is probably secondary. As the assistant, you need to be very familiar with film handling responsibilities regarding small and medium format cameras.

Keeping the photographer in film at all times is of primary importance. Tasks include, loading and unloading film magazines and informing the photographer when nearing the end of a roll. Due to the fast paced shooting, it's equally critical to monitor the ready light found on each power supply. The photographer can't be permitted to shoot faster than the power supply can recharge.

Wedding Photography

I'll address wedding photography briefly. Wedding photographers utilize a 35mm SLR or medium format camera. Lighting is likely to be either oncamera flash units, or electronic flash systems utilizing umbrellas. Wedding photographers hire assistants far less frequently than commercial photographers. If you wish to pursue this area of photography, contact the best and most expensive wedding photographers in your area. They're the ones who can afford assistants. Expect to work weekends, especially during the nicest time of the year. Remember, you're at the wedding to work, not to eat or socialize.

Location Photography

If you're not shooting in the studio, you're on location. The phrase "location shoot" can be correctly applied to many different kinds of photography. It might resemble a studio shoot, but photographed across town at the manufacturing site. It can also mean traveling to a unique locale, living out of a suitcase and working out of equipment cases. The hectic schedule is dictated by the assignment, possibly a once in a lifetime event.

The specific assignment and the photographer's general nature influence what equipment is required. When the photographer is primarily a studio photographer, you're likely to take whatever might conceivably be needed. Basically, transferring the studio and the control it affords to a different location.

On the other hand, location photographers tend to carry only what they really need and what can be packed into sturdy cases. Steady location work puts a premium on being resourceful, and on the ability to improvise.

There's no getting around it, location work is tiring for both the photographer and the assistant. Besides completing the shot to everyone's satisfaction, the appropriate equipment must be selected, packed into cases, and then loaded into a vehicle. Everything must be taken to the site, unpacked, and then set up. After the photograph is taken, everything must be taken down, more or less packed up, and moved to another site. Now you get to start the whole process over again. It's obvious that efficiency and doing things right the first time pay even greater dividends on location.

Background Information

When you book a location job, find out a few specifics about the day's work. Primarily, where will you be shooting, indoors or outdoors? Working at corporate headquarters is a little different than an industrial site in winter. You need to be appropriately dressed.

When you get to the studio, some additional *background information* allows you to function more effectively. Insight as to the day's photography and the camera format to be used, lets you think about what's needed to do the job. This is important whether you do most of the packing, or if the photographer is largely ready upon your arrival. Hopefully, two heads are better than one. Many photographers have *equipment lists* for various types of location shoots. Inquire about one or use the one at the end of this chapter.

The photographer can have half a dozen cases or more, and most items belong in a specific case. When packing equipment cases, make it a point to remember what goes where. Knowing where everything is kept lets you work quickly. And, since you'll be working out of these cases throughout the day, it's the only way to keep organized.

Load the vehicle so that the most needed items are readily accessible. Getting to the site and having to unload half the van just to find the camera and tripod isn't the best way to start the day. Before closing the doors, check to see if a hand cart is available.

Working on Site

Upon arriving at the site, remember that your actions influence how professional both you and the photographer appear to be. You're also likely to be intruding on someone's property or work place, so show respect. While on location, you'll often need or benefit from someone's help, and starting off on the right foot makes your job easier. For most people, a commercial photography shoot is quite different than first imagined. They're often very intrigued, and willing to lend a hand by rounding up a ladder or some props.

Surveying the Site

Before unpacking, survey the work area. Try to find a lesser used corner, as opposed to the hallway. While working, keep unneeded equipment confined to cases or to a limited area. It doesn't take long to have valuable equipment spread everywhere. This increases the chance of breakage or theft, and makes moving to another site difficult. If there's public access to the work site, you must take even greater care to watch equipment, especially recognizable items like cameras and lenses.

One of the first things you need to locate are *electrical outlets*, to supply power for artificial lighting. Hopefully, you brought plenty of *extension cords*. They're essential on most location shoots. If you find yourself in a crowded area, position equipment and their various electrical cords away from the main flow of traffic.

In heavily trafficked areas tape extension cords to the floor with duct tape. Also, booms and their counterweights should be positioned and marked for everyone's safety. When working in *older buildings* try using the power supply's slow recycle setting. If the longer recycle time isn't a hindrance,

this reduces the chance of blowing a fuse.

When combining electronic flash and other artificial lights in one exposure, the shutter often remains open for a relatively long period. Under these circumstances, extraneous lights need to be turned off. In new office buildings one switch often controls many lights, particularly with fluorescent lighting. Individual *fluorescent lights* can be turned off, by rotating the tube about one-fourth of a revolution. If you rotate it further, it's likely to fall out, so be careful.

Leaving the Site

As the shot winds down, you literally have to undo everything you've done. Now comes the test, as to whether you know which case holds what photographic equipment. Once packed, you're still not done, you've got to return the work area to its original condition. This means removing tape, replacing furniture, and one last look for equipment. During a multiday shoot, inquire about a secure room in which to store some gear overnight. This can save valuable time and energy the following morning.

As you throw everything back into the vehicle, keep the exposed film accessible. Your first stop on the way back to the studio may be to the processing lab. If the photographer exposed sheet film, your first responsibility once in the studio may be to unload a few film holders.

Audio-Visual Assignments

One assisting job that's usually done on location is producing an audiovisual presentation, or *slide show*. This requires a 35mm SLR camera, tape recorder, and possibly artificial lighting. If sound isn't being recorded, the assistant's responsibilities resemble any shoot. However, when both the visual and audio portions are being produced, extra care must be taken to control noise.

Often the production of the audio and visual segments must be completed sequentially, because the sound of the camera and the strobes is quite intrusive. When the shooting stops, taping the audio portion can begin. Unfortunately, the time when you must be absolutely quiet is the only time you have to deal with reloading and reorganization.

This concern also applies when working on a *film set*. Here, the photographer and assistant are often shooting *production stills*, and both of you are a secondary part of the activity. If you foresee being restricted in your actions, look for an isolated spot to regroup. The ability to keep a low profile while still performing all tasks is essential in many assisting jobs.

Overnight Assignments

A location assignment can involve overnight travel. It might be to any kind of destination, but whether commonplace or exotic, it's usually all work. As you might expect, now it's even more important to have a good rapport with the photographer.

One way to maintain a good working relationship is to discuss a few details when booking the job. Like any location shoot, get enough background information to pack the appropriate attire. This is especially important when

working outdoors. Also, clarify your rates and how travel expenses will be handled. It's reasonable to expect all expenses for transportation, lodging, and meals are to be paid by the photographer when incurred. Still, carry some cash and a major credit card.

Acquiring Location Work

If you have a real interest in location work, particularly overnight travel, pursue it. There are several approaches you might take. One is to find established *local photographers*, who receive assignments from national magazines or out-of-town clients. Also, review the local creative directories for photographers who emphasize location work.

Another way to acquire location work is advertise your services to *out-of-town photographers*, who might travel to your region. It helps to keep a high profile and to be listed on any assistants list circulated in your area. Consider becoming a member of the American Society of Magazine Photographers (ASMP) and running a classified ad in the magazine *Photo District News*.

Architectural Work

Architectural photography involves photographing the *exteriors* and *interiors* of architectural structures. The photographer uses a view camera to control perspective and must often integrate different kinds of light, such as natural daylight, electronic flash, tungsten, fluorescent, or sodium vapor. Balancing multiple light sources is accomplished through the selection of film type, filters, and artificial light sources. Architectural photography is an area where tungsten balanced film and tungsten lighting is used to complement existing light sources.

Whatever the light source, the photographer is often confronted with the problem of lighting large areas. This translates to a need for lots of power and many lights. Lights are commonly fitted with reflectors and the light is bounced off a wall, the ceiling, a large fill card, or an umbrella. A more diffuse light source is obtained by taping diffusion material over the flash head's reflector, in preference to using a bulky soft box.

These many lights and power supplies must be concealed from the camera's view. Under these conditions, radio transmitters are an excellent replacement for sync cords and flash slaves to ensure every power supply discharges.

When radio transmitters aren't available, it's helpful to attach the power supply's *flash slave to an extension cord*. The flash slave is then positioned to receive sufficient light, while remaining hidden from view. If using tape, attach it to the extension cord, not to the flash slave.

Working Hours

For a variety of reasons architectural photographers work at odd hours. Many locations, both public and private, simply aren't available to the photographer during traditional business hours. For other jobs, such as photo-

graphing a building's exterior, it might be important to integrate natural daylight with the structure's artificial lights. This is best accomplished at sunrise and sunset. Consequently, the assistant should expect to work unconventional hours.

A Giant Still Life

In some ways, it's useful to view an architectural shot as a product shot, only bigger. This is particularly true for *interiors*. Therefore, be familiar with the chapter on surface preparation, especially for carpet. Glass cleaner and paper towels are probably the best choices to handle the range of surfaces encountered on an architectural shoot.

In addition to surface preparation, objects need to be correctly oriented. Besides an object's location in the frame, it's important that horizontal surfaces appear horizontal and vertical lines, vertical, when you view through the camera. Check to make certain that lamp shades, table tops, and picture frames look level, and that drapes hang vertically. Due to an architectural project's size, a ladder can be essential.

Fabrics found on furniture, pillows, and bed spreads must be free of wrinkles. Lamp and telephone cords should be hidden from view. When that's not possible, wires should be positioned to be least obtrusive.

Reflective surfaces, like mirrors and glass, can cause problems. They must not reflect the camera, lighting, or the assistant. Oftentimes, objects like picture frames can be tilted from behind by using small pieces of cardboard. When you feel the problem is alleviated, check the result from behind the camera.

Summary of Responsibilities Related to Photographic Specialties

Product Photographu

☐ Expect to be involved with many <i>set building</i> tasks.
☐ Proper <i>preparation of all surfaces</i> is especially critical.
☐ Precise <i>positioning of objects</i> is often required.
☐ Much time is dedicated to the <i>lighting</i> arrangement.
☐ Tasks related to the use of <i>sheet film</i> are integrated throughout the day.

People Photography ☐ Allow the photographer, art director, or stylist to direct the model.
☐ If a stylist isn't available, inform nonprofessional models of the <i>number of exposures</i> to be made; relay what's important to the shot by showing them a Polaroid print.
showing them a rotatora print.

☐ Remember, the assistant has sole responsibility for specific tasks. However, when conditions dictate <i>look for fatal flaws</i> , such as errant hairs or awkward creases in clothing.
☐ Monitor the film exposure process closely. Keep the photographer supplied with film.
☐ Monitor the power supply's ready light under fast shooting conditions.

Location Photography
\Box Understand the job, so you can dress appropriately.
☐ Determine the camera format and general requirements for the day's shoot, in order to pack most effectively.
☐ <i>Load vehicle</i> , with the most needed items readily accessible. Check for a hand cart.
☐ Remember what equipment goes in each case.
☐ Keep close tabs on all equipment when on site, especially cameras and lenses.
☐ Watch for everyone's <i>safety</i> , tape down electrical cords and flag the boom's counterweight.
☐ Realize <i>you're intruding</i> on someone's work place or property, and act accordingly.
\square After the shot, return the site to its original condition.
☐ <i>Keep exposed film readily accessible</i> when returning to the studio.
Architectural Photography
\Box Treat an architectural shot, particularly interiors, as a giant still life.
☐ Expect to work with a variety of light sources.
☐ When packing include cleaning items, a <i>ladder</i> , and plenty of <i>extension cords</i> .
☐ Be prepared to act quickly, especially under fast-changing lighting conditions.
☐ It's important that <i>horizontal surfaces appear horizontal</i> and <i>vertical lines</i> , <i>vertical</i> . Check picture frames, table tops, and drapes.
☐ Be watchful of <i>reflective surfaces</i> , such as mirrors and glass.
☐ Expect to work unconventional hours.

Location Equipment Check List

☐ View Camera with standard and wide angle (bag) bellows
☐ Lenses, cable release, and sync cords
☐ Dark cloth and focusing loupe
☐ Compendium, filter frame, and filters
lacksquare Polaroid film holder and Polaroid instant film
☐ Loaded sheet film holders
☐ Changing tent or bag
☐ Tripod and possibly 3/8" to 1/4" reducing bushing
<u> </u>
<u> </u>
☐ Small and medium format camera bodies
☐ Film magazines
☐ Lenses, cable release, and sync cords
\square Lens shade, filter frame, and filters
lacksquare Polaroid film holder and Polaroid instant film packets
☐ Roll film and storage bags
\square Spare batteries for the camera and motor drive
☐ Tripod and possibly 3/8" to 1/4" reducing bushing
_
<u> </u>
☐ Power supplies, power cords, and extension cords
☐ Sync cord and flash slaves, or radio transmitter/receivers with batteries
☐ Flash Heads with flash tube protectors
☐ Inserts/adapters to fit flash heads to light stands
☐ Flash meter with batteries
☐ On-camera flash unit and sync cord
☐ Battery pack and battery pack recharger
<u> </u>
<u> </u>

Reflectors for flash heads
☐ Soft boxes and mounting (speed) rings
☐ Diffusion material and colored gels
☐ Fill cards, especially white and black; black velvet cloth

☐ Stands of all sizes
☐ Boom and counterweight
☐ Crossbar for background materials
☐ Shot bags
☐ Clamps of all sizes
☐ Tape including: gaffers, black photographic, white artists, duct, double-stick, and masking

lacksquare Background material and specific cleaning materials
☐ Background supports
☐ Surface preparation material including window cleaner, paper towels, dull spray, temporary adhesive, erasers, and white gloves
☐ Canned-air
☐ Scissors, straight edge, and utility knife
☐ L-shaped croppers and proportion wheel
☐ Ladder and hand cart
☐ Directions
☐ Model release forms
☐ Spare batteries for camera, light meter, flash units, radio transmitters
☐ Pocket knife, flashlight, indelible pen

<u> </u>

How to Learn While Assisting

hat the assistant needs to know has been presented in almost every chapter. However, besides providing a service, assisting is also the best opportunity to learn about all aspects of photography. But little can be gained by passively observing what's happening on the set. Certainly, you'll learn which processing labs are best and the preferred types of equipment. But there's much more. To realize this potential takes a conscious and directed effort.

Be a Good Assistant

One of the most basic ways to learn is to work hard at being a good assistant. By concentrating on the photographer and the progress of the shot, you not only sense the photographer's needs, you begin to think like a professional photographer.

In addition, the repetition of basic photographic tasks is a tremendous benefit to learning. Eventually, you become proficient at the many photographic processes that, if not done correctly, can subtract from the final image. With consistency comes the ability to improvise and create new solutions.

It's important to remember that assisting isn't one continuous question and answer session. Rather than asking numerous questions, try to think of the answer yourself. If you remain perplexed, approach the photographer at a less hectic moment or at the end of the day.

Lighting is one of the most critical aspects of good photography. Here, much can be learned by following the evolution of the lighting arrangement and reviewing the resulting series of Polaroid prints. Since these prints are sequentially numbered, they can be examined later in the day.

On your way home from the job, reflect on the day's activities. This will make you a better assistant and technical or creative aspects of the shot are more likely to be remembered. Consider keeping a notebook. In it you can record information, such as filter combinations for mixed lighting conditions or perhaps a unique light modifying device.

Finally, review the discussion on freelance versus full time assisting. Your decision, and how you market your services, can profoundly influence who you work for and the type of photography you encounter. Ultimately, this affects what you learn.

Keep Shooting

Assisting is so beneficial because you learn by doing. You'll find that your own photography will progress at a faster rate if you continue to shoot frequently while assisting. This is partly because you can employ recently learned techniques, but you'll also become more critical of your own work, and consequently more demanding.

Unfortunately, your progress can be hindered by a lack of equipment or shooting space. If this is the case, review the section on establishing your rates and consider exchanging your services for the use of these items. With time, you'll know which photographers might be receptive to your proposal, and they'll know they can trust you with their equipment. If they didn't, they wouldn't continue to hire you.

Making the Most of What's Available

Many photographers continue to learn by being involved with professional organizations in their city. Local branches of the A.S.M.P. and A.P.A. have regular meetings, which are open to nonmembers for a small charge. These expose you to a variety of topics, while introducing you to the local photographic community.

And, finally, continue to read. Get into the stream of printed information that's readily available to the professional photographer. These include books, professional magazines, and equipment catalogs. Many of these resources are listed in the following appendices and provide a good starting point.

An Interview with **Shel Secunda**

hel Secunda is an advertising and editorial photographer based in New York City. He specializes in photographing people and his subjects range from children to celebrities. Currently he is placing more and more emphasis on art photography.

John Kieffer: What do you look for most in an assistant regarding their personal attributes?

Shel Secunda: I guess the most important thing to me is how I perceive their attitude. I am less interested in the quality of their own photography. If there is an eagerness and a curiosity, that's much more important to me than who they've worked for or where they've gone to school. For instance, if I like them and they're not familiar with the Hasselblad, I'll let them visit the studio and practice loading my Hasselblad® back. That's an important skill and it can be learned quickly.

Also, overall personal appearance is important and I'm not talking about anything as specific as length of hair. A major turn off is someone who looks dirty or grubby. Beyond that I require a cheerful attitude. I don't want someone who is a downer on the set.

J.K.: Do you interview potential assistants?

S.S.: I screen and interview my assistants very carefully and I tend to interview those people who have contacted me. That shows they're interested in me. It's often in the form of a letter saying they've seen my work. Nothing turns me off more than an assistant calling me and saying, "by the way, what kind of work do you do?" That indicates a lack of interest, immediately. But most assistants who contact me do so because they've seen my work in various creative directories and are smart enough to butter me up a little bit.

When I interview assistants I take Polaroid pictures of them, which I keep with their resumes. Also, I ask them for references and I check the references. What's always amazing to me is the number of kids who assume you're not going to check the references, and apparently a lot of photographers don't. I've had assistants give a photographer's name as a reference and I'll call the photographer and the photographer will say, "He gave you me as a reference? That kid cleaned out my cash box!"

J.K.: Do you like to see an assistant's portfolio and what's important in it?

S.S.: In an assistant's portfolio I look for photographs that indicate craftsmanship and attention to detail. It's nice that they're very artistic and creative, but if somebody shows me a whole portfolio of blurred, abstract pictures, that really doesn't show me very much.

When I look at their work, I like to see their black and white. This gives me an indication of their darkroom skills. I do a lot of black and white and I need skills in that area. Since I don't do any color printing or processing in the studio that's not important to me.

J.K.: Are most of the people who contact you about assisting graduates from a photographic school or have many learned on their own?

S.S.: Now a days the vast majority are graduates. They come from photography schools such as R.I.T. and Brooks, or they've gone to a school such as New York University which has a very fine photography major. In my early days it wasn't this way.

J.K.: Do you have a full time assistant or do you use free lancers?

S.S.: Throughout most of my career I've had a full time assistant and would hire two to three additional free lancers depending on the scope of the job. But for the last year or so I've decided to go without a full time assistant. I have several free lancers who work for me on a fairly regular basis. They have keys to my studio, so they're almost full timers in terms of my trust. I also let them use my studio for their darkroom work. It works out much better financially and every other way because it also gives me great freedom. When you have a full timer and things get a little slow you get anxious.

J.K.: I'm curious, do you have any preference for male or female assistants? **S.S.:** Over the years I've had three women as full timers and I use women as free lancers. The only thing I'm careful about is that they are reasonably strong.

I ask them directly because I don't want to be picking up a heavy case just because I'm concerned about a female assistant not being able to. As long as they assure me that they expect no preferential treatment, then I make no distinction.

In many areas I prefer a woman assistant. There are a lot of things I feel a female assistant can do that a male assistant can't. I do a lot of work with children and they can be very helpful under those circumstances, or if something needs sewing. Let's face it—the average young woman can sew better than a man.

J.K.: Do your female assistants ever get involved with styling or do you have a stylist on the set?

S.S.: I almost always have a stylist on the set. I never hire a female assistant with the idea of having her function as a stylist.

J.K.: Do you set any ground rules regarding the assistant's etiquette on the set? Do you like assistants to interact with the client or or do you prefer them to stay in the background?

S.S.: I have very firm ground rules on that score, best summed up in two words, "dummy up." I let them know right away, and it's not because of anxiety that they'll steal my clients. Over the years I've found that a loquacious assistant can be very detrimental to a shoot, whether he's engaging the models in conversation or the client. He's not only not paying attention to me so that if I need something I have to first get his attention, but he's also distracting either the model or the client and I might want their attention. So I tell all my assistants to be friendly, but do not initiate conversation with either the clients or models. I also tell them

to make sure to pay attention to me at all times. Anyone who doesn't seem to get the message doesn't work for me very long.

J.K.: Earlier you mentioned the Hasselblad and the importance of loading film, have you had any disasters caused by assistants?

S.S.: I had one that could have been, but it turned out to be rather funny. Early in my career, I had a studio manager and he had an assistant. Well, one day on a shoot the studio manager had to go into the darkroom to start processing film, leaving the assistant to load the film magazines and hand them to me. My studio manager had worked with me for long time and we had a short hand jargon worked out. When I would hand him a magazine I would say "dump it," meaning take the roll of film out and put another roll in.

This kid had never assisted me directly and I'd hand him a magazine and say, "dump it." At the same time he'd hand me another loaded film magazine and I'd continue to shoot. After about an hour I turned and looked at the work cart and asked "where's the film?" He replied, "you said 'dump it'." He was methodically watching me shoot the film, and when I'd say dump it he would take the film out of the back and throw it in the garbage. Luckily, even though he had not sealed the ends of the rolls the film had not unraveled too much, and we only had fog on the last shot of each roll. I just marvelled that some people can follow orders so literally.

J.K.: Have you had any occasions where the assistant performed above the call of duty and saved the shot?

S.S.: I'm a great believer in praise whenever an assistant does something great. The first thing I tell them before a shoot is that their primary job is to save my ass and to keep me from totally screwing up. Once I get really involved in a shoot I might overlook some basics, like setting the f-stop correctly, or checking depth of field, or whether or not I pulled the dark slide on a back. It's a fail-safe.

Earlier when I said I didn't want them talking to anybody it's because I really need their total attention to make sure I don't screw up, and I give them that responsibility right at the beginning of the shoot. I want them to say to me, "slide?", "F-stop?", just before I start each roll or each new setup. I need them to pay close attention to me. Whenever somebody catches me about to screw up I'll say "that's one for you."

I'm a photographer who likes to do most things myself. I like to actually put the film magazine on the back of the camera myself. That way, if it falls off because it wasn't put on properly, it's my fault. I don't want to have anyone to blame. I'm not one of those screaming photographers but I've heard many stories of assistant abuse.

Another way I avoid mistakes is that I shoot everything on two cameras, at least in the studio where there is a controlled environment. I have two Hasselblads and my assistant always has the second one ready. It's usually on another tripod which I slide into place. To save time he keeps track of my f-stop, shutter speed, and approximate focus. It's not that I shoot twice as much film. I shoot half of each setup on each camera.

Later when I have my film processed I do split runs. I process every other roll and I run the remaining film only after the first film is done. If there was ever a power failure at the lab I could loose an entire job. There are people worse than I am. I know one very successful competitor of mine who won't even send all of his film to the lab at the same time. There's so much money invested in the shoots I do, that not having backups would be irresponsible.

J.K.: When you go on a location shoot lasting several days, do you take your assistant with you or do you try to hire an assistant after you arrive at the location?

S.S.: It varies. I did a job recently in Richmond, VA and since it didn't require a lot of lights I only took one very reliable assistant with me. In this instance I didn't know if I could find a reliable assistant in that area. On the other hand I did a job about two years ago out in California and all I brought were my cameras. I rented everything and shot in studios and on location. But Los Angeles abounds with capable assistants and I have people I know out there who can recommend assistants. I hired one guy who took care of everything. He rented the equipment, hired the second and third assistants, and found the stylist. It was amazing and you can do that in certain cities.

J.K.: What do you pay a freelance assistant for a day's services in New York City?

S.S.: Rates are all over the place. Some are as low as \$80 a day, and the highest anybody has asked is \$150.

J.K.: When you take an assistant on a multiple day location shoot do you stick with the same day rate?

S.S.: It depends. If it's going to be for quite a few days I'll pay them a little less, maybe work out a weekly rate. But if it's only three days I pay a regular day rate, including travel time and all expenses.

J.K.: What do you think the climate is like for assistants who graduate from a school and spend a couple of years assisting and want to become professional photographers?

S.S.: I think the outlook is very bleak, certainly in advertising. What I read in the trades also tells me that things are down. It has very little to do with the recession the country at large is in because the down turn in advertising started a couple of years ago. What is growing is the stock photography business because more and more agencies are using stock. I would recommend stock as a very important part of anything a young photographer does. Be prepared to build up a vast collection of stock photographs because that seems to be where the business is going.

J.K.: What do you think of assisting as a way to learn photography?

S.S.: I think it's really an excellent way. I never assisted myself and I never went to photography school, I'm totally self-taught. I did several other things before I became a photographer and I came to it accidently. At the time I was a theatrical press agent and my employer knew that I was a fairly capable photographer. He'd seen my work and asked me to photograph one of the Broadway

plays he was handling. I soon realized that I really loved photography, but not that kind of photography. I asked around to find out where the money was, and I was told it's in advertising so here I am all these years later.

Assisting certainly would have been helpful—I had to learn a lot of things the hard way. I read a lot and joined photography organizations. That's how I learned, but I'm sure it's much faster to go to school or assist. I'd say that assisting is absolutely essential nowadays because there's just so much to know. When I started twenty years ago it was so much simpler: for one thing, there were far fewer photographers.

J.K.: Do you have any advice for aspiring assistants or comments about photography in general?

S.S.: A couple of years ago I went to a consultant and I would pass on to aspiring photographers what was advised to me. It might sound very simplistic but if I'd had that advice years before, my career might have been even more rewarding and richer than it has been, and I'm not complaining.

I showed them all these commercial things I had done, along with a sprinkling of personal pictures. It was what I felt the market wanted. I guess it was obvious to the consultant, that I really wasn't shooting that much from the heart. So I started adding more and more of my personal pictures to my portfolio, mainly black and white, and the reaction has been absolutely wonderful. My work has picked up, I'm doing better than I've done in years and I attribute it all to the reaction of art directors to my personal work. I still include the commercial work to let them know that I can follow a layout and satisfy their requirements, but I also want to give them a hint of my vision.

I had always done personal photography and now my greatest aspiration is to see my work in galleries. However, it's very hard for someone who's a commercial photographer to break into the art photography world. I think there are a handful who've successfully crossed over—Irving Penn, Arnold Newman, Elliott Erwitt, and a few others.

I would also emphasize to any beginning photographer the importance of satisfying the needs of the client. In advertising, if you get a layout from an art director you can bet that it has passed through maybe twenty or thirty hands, with all of them stamping their approval. When the final photograph goes back to the client and it doesn't somewhat resemble the layout he has approved, there are going to be a lot of questions asked.

Model Release

of which is acknowledged, I,	In consideration of	Dollars (\$), and other valuable consideration, receipt					
his or her assigns, licensees, successors in interest, legal representatives, and heirs the irrevocable right to use my name (or any fictional name), picture, portrait, or photograph in all forms and in all media and in all manners, without any restriction as to changes or alterations (including but not limited to composite or distorted representations or derivative works made in any medium) for advertising, trade, promotion, exhibition, or any other lawful purposes, and I waive any right to inspect or approve the photograph(s) or finished version(s) incorporating the photograph(s), including written copy that may be created and appear in connection therewith. I hereby release and agree to hold harmless the Photographer, his or her assigns, licensees, successors in interest, legal representatives and heirs from any liability by virtue of any blurring, distortion, alteration, optical illusion, or use in composite form whether intentional or otherwise, that may occur or be produced in the taking of the photographs, or in any processing lending toward the completion of the finished product, unless it can be shown that they and the publication thereof were maliciously caused, produced, and published solely for the purpose of subjecting me to conspicuous ridicule, scandal, reproach, scorn, and indignity. I agree that the Photographer owns the copyright in these photographs and I hereby waive any claims I may have based on any usage of the photographs or works derived therefrom, including but not limited to claims for either invasion of privacy or libel. I am of full age* and competent to sign this release. I agree that this release shall be binding on me, my legal representatives, heirs, and assigns. I have release. I approve the foregoing and waive any rights in the premises. Mitness: Date:	of which is acknowledged, I,		(print Model's name)					
use my name (or any fictional name), picture, portrait, or photograph in all forms and in all media and in all manners, without any restriction as to changes or alterations (including but not limited to composite or distorted representations or derivative works made in any medium) for advertising, trade, promotion, exhibition, or any other lawful purposes, and I waive any right to inspect or approve the photograph(s) or finished version(s) incorporating the photograph(s), including written copy that may be created and appear in connection therewith. I hereby release and agree to hold harmless the Photographer, his or her assigns, licensees, successors in interest, legal representatives and heirs from any liability by virtue of any blurring, distortion, alteration, optical illusion, or use in composite form whether intentional or otherwise, that may occur or be produced in the taking of the photographs, or in any processing tending toward the completion of the finished product, unless it can be shown that they and the publication thereof were maliciously caused, produced, and published solely for the purpose of subjecting me to conspicuous ridicule, scandal, reproach, scorn, and indignity. I agree that the Potographer owns the copyright in these photographs and I hereby waive any claims I may have based on any usage of the photographs or works derived therefrom, including but not limited to claims for either invasion of privacy or libel. I am of full age* and competent to sign this release. I agree that this release shall be binding on me, my legal representatives, heirs, and assigns. I have release. I approve the foregoing and waive any rights in the premises. Witness: Signed:			(the Photographer),					
manners, without any restriction as to changes or alterations (including but not limited to composite or distorted representations or derivative works made in any medium) for advertising, trade, promotion, exhibition, or any other lawful purposes, and I waive any right to inspect or approve the photograph(s) nicripition, or any other lawful purposes, and I waive any right to inspect or approve the photographer, his or her assigns, licensees, successors in interest, legal representatives and heirs from any liability by virtue of any blurring, distortion, alteration, optical illusion, or use in composite form whether intentional or otherwise, that may occur or be produced in the taking of the photographs, or in any processing tending toward the completion of the finished product, unless it can be shown that they and the publication thereof were maliciously caused, and published solely for the purpose of subjecting me to conspicuous ridicule, scandal, reproach, scorn, and indignity. I agree that the Photographer owns the copyright in these photographs and I hereby waive any claims I may have based on any usage of the photographs or works derived therefrom, including but not limited to claims for either invasion of privacy or libel. I am of full age* and competent to sign this release. I agree that this release shall be binding on me, my legal representatives, heirs, and assigns. I have read this release and am fully familiar with its contents. Mitness:	nis or ner assigns, licensees, succ	cessors in interest, legal r	epresentatives, and heirs the irrevocable right to					
distorted representations or derivative works made in any medium) for advertising, trade, promotion, exhibition, or any other lawful purposes, and I waive any right to inspect or approve the photograph(s) or finished version(s) incorporating the photograph(s), including written copy that may be created and appear in connection therewith. I hereby release and agree to hold harmless the Photographer, his or her assigns, licensees, successors in interest, legal representatives and heirs from any liability by virtue of any blurring, distortion, alteration, optical illusion, or use in composite form whether intentional or otherwise, that may occur or be produced in the taking of the photographs, or in any processing tending toward the completion of the finished product, unless it can be shown that they and the publication thereof were maliciously caused, produced, and published solely for the purpose of subjecting me to conspicuous ridicule, scandal, reproach, scorn, and indignity. I agree that the Photographer owns the copyright in these photographs and I hereby waive any claims I may have based on any usage of the photographs or works derived therefrom, including but not limited to claims for either invasion of privacy or libel. I am of full age* and competent to sign this release. I agree that this release shall be binding on me, my legal representatives, heirs, and assigns. I have read this release and am fully familiar with its contents. Middle	use my name (or any fictional name), picture, portrait, or photograph in all forms and in all media and in all							
bition, or any other lawful purposes, and I waive any right to inspect or approve the photograph(s) or finished version(s) incorporating the photograph(s), including written copy that may be created and appear in connection therewith. I hereby release and agree to hold harmless the Photographer, his or her assigns, licensees, successors in interest, legal representatives and heirs from any liability by virtue of any blurring, distortion, alteration, optical illusion, or use in composite form whether intentional or otherwise, that may occur or be produced in the taking of the photographs, or in any processing tending toward the completion of the finished product, unless it can be shown that they and the publication thereof were maliciously caused, produced, and published solely for the purpose of subjecting me to conspicuous ridicule, scandal, reproach, scorn, and indignity. I agree that the Photographer owns the copyright in these photographs and I hereby waive any claims I may have based on any usage of the photographs or works derived therefrom, including but not limited to claims for either invasion of privacy or libel. I am of full age* and competent to sign this release. I agree that this release shall be binding on me, my legal representatives, heirs, and assigns. I have read this release and am fully familiar with its contents. Witness:								
ished version(s) incorporating the photograph(s), including written copy that may be created and appear in connection therewith. I hereby release and agree to hold harmless the Photographer, his or her assigns, licensees, successors in interest, legal representatives and heirs from any liability by virtue of any blurring, distortion, alteration, optical illusion, or use in composite form whether intentional or otherwise, that may occur or be produced in the taking of the photographs, or in any processing tending toward the completion of the finished produced, and published solely for the purpose of subjecting me to conspicuous ridicule, scandal, reproach, scorn, and indignity. I agree that the Photographer owns the copyright in these photographs and I hereby waive any claims I may have based on any usage of the photographs or works derived therefrom, including but not limited to claims for either invasion of privacy or libel. I am of full age* and competent to sign this release. I agree that this release shall be binding on me, my legal representatives, heirs, and assigns. I have read this release and am fully familiar with its contents. Mitness:								
connection therewith. I hereby release and agree to hold harmless the Photographer, his or her assigns, licensees, successors in interest, legal representatives and heirs from any liability by virtue of any blurring, distortion, alteration, optical illusion, or use in composite form whether intentional or otherwise, that may occur or be produced in the taking of the photographs, or in any processing tending toward the completion of the finished product, unless it can be shown that they and the publication thereof were maliciously caused, produced, and published solely for the purpose of subjecting me to conspicuous ridicule, scandal, reproach, scorn, and indignity. I agree that the Photographer owns the copyright in these photographs and I hereby waive any claims I may have based on any usage of the photographs or works derived therefrom, including but not limited to claims for either invasion of privacy or libel. I am of full age* and competent to sign this release. I agree that this release shall be binding on me, my legal representatives, heirs, and assigns. I have read this release and am fully familiar with its contents. Witness:								
licensees, successors in interest, legal representatives and heirs from any liability by virtue of any blurring, distortion, alteration, optical illusion, or use in composite form whether intentional or otherwise, that may occur or be produced in the taking of the photographs, or in any processing tending toward the completion of the finished producet, unless it can be shown that they and the publication thereof were maliciously caused, produced, and published solely for the purpose of subjecting me to conspicuous ridicule, scandal, reproach, scorn, and indignity. I agree that the Photographer owns the copyright in these photographs and I hereby waive any claims I may have based on any usage of the photographs or works derived therefrom, including but not limited to claims for either invasion of privacy or libel. I am of full age* and competent to sign this release. I agree that this release shall be binding on me, my legal representatives, heirs, and assigns. I have read this release and am fully familiar with its contents. Date:	connection therewith. I hereby release and agree to hold harmless the Dhatagrapher, his as he assissed							
distortion, alteration, optical illusion, or use in composite form whether intentional or otherwise, that may occur or be produced in the taking of the photographs, or in any processing tending toward the completion of the finished product, unless it can be shown that they and the publication thereof were maliciously caused, produced, and published solely for the purpose of subjecting me to conspicuous ridicule, scandal, reproach, scorn, and indignity. I agree that the Photographer owns the copyright in these photographs and I hereby waive any claims I may have based on any usage of the photographs or works derived therefrom, including but not limited to claims for either invasion of privacy or libel. I am of full age* and competent to sign this release. I agree that this release shall be binding on me, my legal representatives, heirs, and assigns. I have read this release and am fully familiar with its contents. Witness:								
occur or be produced in the taking of the photographs, or in any processing tending toward the completion of the finished producet, unless it can be shown that they and the publication thereof were maliciously caused, produced, and published solely for the purpose of subjecting me to conspicuous ridicule, scandal, reproach, scorn, and indignity. I agree that the Photographer owns the copyright in these photographs and I hereby waive any claims I may have based on any usage of the photographs or works derived therefrom, including but not limited to claims for either invasion of privacy or libel. I am of full age* and competent to sign this release. I agree that this release shall be binding on me, my legal representatives, heirs, and assigns. I have read this release and am fully familiar with its contents. Witness:								
of the finished product, unless it can be shown that they and the publication thereof were maliciously caused, produced, and published solely for the purpose of subjecting me to conspicuous ridicule, scandal, reproach, scorn, and indignity. I agree that the Photographer owns the copyright in these photographs and I hereby waive any claims I may have based on any usage of the photographs or works derived therefrom, including but not limited to claims for either invasion of privacy or libel. I am of full age* and competent to sign this release. I agree that this release shall be binding on me, my legal representatives, heirs, and assigns. I have read this release and am fully familiar with its contents. Witness:	occur or be produced in the taking	of the photographs, or in	n any processing tending toward the completion					
produced, and published solely for the purpose of subjecting me to conspicuous ridicule, scandal, reproach, scorn, and indignity. I agree that the Photographer owns the copyright in these photographs and I hereby waive any claims I may have based on any usage of the photographs or works derived therefrom, including but not limited to claims for either invasion of privacy or libel. I am of full age* and competent to sign this release. I agree that this release shall be binding on me, my legal representatives, heirs, and assigns. I have read this release and am fully familiar with its contents. Witness:								
scorn, and indignity. I agree that the Photographer owns the copyright in these photographs and I hereby waive any claims I may have based on any usage of the photographs or works derived therefrom, including but not limited to claims for either invasion of privacy or libel. I am of full age* and competent to sign this release. I agree that this release shall be binding on me, my legal representatives, heirs, and assigns. I have read this release and am fully familiar with its contents. Witness: Signed: Model Address: Address: Signed: Parent or guardian of the minor named above and have the legal authority to execute the above release. I approve the foregoing and waive any rights in the premises. Witness: Signed: Parent or Guardian Address: Address: Parent or Guardian Address: Address: Parent or Guardian must then sign the consent.								
waive any claims I may have based on any usage of the photographs or works derived therefrom, including but not limited to claims for either invasion of privacy or libel. I am of full age* and competent to sign this release. I agree that this release shall be binding on me, my legal representatives, heirs, and assigns. I have read this release and am fully familiar with its contents. Witness: Signed: Model Address: Address: One the premises. I am the parent or guardian of the minor named above and have the legal authority to execute the above release. I approve the foregoing and waive any rights in the premises. Witness: Signed: Parent or Guardian Address: Address: Parent or Guardian Address: Address: Parent or Guardian must then sign the consent.	scorn, and indignity. I agree that	the Photographer owns t	he copyright in these photographs and I hereby					
release. I agree that this release shall be binding on me, my legal representatives, heirs, and assigns. I have read this release and am fully familiar with its contents. Witness: Signed:	waive any claims I may have base	d on any usage of the pho	otographs or works derived therefrom, including					
Witness: Signed: Model Address: Address: T9 Consent (if applicable) Consent (if applicable) I am the parent or guardian of the minor named above and have the legal authority to execute the above release. I approve the foregoing and waive any rights in the premises. Witness: Signed: Parent or Guardian Address: Address: Address:	but not limited to claims for either	but not limited to claims for either invasion of privacy or libel. I am of full age* and competent to sign this						
Witness: Signed: Model Address: Address: Date:, 19 Consent (if applicable) I am the parent or guardian of the minor named above and have the legal authority to execute the above release. I approve the foregoing and waive any rights in the premises. Witness: Signed:	release. I agree that this release sh	nall be binding on me, my	legal representatives, heirs, and assigns. I have					
Address: Address: Date:, 19 Consent (if applicable) I am the parent or guardian of the minor named above and have the legal authority to execute the above release. I approve the foregoing and waive any rights in the premises. Witness: Signed: Parent or Guardian Address: Address: Date:, 19 * Delete this sentence if the subject is a minor. The parent or guardian must then sign the consent.	read this release and am fully fam	illiar with its contents.						
Address: Address: Date:, 19 Consent (if applicable) I am the parent or guardian of the minor named above and have the legal authority to execute the above release. I approve the foregoing and waive any rights in the premises. Witness: Signed: Parent or Guardian Address: Address: Date:, 19 * Delete this sentence if the subject is a minor. The parent or guardian must then sign the consent.								
Address: Address: Date:, 19 Consent (if applicable) I am the parent or guardian of the minor named above and have the legal authority to execute the above release. I approve the foregoing and waive any rights in the premises. Witness: Signed: Parent or Guardian Address: Address: Date:, 19 * Delete this sentence if the subject is a minor. The parent or guardian must then sign the consent.								
Address:	Witness:	Sign	ed:					
Date:, 19 Consent (if applicable) I am the parent or guardian of the minor named above and have the legal authority to execute the above release. I approve the foregoing and waive any rights in the premises. Witness: Signed: Parent or Guardian Address: Address: Date:, 19 * Delete this sentence if the subject is a minor. The parent or guardian must then sign the consent.			Model					
Date:, 19 Consent (if applicable) I am the parent or guardian of the minor named above and have the legal authority to execute the above release. I approve the foregoing and waive any rights in the premises. Witness: Signed: Parent or Guardian Address: Address: Date:, 19 * Delete this sentence if the subject is a minor. The parent or guardian must then sign the consent.								
Date:, 19 Consent (if applicable) I am the parent or guardian of the minor named above and have the legal authority to execute the above release. I approve the foregoing and waive any rights in the premises. Witness: Signed: Parent or Guardian Address: Address: Date:, 19 * Delete this sentence if the subject is a minor. The parent or guardian must then sign the consent.	Address:	Add	ress:					
Consent (if applicable) I am the parent or guardian of the minor named above and have the legal authority to execute the above release. I approve the foregoing and waive any rights in the premises. Witness: Signed:								
Consent (if applicable) I am the parent or guardian of the minor named above and have the legal authority to execute the above release. I approve the foregoing and waive any rights in the premises. Witness: Signed:								
I am the parent or guardian of the minor named above and have the legal authority to execute the above release. I approve the foregoing and waive any rights in the premises. Witness: Signed:		Date:,	19					
I am the parent or guardian of the minor named above and have the legal authority to execute the above release. I approve the foregoing and waive any rights in the premises. Witness: Signed:								
I am the parent or guardian of the minor named above and have the legal authority to execute the above release. I approve the foregoing and waive any rights in the premises. Witness: Signed:	Consent (if applicable)							
Witness: Signed:		concent (ii appii	oublo)					
Witness: Signed:	I am the parent or guardian of the	e minor named above and	d have the legal authority to execute the above					
Address: Address: Date:, 19 * Delete this sentence if the subject is a minor. The parent or guardian must then sign the consent.	release. I approve the foregoing and waive any rights in the premises.							
Address: Address: Date:, 19 * Delete this sentence if the subject is a minor. The parent or guardian must then sign the consent.								
Address: Address: Date:, 19 * Delete this sentence if the subject is a minor. The parent or guardian must then sign the consent.	Witness	0:	-4					
Address: Address: Date:, 19 * Delete this sentence if the subject is a minor. The parent or guardian must then sign the consent.	Witness:	Sign						
Date:, 19 * Delete this sentence if the subject is a minor. The parent or guardian must then sign the consent.			raion or dandar					
Date:, 19 * Delete this sentence if the subject is a minor. The parent or guardian must then sign the consent.								
Date:, 19 * Delete this sentence if the subject is a minor. The parent or guardian must then sign the consent.	Address.	Δddr	966.					
* Delete this sentence if the subject is a minor. The parent or guardian must then sign the consent.	/Idd1033	Addi	GSS					
* Delete this sentence if the subject is a minor. The parent or guardian must then sign the consent.								
		Date:	, 19					
	* Delete this sentence if the subject is a minor. The parent or guardian must then sign the consent.							
Reproduced by permission from <i>Business and Legal Forms for Photographers</i> by Tad Crawford (Allworth Press).	Reproduced by permission from <i>Business are</i>	nd Legal Forms for Photographer	s by Tad Crawford (Allworth Press).					

Glossary

- **Angle of incidence law** This states that the angle of incidence equals the angle of reflectance. Therefore, light striking a surface at a given angle is reflected from that surface at the same angle, similar to a banked billiard ball.
- **Artificial light** Usually refers to a light source such as tungsten or electronic flash, which is supplied, positioned, and controlled by the photographer.
- **Available light** The light which already exists in the scene to be photographed. A photograph made with available light implies that the photographer didn't supply professional lighting equipment.
- **Background material** An almost endless variety of materials which can be used as a background or backdrop for the subject.
- **Back light** A light source that's positioned behind the subject and points towards the camera. The subject is referred to as back lit.
- **Bellows** The flexible and light proof part of the view camera connecting the front standard to the rear standard. Most often, a bellows is accordion shaped.
- **Book** Slang for a photographer's portfolio.
- **Booking** A confirmed assisting job for a specific date.
- **Boom** A horizontal crossbar placed on top of a stand, used to position lights and other objects over the set.
- **C-41** The chemical process used to develop color negative film.
- **Camera movements** -The movements which can be performed by a view camera to control perspective and the plane of sharp focus. These are: rise, fall, swing, tilt, and shift.
- **Changing room** A small room used to load and unload sheet film holders.
- **Changing bag** A light proof bag into which the hands can be inserted. It's most likely used to load or unload sheet film holders while on location.
- **Chrome** A term referring to exposed color transparency film.
- Color compensating filters 1 hese are used to achieve precise color rendition by compensating for deficiencies in the color quality from a light source, the film, or reciprocity failure. Available in the primary colors: blue, green, red; and the secondary colors: cyan, yellow, magenta. They're usually a gelatin type filter and held in a filter frame.
- **Color temperature** A way of numerically describing the color of light. Midday sun and electronic flash have a color temperature of about 5500 degrees Kelvin. Light at dawn, dusk, and that produced from tungsten lighting is approximately 3300 degrees Kelvin.
- **Compendium** A bellows shaped lens shade used primarily on large format lenses.

- **Creative directories** Books published on a local or national level to advertise a photographer's services. Also referred to as sourcebooks and photography annuals.
- **Cropping tools** A pair of L-shaped pieces of black cardboard used to crop Polaroid prints and color transparencies.
- Dark cloth See: Focusing cloth.
- **Dark slide** The removable slide utilized in sheet film holders and medium format film magazines. It's designed to protect the film from unwanted light, when the film holder or magazine is not attached to the camera.
- **Day rate** The base amount a photographer, stylist, or assistant charges for a day's services.
- **Diffuse light** The kind of light produced by a source having a large area, such as an overcast day or a soft box. Diffuse light doesn't produce sharp shadows, and is thought of as having a soft quality. It's the opposite of specular light.
- **Diffusion material** A variety of translucent white materials used to make a specular light source more diffuse.
- **E-6** The chemical process used to develop color transparency films, other than Kodachrome.
- **Electronic flash** The brief, but brilliant flash of daylight balanced light produced by electronic flash systems. Also called a strobe.
- **Fill card** A lighting tool used to reflect light back onto the set. Although most often made from white cardboard, their size and shape vary widely. Also referred to as reflector or card.
- **Flag** A light modifying device, usually consisting of a piece of black cardboard, positioned to eliminate lens flare or control a light source.
- **Flash head** The part of the electronic flash system that consists of the flash tube, modeling light, and cooling fan. It's connected to a power supply by a long cable.
- **Flash meter** A kind of light meter capable of measuring the brief duration of a flash of light.
- Flash tube That portion of a flash head which produces the flash of light.
- **Focusing cloth** A black piece of cloth used with view cameras to aid in viewing the ground glass. Also called a dark cloth.
- **Freelance** A photographer, stylist, or assistant who is an independent contractor and solicits work from a variety of sources.
- **Full time** In the context of this book, an assistant who's a full time employee for one photographer or studio.
- **Gaffers tape** A specialized photographic tape, usually black in color and two inches wide. It's very strong, yet doesn't leave a gummy residue when removed from photographic equipment.

- **Ground glass** The viewing screen found on a view camera. This is often protected by a fresnel lens.
- **Hot lights** Common term for tungsten or quartz lights, which produce considerable heat compared to electronic flash.
- **Inverse square law** A law of physics stating: the intensity of illumination is inversely proportional to the square of the distance between the light and subject. In other words, if the distance from the subject to the light is doubled, the illumination is decreased to one-fourth. Therefore, altering a light's distance is an effective means of adjusting the illumination.
- Key light See: Main light.
- Layout A sketch or drawing representing what's to be produced on film.
- **Loupe** Common abbreviation for a focusing loupe or magnifying loupe. Aids in focusing the view camera and viewing color transparencies.
- *Main light* The principal light source used in the photograph. Also called key light.
- **Modeling light** A low wattage tungsten lamp built into a flash head. It's used to judge the approximate effect of the flash.
- **Model release** A form granting the photographer the right to use the photographs. It should be signed by the model shortly after the shooting session.
- *Natural light* Refers to the light produced by the sun.
- **Notch code** The notches found along one edge of sheet film. Allows the film type and emulsion side to be identified in the dark.
- *Open-up* To increase the size of the lens aperture, from f22 to f5.6 for example. The opposite is to stop-down the lens.
- **Perspective** The apparent size and depth of objects within an image. Perspective is the quality that creates the illusion of three dimensions in a two dimensional photograph. Some aspects of perspective can be controlled through the use of the view camera movements.
- **Plane of sharp focus** That area of the scene which is most sharply focused. The placement of the plane of sharp focus can be controlled by proper use of the view camera movements.
- **Polaroid instant film** This type of film produces an instant print which is used to check focus, lighting, and composition. Polaroid instant film can be used with 35mm SLR, medium format, and view cameras. Often referred to as a proof print.
- **Pop** Refers to the sound produced when a flash head produces a flash. An exposure may require multiple pops to produce sufficient light.
- **Power supply** A major component of electronic flash systems. It's basically a large capacitor, or rechargeable battery, that provides energy to produce the flash of light. Power supplies are rated in watt-seconds.

- **Proofing** Refers to using Polaroid instant film to check lighting, exposure, and composition.
- **Pull** To overexpose the film, then compensate by giving the film less than normal development.
- **Push** To underexpose the film, then compensate by giving the film greater, or longer development than normal.
- **Roll film** Film that comes in a roll. Commonly used in 35mm SLR and medium format cameras.
- **Scheimpflug rule** This law states: to obtain overall sharp focus, the plane of the subject, the plane of the lensboard, and the plane of the film must either be parallel to each other, or meet at a common point. Applies to view cameras and their movements.
- **Sheet film** Film that is cut into flat sheets, commonly measuring 4x5 and 8x10 inches.
- **Single lens reflex (SLR)** A camera in which the image formed by the lens is reflected onto the viewing screen by a mirror. Most 35mm and medium format cameras are of this design.
- **Soft box** A light modifying device in which light passes through a large piece of diffusion material, thereby producing a diffuse light. Also referred to as a soff box or light bank.
- **Specular light** That kind of light which emanates from a specific point, such as a bare light bulb. It produces very distinct shadows. The opposite is diffuse light.
- **Still life** A type of photography involving the arrangement of objects into an aesthetically pleasing composition.
- **Stop-down** To decrease the size of the lens aperture, from 5.6 to f22.0, for example. The opposite is to open-up the lens.
- **Strobe** A term used to refer to electronic flash systems.
- **Stylist** An individual utilized during a shooting session to prepare the subject, usually a person and their clothing. However, due to the fickle nature of food, food stylists also exist.
- **Sweep** Refers to a background such as Formica or seamless paper which is swept up to form a concave surface.
- **Tungsten lighting** A continuous light produced from a thin tungsten filament. Often referred to as hot lights, due to the large amount of heat produced.
- **View camera** A camera in which the lens forms an upside down and backwards image, directly on a ground glass viewing screen. The front and back of the camera can be adjusted to control focus and perspective.
- **Watt-seconds(w-s)** The unit used to rate the output from a power supply. The greater the number of watt-seconds the greater the power.

Appendix A

Professional Associations

Advertising Photographers of America (APA)

Los Angeles Chapter 7201 Melrose Ave.

Los Angeles, CA 90046 • 213-935-7283

This is the largest chapter of the APA and it can provide information regarding regional chapters. Regional chapters can also be found in the following cities: Atlanta, Chicago, Detroit, Honolulu, Las Vegas, Miami, New York, Portland, and San Francisco. Membership is open to photographic assistants and an assistants directory is published in larger cities.

Advertising Photographers of America (APA)

Chicago Chapter 1725 West North Avenue, Suite 2D2 Chicago, IL 60622 • 312-342-1717

Advertising Photographers of America (APA)

New York Chapter 27 West 20th Street New York, NY 10011 • 212-807-0399

Advertising Photographers of America (APA)

San Francisco Chapter 22 Cleveland Street San Francisco, CA 94103 • 415-621-3915

American Society of Magazine Photographers (ASMP)

419 Park Avenue South

New York, NY 10016 • 212-889-9144

This is the largest organization of professional photographers. Contact the national office to locate regional chapters. Membership is open to assistants and local chapters publish an assistants list and monthly newsletters.

Professional Photographers of America, Inc. (PP of A)

1090 Executive Way

Des Plaines, IL 60018 • 708-299-8161

Contact the national office for the membership list of your region. Members are categorized by their photographic specialty. *Professional Photographer* is the official magazine of the PP of A. It also publishes the directory, *Who's Who in Professional Photography*.

Professional Photographers of Canada, Inc.

1215 Penticton Avenue Penticton, BC V2A2N3 604-493-4322

This organization publishes a directory for its members.

Appendix B

Creative Directories

American Showcase Illustration and Photography

915 Broadway, Fourteenth Floor New York, NY 10010 212-673-6600 Market: The United States and Canada

Annual Report; AR Creative Directory

The Black Book Marketing Group 115 Fifth Avenue New York, NY 10003 212-254-1330 Market: The United States and Canada Specifically for annual report photogra-

The Alternative Pick

phers

Storm Music Publications 8 West 40th Street, Suite 1901 New York, NY 10018 212-398-8532

Market: The United States, specifically for the music industry

Bay Area Sourcebook

The Black Book Marketing Group 115 Fifth Avenue New York, NY 10003 212-254-1330 Market: San Francisco metropolitan area

The Black Book—Stock

The Black Book Marketing Group 115 Fifth Avenue New York, NY 10003 212-254-1330 Market: United States and Canada, specifically for stock photographers

The Chicago Creative Directory

333 North Michigan Avenue Suite 810 Chicago, IL 60601 312-236-7337 Market: Chicago

Chicago Sourcebook

The Black Book Marketing Group 115 Fifth Avenue New York, NY 10003 212-254-1330 Market: Chicago

Colorado Creative Sourcebook

PO Box 4781 Denver, CO 80204 303-296-1269 Market: Colorado

Corporate Showcase American Showcase

915 Broadway, Fourteenth Floor New York, NY 10010 212-673-6600 Market: The United States and Canada For photographers specializing in corporate accounts.

The Creative Black Book

115 Fifth Avenue, Third Floor New York, NY 10003 212-254-1330 Market: The United States and Canada

N.Y. Gold

10 East 21st Street, Fourteenth Floor New York, NY 10010 212-254-1000

Market: New York City area

Ohio Sourcebook

The Black Book Marketing Group 115 Fifth Avenue New York, NY 10003 212-254-1330 Market: Ohio

Southeast Sourcebook

The Black Book Marketing Group 115 Fifth Avenue New York, NY 10003 212-254-1330 Market: The southeastern United States

Twin Cities Creative Sourcebook

The Black Book Marketing Group 115 Fifth Avenue New York, NY 10003 212-254-1330 Market: Minneapolis and St. Paul

Texas Sourcebook

The Black Book Marketing Group 115 Fifth Avenue New York, NY 10003 212-254-1330 Market: Texas

Who's Who in Professional Photography

Professional Photographers of America 1090 Executive Way Des Plaines, IL 60018 Market: National directory for the Professional Photographers of America

Workbook, The National Directory of Creative Talent

Volume One, Photobook 940 North Highland, Suite B Los Angeles, CA 90038 800-547-2688 213-856-0008

Market: The United States

Workbook's Single Image 940 North Highland, Suite B Los Angeles, CA 90038 800-547-2688 213-856-0008

Market: The United States

Appendix C

Photographic Literature and Catalogs

AMPHOTO, American Photography Book Publishing Company

1515 Broadway
New York, NY 10036
201-363-5679
Publishes many photography books and has a catalog available.

Beseler Photo Marketing Co.

1600 Lower Road Linden, NJ 07636 Darkroom equipment, including enlargers.

Bogen Photo Corporation

565 East Crescent Avenue Ramsey, NJ 07446-0506 201-818-9500 Distributes Bogen tripods and stands, Gossen light meters, Lightform light control panels, and Metz on-camera flash units.

Bronica Cameras

GMI Photographic, Inc. 1776 New Highway P.O. Drawer U Farmingdale, NY 11735 516-752-0066 Bronica medium format cameras and lenses.

Calumet Photographic, Inc.

890 Supreme Drive
Bensenville, IL 60106
800-225-8638
An excellent general purpose catalog directed to the professional photographer. Features all camera formats, electronic flash systems, lighting hardware, darkroom supplies, and many related accessories.

Canon U.S.A., Inc.

One Canon Plaza Lake Success, NY 11042 516-488-6700 Canon 35mm SLR camera and lenses.

Chimera Photographic Lighting

1812 Valtec Lane
Boulder, CO 80301
303-444-8000
800-424-4075
Light modifying devices, such as light banks and soft boxes.

Domke Photo Resources

21 Jet View Drive Rochester, NY 14624 716-328-7800 Domke camera bags.

Eastman Kodak

343 State Street
Rochester, NY 14650-0811
716-254-1300
800-242-2424
Photographic films, papers, and chemicals. The Kodak Index to
Photographic Information is free, and provides a listing of hundreds of books and pamphlets published by Kodak.

Fidelity Manufacturing Company

3120 Damon Way Burbank, CA 91505 818-846-5550 800-446-5565 Fidelity and Riteway sheet film holders.

Gitzo Tripods

Karl Heitz, Inc. 34-11 62nd Street Woodside, NY 11377 718-565-0004 Professional tripods and tripod heads.

Hasselblad Cameras

Victor Hasselblad, Inc. 10 Madison Road Fairfield, NJ 07006 201-227-7320 800-338-6477 Medium format cameras

Medium format cameras.

310 South Racine Avenue

Helix Ltd.

Chicago, IL 60607 312-421-6000 800-621-6471 Diverse selection of photographic equipment for the professional photog-

Diverse selection of photographic equipment for the professional photographer. Includes all camera formats, lighting, darkroom, and everything in between.

HP Marketing

16 Chapin Road Pine Brook, NJ 07058 201-808-9010 Linhof view cameras and Rodenstock large format lenses.

JOBO Processors

JOBO Fototechnic P.O. Box 3721 Ann Arbor, MI 48106 313-995-4192 800-627-5511 Automated photographic processing equipment.

Leedal, Inc.

1918 South Prairie Avenue Chicago, IL 60616 312-842-6588 Leedal portfolio materials including slide presentation systems.

Light Impressions Corporation

439 Monroe Avenue Rochester, NY 14607 716-271-8960

Excellent selection of portfolio related materials, such as presentation boards and cases. Also has a photography book catalog containing a large and diverse selection.

Lightware, Inc.

equipment.

1541 Platte Street Denver, CO 80202 303-455-4556 Cases for every kind of photographic

Lowel-Light Manufacturing, Inc.

140 58th Street Brooklyn, NY 11220 718-921-0600 800-334-3426 Tungsten photographic light

Tungsten photographic lighting equipment.

Mamiya America Corporation

8 Westchester Plaza Elmsford, NY 10523 914-347-3300 Mamiya medium format cameras and Toyo view cameras.

Matthews Studio Equipment

2405 Empire Ave. Burbank, CA 91504 818-843-6715 213-849-6811 Vast array of stands and studio hardware related to lighting.

Minolta Corporation

101 Williams Drive Ramsey, NJ 07446 201-825-4000 Minolta 35mm SLR cameras and light meters.

Nikon, Inc.

623 Stewart Avenue Garden City, NY 11530 516-220-0200 Nikon 35mm SLR cameras, lenses, and on-camera flash units.

Norman Enterprises, Inc.

2601 Empire Avenue Burbank, CA 91504 818-843-6811 Norman electronic flash equipment.

NPC Photo Division

1238 Chestnut Street
Newton Upper Falls, MA 02164
617-969-4522
Polaroid instant film backs for 35mm and medium format cameras.

Paterson Darkroom Accessories

The Saunders Group
21 Jet View Drive
Rochester, NY 14624
716-328-7800 ext. 23
Wide range of darkroom equipment, including accessories for film processing and printing.

Pentax Corporation

35 Inverness Drive East Englewood, CO 80112 303-799-8000 Pentax 35mm and medium format SLR cameras.

Photoflex, Inc.

541 Capitola Road Ext., Suite G Santa Cruz, CA 95062 800-826-5903 Photoflex light modifying devices, including soft boxes and reflector panels.

Plume Ltd.

432 Main Street
P.O. Box 9
Silver Plume, CO 80476
303-569-3236
Light modifying devices such as soft boxes.

Polaroid Corporation

575 Technology Square Cambridge, MA 02139 617-577-2000 800-225-1618 Polaroid instant film and film holders.

Quantum Instruments

1075 Stewart Ave. Garden City, NY 11530 516-222-0611 Rechargeable battery packs for small electronic flash units and flash meters.

Sekonic Light Meters

R.T.S., Inc. 40-11 Burt Drive Deer Park, NY 11729 516-242-6801 Sekonic light meters.

The Set Shop

37 East 18th Street New York, NY 10003 800-422-7381

Primarily products for the studio, including background materials and stands. But, it also has many hard to find supplies like adhesives, props, and portfolio related materials.

Sinar Bron, Inc.

17 Progress Street Edison, NJ 08820 908-754-5800 Distributors of Sinar view cameras, Broncolor electronic flash equipment, Foba studio stands, and Just transparency viewers.

Smith-Victor Lighting Equipment

Smith-Victor Corporation 301 North Colfax Street Griffith, IN 46319 312-768-1025 Tungsten photographic lighting equipment.

Speedotron Corp.

310 South Racine Avenue Chicago, IL 60607 312-421-4050 Speedotron electronic flash equipment.

Superior Specialties, Inc.

2525 North Casaloma Drive Appleton, WI 54913 414-749-5055 800-666-2545 Background materials, studio accessories, and photo props.

Tekno, Inc.

100 West Erie Street Chicago, IL 60610 312-787-8922 Arca-Swiss view cameras and Balcar electronic flash.

Trengove Studio, Inc.

60 West 22nd Street New York, NY 10010 212-255-2857 800-366-2857 Special effects materials like artificial ice and steam chips.

The F.J. Westcott Company

1447 Summit Street, P.O. Box 1596 Toledo, OH 43603 419-243-7311 800-833-1689 Halo brand light modifying devices, including soft boxes.

Wolf Camera and Video

Commercial Division 150 14th Street, N.W. Atlanta, GA 30318 404-875-0071 800-241-5518 A broad selection of equipment for the professional photographer, including view cameras, electronic flash, and lighting accessories.

Appendix D

Periodicals

American Photo

1633 Broadway New York, NY 10019 This presents a wide va

This presents a wide variety of photographic articles. The non-technical writing is directed to both advanced amateurs and professional photographers.

Aperture

20 East 23rd Street New York, NY 10010 Aperture features mostly fine art photography.

Industrial Photography

PTN Publishing Company 445 Broad Hollow Road Melville, NY 11747 516-845-2700 This is directed to commercial and industrial photographers, and provides a

Outdoor Photographer

Werner Publishing Company 12121 Wilshire Blvd., Suite 1220 Los Angeles, CA 90025 A magazine for those interested in landscape, travel, and wildlife photography.

wide range of technical information.

Photo/Design

1515 Broadway
New York, NY 10036
212-536-5329
An excellent publication presenting current trends in commercial photography.

Photo District News

49 East 21st Street
New York, NY 10010
212-677-8418
Provides thorough coverage of many subjects related to professional photography. It includes business and legal

aspects, trends in photographic styles,

and the future of photography. The best periodical for the majority of professional photographers.

Photo Electronic Imaging

Professional Photographers of America 1090 Executive Way Des Plaines, IL 60018 708-299-8161

A publication for industrial and commercial photographers, including those in the audio-visual professions.

Photographic Magazine

8490 Sunset Blvd. Los Angeles, CA 90069 A general purpose magazine directed to the amateur photographer.

Popular Photography

1633 Broadway
New York, NY 10019
This is a widely circulated magazine for the amateur photographer.

Professional Photographer

Professional Photographers of America Publications 1090 Executive Way Des Plaines, IL 60018 708-299-8161 Presents business and technical subjects for professional photographers.

Presents business and technical subjects for professional photographers. The official journal of the Professional Photographers of America.

Studio Photography

PTN Publishing Company 445 Broad Hollow Road, Suite 21 Melville, NY 11747 516-845-2700 This publication is directed primarily to wedding and portrait photographers.

Test-Polaroid Corporation

575 Technology Square 2M Cambridge, MA 02139-9878 800-225-1618 Test is published by Polaroid

Test is published by Polaroid Corporation, in order to provide technical information on its film and equipment.

Index

Clamps, 146-147. See also Hardware Cleaners, kinds of, 151-153 Cleaning, 149-152, 156, 181. See also Surface preparation A common surfaces, 152-154 responsibilities, 152, 156 Adhesives, 136, 147-148, 168 Commercial photography, 10, 34, 173-182 Aerial photography, 53 Compendium lens shade, 75, 84 Aerosol sprays, 155-156 Creative directories, 20, 34-35, 40-41, 180, 198-199 Architectural photography, 11, 82, 153, 178, 180-184 Artificial light 78, 113-127, 129-130, 139 Dark slide, 71, 87, 102. See also Medium format kinds of, 113-114 camera: View camera qualities of, 129-130, 136 Darkroom, 23, 162, 170-171, 188 responsibilities, 9, 122, 125, 136 Diffusion material, 131-132, 180 Assistant, employed by, 7-8, 10-13 Droy, Todd, 139-142 freelance/full time, 12-13, 15, 43, 162, 170-171, Dulling spray, 155 interaction with clients, 28, 50, 79, 188 E second, 56, 112 Editorial photography, 11-12 transition to photographer, 10, 17, 142 Electronic flash systems, 113-114, 122, 130, 140 what is an, 7, 77, 163 flash head, 119-121 (See also Flash head) woman as, 15-16, 52, 79, 110-111, 141, 164, monolights, 78, 121 multiple flashes (pops), 121, 122 Assisting, benefits from, 8-10, 12-13, 52-54, power supply, 114-119 (See also Power supply) 141-142, 163, 173, 185-186, 190 responsibilities, 122 organizations, 20, 35, 36, 52, 180, 186, 197 Equipment, acquiring, 45-46 rates, 16 (See also Rates) location check list, 183-184 requirements, 25-26 (See also Skills; packing, 177-179, 183 Photography schools) Ethics, 47-48, 50-51, 78-79, 111, 163, 164 responsibilities, 8-9, 80, 189 (See also Responsibilities) skills, 8 (See also Skills) Fashion. See People photography Audio-visual photography, 179 Fill cards, 100, 134-135, 144 Film. See also Medium format camera; Sheet film; 35mm SLR camera. Background materials, 56, 157-161, 184 exposure process, 73 74, 154, 176 177 applications, 159-161 handling, 56-58, 189-190 cleaning, 150-153 processing, 74-75, 93-94 kinds of, 135-136, 158-161 types of, 87, 94 responsibilities, 157-158, 161 Film magazine (back). See Medium format camera storage, 159, 160, 171 Filter frame, 67, 75, 85. See also Compendium working with, 147, 148, 157-158, 167 lens shade Bartering, 45-46. See also Rates Filters, for lenses, 66-67, 75, 84-85. See also Medium Black velvet cloth, 135-136, 161 format camera; 35mm SLR camera; View camera Booking assisting jobs, 44-45, 62, 178, 179-180 for lights, 131-132, 134 cancellations, 48 Fischer, Carl, 162-164 Bookkeeping, 46-47 Flash head, 119-121, 144, 183 Booms, 144, 145-146, 176, 182 attaching to stand, 121 Brown, Nancy, 14-17 metering process, 122, 137 (See also Light meters) Business, 13, 43 parts of, 119-120 expenses, 45, 47, 180

Call report, 37-38, 40, 56 Changing bag, 94-95 safety, 120
light modifying devices, 130-134
responsibilities, 122
Flash meter, 137-138. See also Light meters

Gaffers tape, 147. See also Adhesives

Н

Hasselblad camera, 21, 72, 140, 187, 201 lenses, 75 Hardware, photographic, 136, 143-148, 158-160. *See also* Adhesives; Clamps; Stands responsibilities, 136, 148 Heron, Michal, 77-80

I

Insurance, 24, 43, 111 Interview, 31-32, 39-41, 50, 78, 140, 187

K

Kitchen, 168-169

L

Layout, 149, 157-158 Lenses. See Medium format camera: 35mm SLR camera; View camera Lens flare, 84, 135 Lighting. See Artificial light; Electronic flash systems: Tungsten light Light meters, 136-138 flash meter, 122, 137-138 responsibilities, 57, 137-138 Light modifying devices, 125, 130-136, 184. See also Reflectors; Soft boxes; Umbrellas responsibilities, 134-135, 136 Literature, photographic, 20, 198-203. See also Periodicals; Creative directories Location photography, 21-22, 52, 111, 148, 168, 177-184, 190 acquiring work, 36, 180 equipment check list, 178, 183-184 out-of-town, 16, 45, 179-180 responsibilities, 182 skills, 21-22, 24

M

Lounge area, 169-170

MacTavish, David, 49-54
Make-up room, 170
Marketing. *See also* Promotional material defining your market, 35-36, 180
strategies, 26-27, 33-37, 39, 41, 180
Medium format camera. *See also* Hasselblad camera

characteristics, 9, 69-71 exposure process, 73-74, 176-177 film magazine (back), 69, 70-71, 96, 102 film processing, 74-75, 189-190 lenses and filters, 75 loading film, 70, 71-73 responsibilities, 70, 73-74, 96, 183 unloading film, 74 Model releases, 176, 192

N

Notch code. See Sheet film

0

On-camera flash units, 123-125
responsibilities, 125
Organizations. See also Assisting
Advertising Photographers of America (APA), 20,
35, 36, 164, 186, 197
American Society of Magazine Photographers
(ASMP), 20, 35, 36, 52, 112, 180, 186, 197
professional, 197
Professional Photographers of America (PP of A),
197, 204

P

Painting, 24, 154-155 People photography, 11, 170, 175-177, 181-182, 187 models, 8, 15, 152, 175-176, 192 nonprofessional models, 175-176, 192 responsibilities, 175, 177, 181-182 Periodicals, 20, 36, 180, 204 Plexiglass, 160. See also Background materials Photographer, billing the, 46-47 communicating with, 25-26, 57, 108, 174, 175 contacting the, 36-41, 50, 78, 141 hiring assistants, 7-8, 10-13, 33 Photographic assistant. See Assistant; Assisting Photography schools, 14-15, 25, 40, 51, 109-110, 142 Polaroid instant film, 9, 69, 92, 96 annotating prints, 59, 100-101, 107, 117 characteristics, 99, 102 medium and small format cameras, 101-103 model 545 film holder, 104-106 processing, 99, 103, 105 responsibilities, 57-58, 96, 99-100, 107 uses, 97-98, 103-104, 175 view cameras, 103-106 Portfolio, 29-32. See also Promotional material Portrait photography, 12, 175. See also People photography Power supply, 114-115, 122 flash meter, 137-138

master-slave, 118-119

operating 115 118 122	162, 187
operating, 115-118, 122 recycle time, 116, 178-179	skill list, 19, 22-24
responsibilities, 122	technical, 14, 51-52, 108-109, 139-140
safety, 108, 119, 122	Soft boxes, 132-134. See also Light modifying devices
synchronizing, 57, 117-118, 122, 138, 180	Sourcebooks. See Creative directories
watt-second, 114, 116-117	Stands, 143-145, 148
Product photography, 11, 34, 81, 173-174, 181	Strobe. See Electronic flash systems
Promotional material, 24-32	Studio, 58, 165-171
alternatives, 27-29	learning the, 56, 165-167
business cards, 27, 35, 141	parts of, 166-171
letters, 26	Surface preparation, 149-156, 167, 173, 181. See also
portfolios, 15, 29-32, 49, 78, 109, 162, 187, 188 resumes, 25-26, 141	Cleaning; Painting; Aerosol Sprays
strategies, 12-13, 26-29, 31, 39 (See also Marketing)	T
Q	Tape, 147. See also Adhesives Tasks, 55-61.
Qualifications. See Skills; Responsibilities	Telephone, answering machine, 40, 47
,,	using, 19, 39-40, 49-50, 169
R	35mm SLR camera, characteristics, 63-64, 66-67, 179
Radio transmitter/receiver, 118-119. See also Power supply	exposure process, 65-66, 176-177 film handling, 64-66, 74-75, 79-80
Rates, 16, 51, 78, 109, 163, 190	lenses and filters, 66-67
bartering, 45-46, 186	on-camera flash units, 123-124
cancellations, 48	responsibilities, 64-67, 96, 183
establishing, 43-45	Travel. See Location photography
Reflectors, 130, 132, 180. See also Light modifying	Tripod, 76, 83, 183
devices	Tungsten light, 114, 126-127, 130-132, 136, 180
Releases, 176, 192	applications, 127, 154
Responsibilities, introduction to, 55-61	kinds of, 126-127
Resume, 25-26 See also Promotional material	operating, 126
5	U
Safety, 53, 108, 146, 150, 178	Umbrellas, 131, 180
Salary. See Rates	Umland, Steve, 108-112
Seamless paper, 159-160. See also Background .materials	v
Secunda, Shel, 187-191	View camera. See also Sheet film
Set, working on, 56, 174	characteristics, 81-85, 173-174
Set cart, 167-168	dark slide, 87, 88, 90
Sheet film, 85-86. See also Sheet film holders	filters, 84-85
handling, 89-93	focusing, 85, 98, 104
identifying, 87, 92-93	large format lenses, 83-84, 127
notch code, 89, 90-91	movements, 82
processing, 93-94, 96	responsibilities, 83-84, 96, 183
Sheet film holders, 56, 85-93. See also Sheet film	w
cleaning, 59, 85-89	
exposure process, 92, 96, 154	Watt-second, 114, 116-117. See also Power supply
loading film, 89-92	Wedding photography, 12, 177. See also People
unloading film, 93, 179 Skills, 8, 19-24	photography Workmen's compensation. See Insurance
developing, 19-21	Workshop, 21, 166, 168
nonphotographic, 21-22, 24, 25-26, 77, 168	1101K5110p, 21, 100, 100
objectivity, 22, 41, 171	
personal attributes, 14, 16-17, 48-50, 77, 108, 139,	
1	

ALLWORTH BOOKS

Allworth Press publishes quality books for photographers, artists, authors, graphic designers, illustrators, and small businesses. Titles published include:

Business and Legal Forms for Photographers by Tad Crawford.

Twenty-four essential forms covering all aspects of photography, plus careful explanations and negotiation checklists. "A simple one sentence review: Every photographer needs this book." — *Shutterbug.* (208 pages, 8 1/2" X 11", \$18.95)

Caring for Your Art by Jill Snyder.

Step-by-step guidance on the best methods to store, handle, mount and frame, display, document and inventory, photograph, pack, transport, insure, and secure art. (176 pages, 6" X 9", \$14.95)

How to Sell Your Photographs and Illustrations by Elliott and Barbara Gordon.

Two experienced reps tell who buys and how to reach them, creating your best portfolio, how to do promotion, pricing and negotiation, using reps, and more. (128 pages, 8" X 10", \$16.95)

How to Shoot Stock Photos that Sell by Michal Heron.

Everything you need to know for success as a stock shooter, from how to shoot to how to sell. Contains 25 unique self-assignments to let you create images that buyers want today. "One of the top publications in today's hottest photographic area." — *Studio Photography* (192 pages, 8" X 10", \$16.95)

Legal Guide for the Visual Artist by Tad Crawford.

This classic guide covers copyright, contracts, moral rights, privacy, leases, taxes, estate planning, and more, with valuable resource sections. (224 pages, 7" X 12", \$18.95)

Make It Legal by Lee Wilson.

This is the definitive guide to advertising, covering copyright, trademarks, libel, rights of publicity, and false advertising law. Includes model forms and releases. (272 pages, 6" X 9", \$18.95)

Overexposure: Health Hazards in Photography by Susan D. Shaw and Monona Rossol. This highly acclaimed work is completely revised from its 1983 edition. It offers a complete guide to all risks that photographers, lab personnel, and others using photographic chemicals face — and tells how to protect health and safety. (320 pages, 6 3/4" X 10", \$18.95)

Protecting Your Rights and Increasing Your Income by Tad Crawford.

This hour-long audio cassette covers copyright law (including the Supreme Court's work-for-hire decision and the test for infringement), and how to handle contracts and negotiations. (60 minutes, \$12.95)

Stock Photo Forms by Michal Heron.

Here are 19 forms that will organize your stock shoot and help you achieve success. Included are a stock job form, estimate for shoot expenses, a shooting day organizer, pocket releases, and more. A Main Selection of the Photography Book Club. (32 pages, 8 1/2" X 11", \$8.95)

Travel Photography: A Complete Guide to How to Shoot and Sell by Susan McCartney. This unique and complete guide tells how to shoot the best possible photos — and earn money doing it. "Mandatory reading for all travel photographers," according to Bill Black, Picture Editor of Travel/Holiday Magazine. Includes ten self-assignments, world travel highlights, and releases in twenty-nine languages. (384 pages, 6 3/4" X 10", \$22.95)

Please write to request our free catalog. If you wish to order a book, send your check or money order to **Allworth Press**, **10 East 23rd Street**, **Suite 400**, **New York**, **NY 10010**. To pay for shipping and handling, include \$3 for the first book ordered and \$1 for each additional book (\$7 plus \$1 if the order is from Canada). New York State residents must also add sales tax.